Digital Photography

For Seniors

FOR

DUMMIES®

by Mark Justice Hinton

WILEY

Wiley Publishing, Inc.

Digital Photography For Seniors For Dummies®

Published by
Wiley Publishing, Inc.
111 River Street
Hoboken, NJ 07030-5774

www.wiley.com

Copyright © 2009 by Wiley Publishing, Inc., Indianapolis, Indiana

Published by Wiley Publishing, Inc., Indianapolis, Indiana

Published simultaneously in Canada

For general information on our other products and services, please contact our Customer Care Department within the U.S. at 877-762-2974, outside the U.S. at 317-572-3993, or fax 317-572-4002.

For technical support, please visit www.wiley.com/techsupport.

Wiley also publishes its books in a variety of electronic formats. Some content that appears in print may not be available in electronic books.

Library of Congress Control Number: 2009922966

ISBN: 978-0-470-44417-7

Manufactured in the United States of America

10 9 8 7 6 5 4 3 2

About the Author

A computerist for more than 30 years, **Mark Justice Hinton** has written two books on digital photography and one on Microsoft Windows Vista. He has taught computer classes since 1988 for the University of New Mexico Division of Continuing Education. Mark writes a blog on computer topics: www.mjhinton.com/help.

Author's Acknowledgments

Thanks to everyone at Wiley for their part in producing this book. Special thanks to my acquisitions editor Steve Hayes; project editor Mark Enochs; technical editor Chuck Pace; copy editors Linda Morris and Teresa Artman; and editorial assistant Cherrie Case. My deepest thanks to Merri Rudd, long-time senior advocate, photographer, writer, and editor, as well as *mi corazón*.

Peace,
mjh

Dedication

To my Droogs, my friends, and my buddy. Smile!

All I have is a photo in my wallet,
a small remembrance of something more solid.
All I have is a picture of you. — Blondie

Publisher's Acknowledgments

We're proud of this book; please send us your comments through our online registration form located at http://dummies.custhelp.com. For other comments, please contact our Customer Care Department within the U.S. at 877-762-2974, outside the U.S. at 317-572-3993, or fax 317-572-4002.

Some of the people who helped bring this book to market include the following:

Acquisitions, Editorial, and Media Development

Senior Project Editor: Mark Enochs

Executive Editor: Steve Hayes

Copy Editors: Teresa Artman, Linda Morris

Technical Editor: Chuck Pace

Editorial Manager: Leah Cameron

Editorial Assistant: Amanda Foxworth

Sr. Editorial Assistant: Cherie Case

Cartoons: Rich Tennant (www.the5thwave.com)

Composition Services

Project Coordinator: Katie Key

Layout and Graphics: Sarah Philippart, Ronald Terry

Proofreader: Linda Seifert

Indexer: Becky Hornyak

Special Help: Virginia Sanders

Publishing and Editorial for Technology Dummies

 Richard Swadley, Vice President and Executive Group Publisher

 Andy Cummings, Vice President and Publisher

 Mary Bednarek, Executive Acquisitions Director

 Mary C. Corder, Editorial Director

Publishing for Consumer Dummies

 Diane Graves Steele, Vice President and Publisher

Composition Services

 Gerry Fahey, Vice President of Production Services

 Debbie Stailey, Director of Composition Services

Contents at a Glance

Table Of Contents

Digital cameras put all the art and science of photography into your hands. Few things are as personal and instantly gratifying as a photograph. We freeze a moment in time to be marveled over for years to come.

You may already have a camera or perhaps you're getting ready to buy one. The choice can be simple because the major features you're looking for are common to many models. After you have your camera, you'll be amazed by what it does automatically and what you can do with a little control.

Those of us who grew up using film cameras remember the hassles associated with taking pictures. We bought film in rolls and struggled to get it into the camera. (Unless you used Polaroid or an Instamatic.) We weighed each potential photo to decide whether it was worth taking: Would it come out okay? What if we ran out of film because of that one wasted shot? Before every corner drugstore got a processing lab, we took or mailed our photos to specialists and waited days, which might have been months after we took our photos. (There always seemed to be a photo or two we had forgotten taking.) Finally, the photos came back and soon joined countless others in a shoebox or, if you were really diligent, in a photo album. Every aspect of that process has changed with digital photography.

Digital cameras free you from the expense and effort to be ready for next photo. No film means no processing, and no delay or expense for that. (Although, you can still print photos whenever you want to.) Above all, digital

Introduction

Conventions used in this book

This book uses certain conventions to help you find your way around, including these:

➡ **Bold:** I use bold on the important, find-it-now stuff.

- *When you have to type something* in a text box, like in a dialog box in a computer program

- *When I mention a button to press or an option to click,* whether it's on your camera or computer

- *Figure references*

🎯 Some illustrations and figures have notes or other markings to draw your attention to a specific part of the figure.

- *Dialog box names and menu choices.*

➡ **Web site addresses:** They look like this: www.website.com.

➡ **Menu choices:** Look for this arrow symbol: ➪. This shows a sequence of steps on a camera or a computer menu. For example, Menu➪Image Quality➪ JPEG means to click the Menu button, choose Image Quality from the menu that opens, and then choose JPEG.

🎯 On the computer, you single-click the left mouse button to select an option or open a file. A single click of the right mouse button always produces a special, contextual menu with commands tailored to the situation. Only when appropriate will I tell you to click the right mouse button. All other times when I tell you to click the mouse, you can assume that I mean the left button.

🎯 Tip icons point out helpful suggestions related to tasks in the steps lists.

photography provides instant feedback, so you can immediately decide whether to take another shot or whether a particular setting worked.

With a computer and software, you can edit a digital photo, correcting issues in pictures that would have been worthless years ago. You can fix or improve the brightness of the photo, as well as, many other aspects. With the techniques you learn in this book, you can turn a photo from blah to ah.

Finally, you can enjoy your digital photos and share them in so many ways. E-mail photos to friends and family for instant updates. Let people experience your travels online with photo hosting services. Display your photos in any room on digital picture frames. And, print your favorite photos, not only on individual prints, but in handsome bound books. This book shows you how.

About This Book

Age is just a number. This book is intended for anyone getting started with digital photography. I'll tell you how to use your camera and provide step-by-step instructions, in many cases. Numerous figures illustrate camera controls and the photos you can take using recommended settings and techniques.

Foolish Assumptions

I assume you want clear, brief instruction on taking, editing, and sharing photos with others. I also assume you want to know just what you need to know, just when you need to know it. This isn't Photography 101. This is Practical Picture Taking and Sharing. As an old friend of mine says, "I don't want to make a watch; I just want to know what time it is."

The camera and photography topics and tasks should be of use to computer and non-computer users, alike. Halfway through the book, the subject shifts to include computer software, primarily photo-editing programs. Computer-based tasks are based on Windows Vista and XP. Most of the editing and organizing tasks in this book use Windows Live

Photo Gallery because it's free to any Vista or XP user, it's fairly straight-forward to use, and because I use Photo Gallery every day. I do not mean to slight Mac users, who can adapt the coverage to include iPhoto on the Mac. Unfortunately, I know of only one free photo-editing and organizing program that works on both Windows and Mac. That's Google's Picasa, which came out for the Mac just before this book went to press. I also don't mean to ignore popular programs like Adobe Photoshop Elements. However, Elements isn't free and its many tools take more time to master.

Why You Need This Book

You know taking pictures can be easy. Technology always comes with its own terms and concepts, but you don't need to learn another language to have fun taking photos. You don't need any prior experience with cameras, digital or film. Step-by-step instructions guide you through specific tasks, such as choosing a particular setting on your camera. These steps provide just enough information for the task at hand.

You can work through this book from beginning to end or simply open up a chapter to solve a problem or help you learn a new skill whenever you need it. The steps in each task get you where you want to go quickly without a lot of technical explanation. In no time, you'll start picking up the skills you need to become a confident digital photographer.

How This Book Is Organized

This book is divided into four parts to help you find what you need. You can read from cover to cover or just jump to the page that interests you first.

➞ **Part I: Getting Started with Your Digital Camera.** These chapters guide you through shopping for a digital camera and taking your first photos. Which camera features matter most? Chapter 1 explains features such as resolution, macro, and zoom. Chapter 2 covers the basic steps to taking photos with minimal fuss. Chapter 3 takes you into the setup menus for more control over your camera.

➡ **Part II: Taking Better Digital Photos.** Taking photos can be as simple as point and shoot. These chapters provide guidance on taking better photos, based on the subject and the scene. Chapter 4 covers basic guidelines. Chapters 5 and 6 focus on people, animals, flowers, places, and other scenes. Chapter 7 introduces information to help you understand more of what the camera does automatically and what you can do manually, if you choose.

➡ **Part III: Editing Photos in the Digital Darkroom.** After you take your photos, then what? In Chapter 8, you move your photos to a personal computer. In Chapter 9, you use Windows Live Photo Gallery — a free program — to organize and categorize your photos. You also use Photo Gallery to enhance your photos through easy edits in Chapters 10 and 11.

➡ **Part IV: Showing Off Your Photos.** Digital photos don't gather dust in shoe boxes. Sharing your photos is more than half the fun. These chapters help you share your photos with friends, family, and the world. Chapters 12 and 13 provide information on printing photos at home and through a printing service. In Chapter 14, you share photos in e-mail and on the Web. Chapter 15 covers digital picture frames, the 21st-century replacement for family photo albums. In Chapter 16, have some fun putting photos on your computer desktop, in screen savers, and in photo books purchased online.

Time to Get Started!

Scan the Table of Contents or the Index for a topic that interests you most. Or, just turn the page, and start at the beginning. It's your book.

Comments and suggestions are welcome. Write me at mark@ mjhinton.com. Visit the book Web site for supplemental material: www.mjhinton.com/dpfs.

Part I

Getting Started with Your Digital Camera

Buying a Digital Camera

The right digital camera for you becomes a handy tool for recording precious memories. You'll snap shots of your friends, family, pets, and special events to preserve forever and look back at fondly years from now.

Photos don't just freeze the past. With a digital camera, you can stay in touch with people no matter how distant. Let them see what you're up to, at home or while you travel. A vacation snapshot makes the best postcard.

Your camera should be a good fit for you — not too small, not too large, and not too heavy. You want to feel comfortable carrying your camera, so that you'll always have it nearby, even when you don't expect to need it.

Buying a camera doesn't have to be a difficult decision. As with any device, some features matter more than others. You may choose a camera by price, size, picture-taking features, or even the color of its body. Dozens of camera manufacturers sell countless models. In this chapter, I introduce you to digital cameras and the features you may want in your next camera. This information will help you navigate through ads and reviews to find the right fit.

Get ready to . . .

Explore Types of Digital Cameras

Cameras have a wide range of features. Expect features such as *automatic scene modes,* which are settings that are designed for taking pictures in particular conditions, such as at night or at a sporting event. Some cameras are extremely compact, while others are larger and accept add-on lenses. The number of features available is determined by the type of camera:

➠ **Compact,** *point-and-shoot* **cameras** are small and easy to use, as the name implies. You don't have to worry about having too many options or controls with most point-and-shoot cameras. This is a great camera type for casual photography and snapshots. Most manufacturers, including Casio (as shown in **Figure 1-1**), Kodak, and Olympus, sell models in this category.

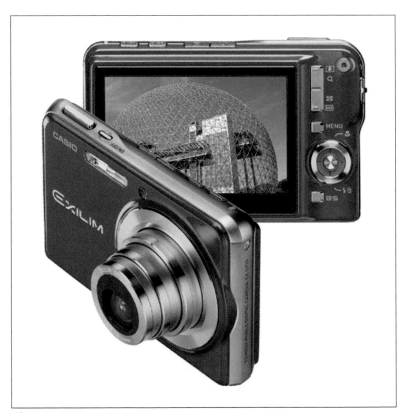

Figure 1-1

⟶ **Digital single-lens reflex (DSLR) cameras** are the choice of professionals and serious amateurs or hobbyists. Unlike a simple point-and-shoot camera, a DSLR has many features designed to give you control over every aspect of picture taking. DSLRs have a faster response time than other types of cameras, with almost no delay between the moment you click and when the photo is taken. (Non-DSLR cameras often have a fraction-of-a-second delay.) Canon and Nikon dominate the DSLR category. **Figure 1-2** shows a Nikon DSLR camera.

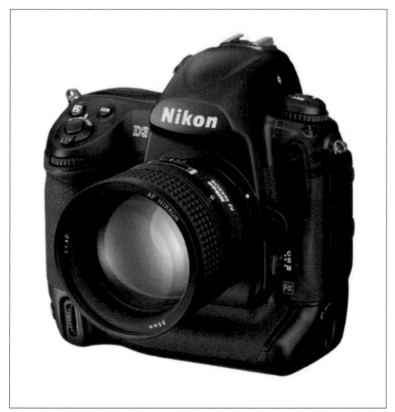

Figure 1-2

⟶ **Bridge or** *prosumer* **(a combination of professional and consumer) cameras** fill the gap between the casual point-and-shoot camera and the highly controllable, professional-level DSLR camera. Some reviews classify bridge cameras as point and shoot in spite of

their extra features. Falling between the other camera styles in features, size, and price, a bridge camera is a good choice for someone who wants more options than those that come with a point-and-shoot camera without the more complex and expensive features of a DSLR. Manufacturers of bridge cameras include those named in the preceding categories plus Panasonic and Sony. **Figure 1-3** shows an example of a Sony bridge camera.

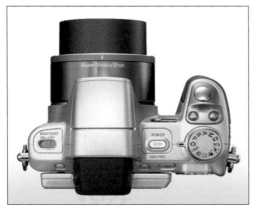

Figure 1-3

Choose a Price Range

Camera prices start near $50. Anything less than that may not really be a bargain — though it might make a good door stop. Consider these price ranges:

➡ **Cameras between $50 and $250:** These cameras are usually compact, pocketable, easy to carry, and easy to use. Perfect for casual photography, these less expensive point-and-shoot cameras can't be expected to provide all the bells and whistles of more expensive models. Still, don't feel you have to spend more than you want to. You have to start somewhere, and a reasonably priced camera makes sense if you don't need all the features found in more expensive cameras.

 Cheaper cameras may need more time to turn on, store pictures, or ready the flash than more expensive models need. Response time matters if you plan on shooting photos in rapid succession, such as at a fast-paced event.

➡ **Cameras between $250 and $600:** These cameras offer more features than cheaper cameras, such as additional automatic settings for shooting in a wider range of conditions. These cameras are likely to be larger and heavier. This price range includes some point-and-shoot cameras and all of the bridge models. You may find a cheap DSLR body at the high end of this range, but that won't include a good lens. You may need to spend more time exploring and figuring out the features of these cameras.

➡ **Cameras above $600:** These DSLR cameras have features that professional photographers and advanced amateurs crave, including exchangeable lenses and more direct control over combinations of settings. There is no upper limit to what you can pay; it would be easy to spend $1,000 to $3,000 on one of these high-end cameras and the accompanying gear.

 The CNET Web site (`http://reviews.cnet.com/digital-cameras`) compares cameras by price.

Identify the Features You Want

Do you want a camera that fits in your pocket or purse to pull out for spontaneous photos? Do you want to get close to flowers or wildlife? Is photography your passion (or can you imagine it becoming that)? As you look at cameras, consider which features matter most to you. The following lists describe all the features and options you should consider before you purchase a digital camera.

Consider these features first, because they matter to most photographers:

➠ **Ease of use:** If you want decent photos under most conditions without making many decisions, look at point-and-shoot models such as Canon Power Shot, Kodak EasyShare, Nikon COOLPIX, or Sony Cyber-shot.

➠ **Scene modes:** These options set up the camera for taking the best photos under different conditions. Landscape mode works best for, well, landscapes — long, sweeping shots of vistas with lots of scenery. Sports or Action mode freezes action at an athletic event or captures fast-moving wildlife. Portrait mode puts the emphasis on a person. Some cameras provide you with a dozen or more scene modes to choose from. In Chapter 4, you can practice working with some of these modes.

➠ **Face and smile detection:** Some cameras recognize faces in a scene and focus on those faces automatically, ensuring that part of the photo will be sharp. Some cameras can even detect when subjects are smiling and can take a picture at the precise moment everyone in the scene is smiling. Some cameras also warn you if a subject blinked.

➠ **View options:** A *viewfinder* lets you hold the camera up to your eye to compose or frame your photo, just like a film camera. An *electronic viewfinder* (EVF) displays information about camera settings superimposed over the scene. An LCD is a small screen on the back of the camera that you can use instead of an electronic viewfinder. Using the LCD to take a picture, you hold the camera away from your face, up to arm's length. An LCD makes it easy to see the pictures you've taken and to use the setup menus most cameras have.

A camera with both an electronic viewfinder and an LCD screen gives you the best of both worlds. If you wear glasses, you'll appreciate having a way to adjust the viewfinder focus to suit your glasses. This option is sometimes called a *diopter correction* knob or wheel.

➠ **Battery type:** All cameras use batteries to power every aspect of operation. You can use up your camera batteries in one day if you take lots of photos. Check to see if the camera you are considering uses a special battery (like a cell phone does). A spare special battery could cost between $30 and $60, so you might want a camera that uses two or four standard AA batteries. Rechargeable batteries are a must — don't use regular one-use batteries.

➠ **Control types:** The more options a camera has, the more controls it probably has. Many cameras use a dial for scene selection. Other functions may use buttons — often tiny buttons. Cameras even use rings, joy-sticks, and touch screens. Controls can be easy and intuitive or not, depending on the camera and on you.

The following features may be important to you if you intend to take more than casual snapshots:

➠ **Close-ups:** A macro setting allows you to put the camera extremely close to the subject, even less than an inch away. The result is an extreme close-up that reveals details that are often missed, such as the heart of a flower or the pattern on a butterfly's wings. **Figure 1-4** shows a composite shot of an extreme close-up of a flower. The regular shot on the left is out of focus, while the macro shot on the right is in focus.

Regular focus

Macro shot

Figure 1-4

➡ **Distant shots:** A zoom lens ranges from near to far, bringing a distant subject closer to you. You can photograph an entire sports team or zoom in to photograph one player. If you plan to photograph birds and other wildlife, you want an extreme zoom — 10X or larger — to bring distant subjects closer.

Most point-and-shoot cameras are limited to a 3X zoom; bridge cameras and so-called ultrazooms zoom to 10X and beyond. The X factor (10X, 3X, and so on) indicates the magnification from a normal, unzoomed, so-called *wide-angle shot* taken with that camera and a zoom shot, also called *telephoto*. A 3X zoom is adequate for most close-ups of people and pets. A 12X zoom will bring distant subjects much closer to you, as shown in **Figure 1-5**.

Differences between one camera's wide-angle and another's make it tricky to compare zoom factors (zoom is a multiple of wide-angle). Look for so-called *35mm equivalents*, which convert these lens measurements into the standard of film cameras for more accurate comparisons between camera models. A 10X zoom is likely to be equivalent to something between 280mm and 380mm, depending on the wide-angle portion of the lens.

 Ignore references to *digital* zoom or *combined* zoom. *Optical* zoom is the measurement that means the most when you're comparing cameras.

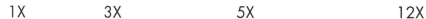

1X 3X 5X 12X

Figure 1-5

⟶ **Image stabilization:** If your camera moves as you take a picture, the photo may not be sharp. Even if your grip is rock-steady, the slightest movements can ruin a long-distance zoom shot. (The longer the zoom or the darker the scene, the worse the effect

movement will have on the shot.) Be sure your camera has an image-stabilization feature (also called *antishake* or *vibration reduction*), which assures sharp focus in spite of normal minor movement.

➡ **Focus modes:** All digital cameras focus automatically. However, some cameras provide multiple focus modes, such as center focus, multiple spot focus, and manual focus. *Center focus* assures you the subject in the center of the frame is in focus, while other areas may be blurred, which can be used to make the subject stand out from the surrounding scene. *Multiple spot focus* assures that all areas of the photo are in focus. *Manual focus* lets you specify the distance between the camera and the subject in feet or meters.

➡ **Image resolution:** The *image sensor* is a computer chip with a light-sensitive surface that captures photos. The width and height of a photo are measured in tiny dots called *pixels,* and the area of the photo is measured in millions of pixels (*megapixels,* MP). The more megapixels a camera has, the larger a photo it takes.

Having more megapixels is especially important when you want to edit (see Chapter 10) or print (see Chapter 12) the photo. The megapixel total is less important if you don't plan to print or edit. Smaller photos are fine for e-mail and on-screen viewing. A typical edit is to *crop* or cut a portion of the picture to make the subject fill more of the frame. Having more megapixels allows you to crop a smaller area of the picture and still have a big enough picture left over to enjoy.

➡ **Memory card:** In a digital camera, photos are stored as digital files in the camera. Although some cameras have built-in, non-removable memory for saving pictures, that is usually limited to a few photos. Most

cameras use removable *memory cards* to enable you to save more photos. Consider buying more than one memory card if you plan to shoot more photos than one card can hold before you can delete photos or move them to a computer. Buy a large capacity memory card — at least 1 gigabyte (1GB) — that is the correct type for your camera. Read the camera specification on the box or in the manual to identify the correct card for your camera. The wrong type of card won't fit your camera. **Figure 1-6** shows four typical memory cards.

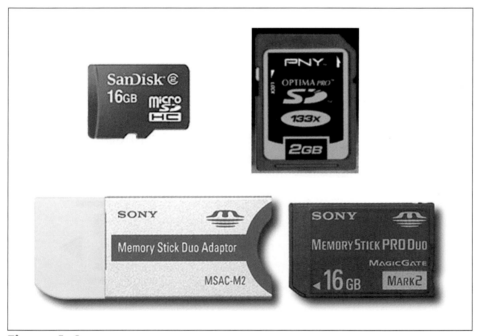

Figure 1-6

⸺➡ **File format:** Photos are usually stored as JPEG files (JPEG stands for Joint Photographic Experts Group), which is an optimal file format for photos. Some bridge cameras or DSLRs store photos as RAW files, which may be a better file format for you if you plan to edit your photos extensively on your computer by using advanced software tools. I talk more about photo editing in Chapter 10.

The following features may be nice to have or more than you need:

➡️ **Red-eye fix or reduction:** When a camera flashes, light may reflect from the back of the subject's eye, producing *red-eye,* a rather creepy effect. Some cameras have red-eye reduction settings or features, such as producing two flashes in a quick sequence: The first flash contracts the subject's pupils, and the second is used for the actual snap of the photo. Other cameras can remove red-eye automatically. You can also fix red-eye later, with photo-editing software.

➡️ **Special effects:** In-camera processing options can let you add effects to your photos, such as shooting in black and white, sepia, or pastel colors. But don't worry: If your camera doesn't offer these options, you can add many effects to photos later by using photo-editing software on your computer.

 See the Cheat Sheet inside the front cover of this book for a list of camera features and recommendations on what to look for as you compare cameras.

Research Digital Cameras on the Web

Many Web sites offer information about digital cameras and feature reviews by people who have bought and used a particular camera. You can also go online and compare camera prices from different vendors.

Online reviews often include detailed photos of the camera's features, as well as sample photos taken with the camera. The best camera reviews grade specific features, such as the preset scene modes and the camera's setup menus, which are hard to judge without hands-on experience.

Consider the ratings and reactions of individual buyers with a grain of salt. You don't know whether the reviewer wants the same things in a camera that you want. Look at as many comments and reviews as you can to get a consensus reaction. Many Web sites summarize user ratings.

 If you don't have a computer, most public libraries and many community centers do, and a librarian can also help you get online.

Look for camera reviews at these Web sites (**Figure 1-7** shows the Web page from `http://reviews.cnet.com/digital-cameras`):

➠ `http://reviews.cnet.com/digital-cameras`

➠ `www.dcviews.com/cameras.htm`

➠ `www.digitalcamerareview.com`

➠ `www.imaging-resource.com`

➠ `www.steves-digicams.com/hardware_reviews.html`

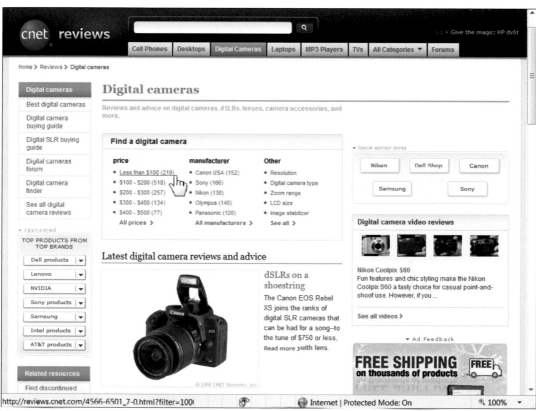

Figure 1-7

You can also visit camera manufacturer Web sites for details on different models. Here are some to check out:

➧ www.canon.com

➧ www.nikon.com

➧ www.olympus.com

➧ www.panasonic.com

➧ www.sony.com

In addition, check out these opinion-sharing Web sites:

➧ www.epinions.com/Digital_Cameras

➧ www.viewpoints.com/Digital-Cameras

➧ www.flickr.com/cameras

If you're ready to buy, and you want to do your purchasing online, check out the following sites — but be sure to look for customer ratings and reviews before you click the Buy button:

➧ www.amazon.com/camera

➧ www.47stphoto.com

➧ www.ritzcamera.com

Get Your Hands on a Camera in a Store

The Web can't tell you whether a camera fits comfortably in your hands or whether the buttons are small or difficult to reach. You have to hold a camera to find that out. Consider going to a couple of stores so that you can handle a few different cameras.

Look for a store with a camera kiosk that groups cameras together, like the kiosk shown in **Figure 1-8**. Pick up each camera and pretend to

take a picture. How does it feel in your hands? Consider the camera's shape, size, and weight. Is the Shutter Release button (usually a wide, flat button on the right side on top of the camera body or grip) that you press to take a photo a comfortable size and in a convenient place?

Here are some stores to check out:

→ Office supply stores, such as Office Max and Office Depot

→ Discount clubs, such as Costco and Sam's Club

→ Electronics retailers, such as BestBuy and Target

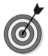 These stores all have Web sites, too, if you prefer to shop online. But again, it's a good idea to spend at least a little time in a store where you can actually hold some cameras in your hands.

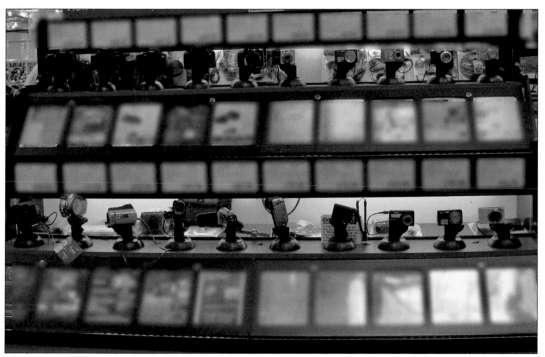

Figure 1-8

If you choose to do your shopping at a camera store — a retailer that specializes in cameras and camera equipment — you should expect to find knowledgeable, experienced staff. You should also expect to have access to less-common camera models than electronics retailers carry. You're likely to find higher-end, more expensive cameras in a camera store. But if you're shopping for a DSLR, that's exactly the type of place you should check out.

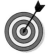 Keep in mind that the models you find on display in a store may not be the same models you've researched online. If you like a camera you haven't already researched, take the time to do that research. Beware impulse buying.

Select Accessories

Tools (or toys) beget more of the same. You may just be looking for a camera, but you'll find plenty of camera accessories to consider:

➡ **Spare memory card:** Definitely consider having a spare card on hand, especially if you'll be shooting a lot of photos before you can delete any of them or move them onto a computer. A full card is like running out of film — you can't take any more photos. A large memory card may hold hundreds of photos, however, so depending on how much shooting you plan to do, one card may be all you need.

➡ **Camera cables:** For some cameras, a cable connects the camera to a USB port of a computer for transferring photos from the camera to the computer. This connection is essential if you want to view your photos on your computer monitor, e-mail them to friends and family, or edit them with photo-editing software. (You find out how to copy photos to a computer in Chapter 8.) Some cameras use a cable to connect to a TV or DVD player for displaying photos on TV.

➠ **Card reader:** This device is another way to get your photos from the camera to your computer. A card reader accepts a memory card you have removed from your camera, and then you connect the card reader to a USB port of your computer. You don't need a card reader, however, if your camera connects directly to the computer with its own cable.

➠ **Spare batteries:** These are always good to have on hand. You can easily drain a set of batteries in a day. If you run out of power, you're done taking pictures. Rechargeable batteries are a must. Practice replacing your batteries so that you can do so quickly when you need to.

➠ **Battery charger:** This item will be a welcome addition on longer trips, such as a vacation. If you're traveling out of the country, add an electrical outlet adapter. If you're traveling by car, get an adapter for your car cigarette lighter so you can charge as you drive.

➠ **Camera bag:** This handy accessory keeps all your gear in one safe place. Look for a padded bag large enough for the camera plus everything else. The bag or a compartment of the bag should snuggly hold your camera. Most camera bags have a handle and a shoulder strap. Small bags may have loops for a belt.

➠ **Tripod:** You attach your camera body to a tripod to hold your camera steady. Tripods are also great for photos taken with a timer so that you can jump into the picture. (Make sure your camera has a metal tripod socket on the bottom of the body.) A tripod is also useful for holding the camera still for shots taken in low light or when you're using a long zoom.

You may want a large tripod up to 6 feet tall with telescoping legs, although not everyone needs such a big one. However, almost anyone will get good use out of

a pocket-sized, fold-up tripod that costs around $10. Some small tripods use a beanbag instead of the traditional three legs (is it still a tripod, then?) to provide a steady base that can rest on an irregular surface, such as a rock. **Figure 1-9** shows some of the different sizes of tripods you can choose from.

➠ **Monopod:** It's like a tripod, but this variation has a single leg instead of three. (In Figure 1-9, the monopod is on the far left in the background.) It also has the usual tripod screw at the top. A monopod won't stand without your help, but it can help you steady the camera. If you need increased steadiness for your photography, but you're frequently on the move, a monopod may be a better choice than a tripod because it's easier to move around. Some walking sticks even have monopod attachments at the top of the pole. Check sporting goods and outdoor retailers.

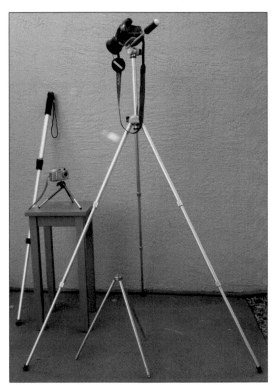

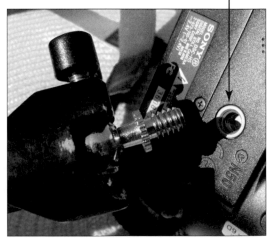

Attach your tripod to your camera here.

Figure 1-9

⟶ **Printers:** You have all kinds of very affordable printer options these days — printers that can produce glossy enlargements or high-quality smaller prints. But don't buy a printer until you've read Chapter 12.

⟶ **Computer:** This is more than just an accessory. A computer gives you ways to store, edit, and share your photos. You can enjoy a digital camera without owning a computer, but you'll enjoy your photos more with a computer. Part III covers the digital photography reasons you'll want a computer.

Unpack and Set Up Your Camera

1. When you get your camera, lay out all the items that came with it and confirm that you received everything you expected from the packing slip, box label, or ad. If your camera came with specific step-by-step instructions for setting up the camera for its first use, follow those steps instead of these before you take your first picture.

2. Remove all packaging, including tape. Store this material until you're sure you won't need to return your camera to the seller.

3. If your camera has a neck or wrist strap, thread the strap ends through the slots on either side of the camera body. Take care to attach the strap securely. Test it gently. You don't want your camera to fall off this strap.

4. Install the memory card, if you have one. Look for a small cover on the bottom of the camera or either side. Some cameras have one cover for both memory card and batteries, as shown in **Figure 1-10**. Open the door by pushing or sliding the cover. With your thumb on the label side of the memory card and any exposed metal contacts away from you, gently insert the card into the card slot. If you meet resistance, pull the card out and turn your hand to

try inserting the card the other way. The card should slide in easily and stay in. (It may click in place.) Do not force the card. Close the memory card slot cover.

Battery Memory card

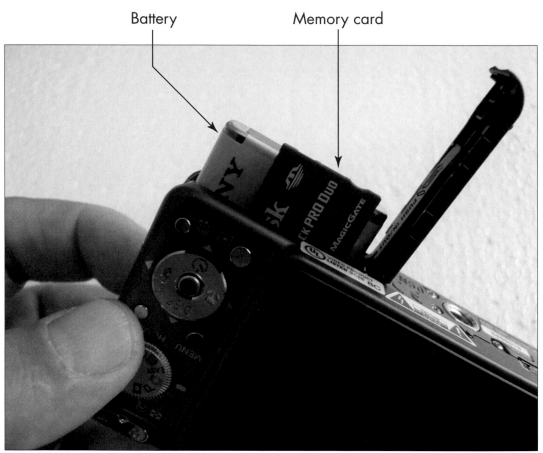

Figure 1-10

To remove a memory card, with the cover open, push the card in slightly, and when you release, it should pop out. Never pull or pry a card out.

 Never install or remove a memory card while the camera is on. You could lose photos or damage the card.

5. Install the battery or batteries. Look for a small door on the bottom or side of the camera. Open the door by pushing or sliding the cover. If the battery is rectangular, put your thumb on the label and gently push it in — the battery will go in only one way. If your camera uses two or four standard batteries, look for an indication of which end goes in for each battery. (The standard batteries don't all go in the same way; they alternate.)

6. Locate the lens cover. If it's a separate piece, leave it unattached for now. If the lens cover clips in place, remove the cover before you turn on the camera. (In some camera models, when you turn on the camera, the lens will strike the lens cover if you forget to remove the cover.) If the cover slides, gently sliding it may turn the camera on. Don't force the lens cover off or on.

Some lens caps come with a thin string you can slip through a hole in the lens cap and another hole in the camera body or around the camera strap to keep the cap with the camera.

7. Turn on the camera if moving the lens cover didn't do that automatically. Look for a message on the LCD or in the viewfinder.

The camera may automatically ask for the current date and time, which will be recorded with each photograph. Enter that information using the up and down buttons to change numbers and use the right and left buttons to move to different parts of the date and time. These buttons are usually arranged around the outside of a circular button. After you've selected the current date and time, press the OK button.

8. Go ahead: Take a picture of anything. You know you want to.

9. If your camera came with a CD or DVD, you can install that software on a computer later. The software may include a program for viewing and editing your pictures.

 Stick an address label (plus your phone number and e-mail address) onto your camera in the hope that someone will return it to you if you lose it. I also put a copy of this info in the battery compartment of my camera.

Taking Your First Photos

Chapter 2

*T*aking pictures is easy: In most cases, you just point and shoot, assuming that you turn on the camera first and that there's no lens cap in the way. No matter how easy cameras make taking pictures, though, spend a little time exploring the buttons, knobs, and switches scattered about the top and back of your camera. Where is the Power button? Do you have to remove the lens cover, or does it move automatically?

In this chapter, you work with major controls on your camera. You'll use these features more often than any others, such as Automatic mode. As you explore these controls, take some pictures and some movies for practice.

The LCD panel on the back of your camera displays the photos and movies you've taken. You'll also use the LCD to display photos or movies you intend to delete from the camera.

If your camera came with a video cable, you can connect the camera to a TV or DVD player to see you pictures on the big screen — no computer needed!

Locate the Camera's Controls

Turn your camera over a few times, looking closely at every surface. You may never use every control, but you'll want to identify as many controls as you can (see **Figure 2-1**). You'll use each of these controls in this chapter.

➡ **The Power button:** Use the **Power button** or switch to turn the camera on and off. There is usually a slight delay between using the switch and being able to take pictures, so plan accordingly to turn the camera on shortly before you need it. The camera will turn off automatically if you don't use any controls for a few minutes.

➡ **The LCD display:** This panel is on the back of the camera and is between 2" and 4" across diagonally. When the camera is on, you will see the scene before you on this LCD. You also review the pictures you've taken on this LCD.

 If your camera has an electronic viewfinder, there is a button to switch the display from the viewfinder to the LCD. It may be labeled **Finder** or **EVF/LCD**. You can use either display at any time.

➡ **The Scene Mode dial:** This dial lets you identify the type of scene you are shooting, such as a landscape. You'll explore these options in Chapter 4.

➡ **The Shutter Release button:** This button is usually on the top of the camera on the right side or on the back in the upper-right corner. Press this button to take a picture.

➡ **The flash and Flash Control:** The flash may be built into the front of the camera, or it may pop up from the top. Your camera may have a button to open the flash. Look for a button with a **lightning bolt** on it to turn the flash on and off.

➟ **The Review button:** Press this control (often a **green triangle**) to switch from previewing the scene you are about to photograph to reviewing the photos you have already taken. Press it again to stop reviewing and return to previewing.

➟ **The Delete button:** This button is often marked with a trashcan. As you review photos, press this button to delete the picture or movie you are currently reviewing. You may have to confirm the deletion by pressing the **Delete button** again or by pressing an OK button or something similar.

Power button Shutter Release button

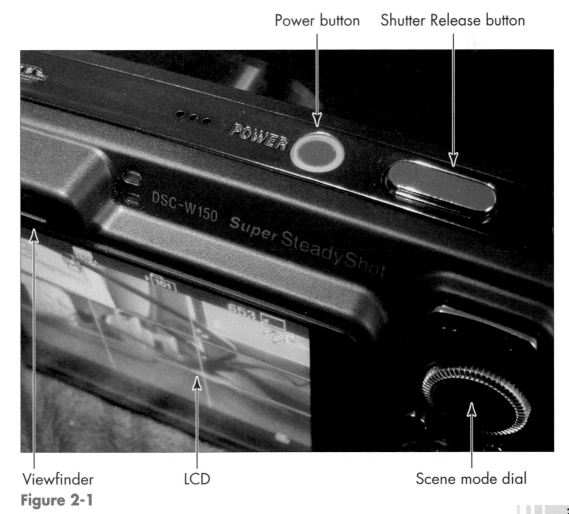

Viewfinder LCD Scene mode dial

Figure 2-1

Turn the Camera On and Off

1. Before you turn on the camera, be sure you have inserted a charged battery (or batteries). See Chapter 1 for information on setting up your camera for the first time.

2. Take off the **lens cap**.

If your camera has a **clip-on lens cap**, remove the lens cap before turning on the camera. This prevents the lens from bumping the lens cap.

If your camera has a **sliding lens cover**, slide it left or right to open. That may turn your camera on automatically.

3. Press the **Power button** or slide the **On-Off switch** to turn on the camera. See **Figure 2-1** above. You may hear the lens move. A logo may appear on the LCD or in the viewfinder, followed by the scene before the camera lens, which may be your lap or this book, at the moment.

4. The LCD displays some of your camera settings superimposed over the scene. If your camera has a **Display button** (sometimes, simply labeled DISP), you can turn off this information display if you find it too distracting.

5. When you're done with your camera, turn off the **power** with the same control that turned it on. Replace the **clip-on lens cap**, if you have one. If your camera has a sliding lens cover, slide it closed, which may also turn the camera off.

 Maximize your battery life by turning off the camera as soon as you know you don't need it any longer.

Use Automatic Mode

1. Automatic mode puts the camera in charge of all settings. (You still have to turn on the camera.) Look for a button labeled **Auto**. If your camera has a mode dial, the Auto

setting should stand out from all others, as shown in
Figure 2-2. It may be green or red. See Part II for informa-
tion on other modes, including various scene modes
shown in **Figure 2-2**.

Auto mode

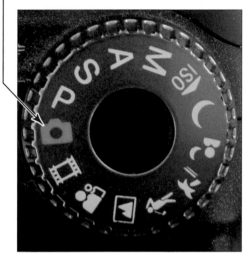

Figure 2-2

2. Point your camera at something interesting. Watch the LCD
or look through the viewfinder as you lightly press the
Shutter Release button. This button should be on the top
of the camera body, in reach of your right index finger —
or on the back of the camera, under your right thumb.

3. Press the **Shutter Release button** halfway down to let
Automatic mode adjust settings and fix focus. You may
hear the lens move and see the image adjust on the LCD
or in the viewfinder. Look for one or more boxes or brack-
ets around the areas the camera is focusing on. Those indi-
cators may turn green when the camera has focused, as
shown in **Figure 2-3**. (A few cameras indicate focus with a
green dot, or a red dot may indicate a focus problem.)

4. Press the **Shutter Release button** all the way to take the
picture, and then let go. Your camera may make a click to
signify the picture has been taken.

Look for one or more boxes or brackets around focus areas.

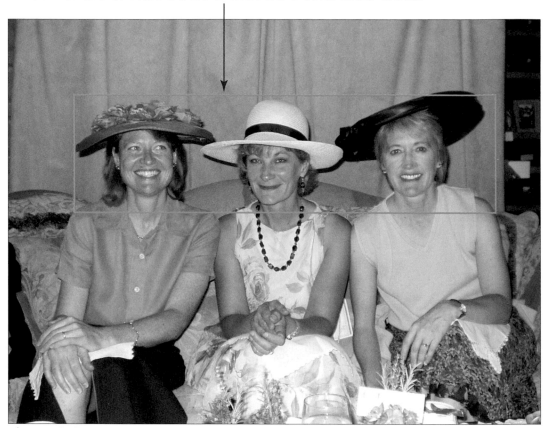

Figure 2-3

 If you hold down the **Shutter Release button**, your camera may take multiple photos at once. This is called *burst mode*, which is very useful when there is movement in the scene and you're trying to capture the changing scene in a series of photos, for example, at a sporting event. Avoid holding the button down, though, if you don't want to take multiple shots at once.

Turn the Flash On and Off

1. If the scene is dark, the camera will adjust settings to brighten the exposure. The camera may also need to flash extra light to take the photo. Some cameras flash automatically.

Others allow you to turn the flash on and off. In some cases, you manually open the flash to turn it on.

2. With your camera on, locate the **Flash control**, which is usually marked with **a lightning bolt** (see **Figure 2-4**). Watch the LCD or viewfinder as you press the **Flash control** to turn it on or off. A lightning bolt may appear on the LCD to indicate the Flash is on; **a lightning bolt with a circle and slash** indicates that the flash is off or unavailable as it recharges. See Chapter 4 for information about various flash options.

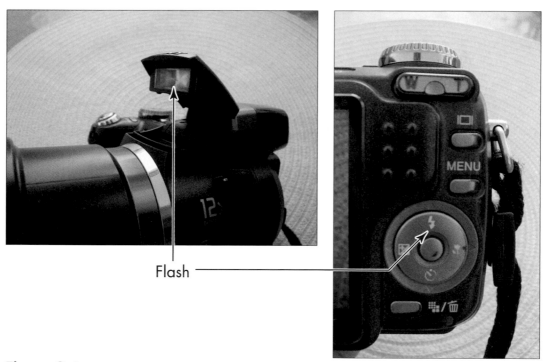

Flash

Figure 2-4

Shoot Some Photos

⟹ Take your camera outside and shoot some pictures. Turn the camera on and off a few times. Remove and replace the lens cap, if you have one. Get comfortable with the basics of taking photos. Go back inside, and take some more shots with the flash on.

➠ You can take as many photos as your camera can hold. The LCD may display a countdown number of the remaining photos you can take. Take lots of photos without hesitation — you don't have any film or developing to pay for.

Review Your Photos

1. Immediately after you take a picture, it will appear on the LCD for a few seconds. That may be long enough to know whether you're satisfied with the photo. To review more than one photo, press the **Review button**, which is often a green triangle in a green square (see **Figure 2-5**). Your latest picture should appear on the LCD.

 If you don't see anything on the LCD, the review may be on your electronic viewfinder. Press the button, which is often labeled DISP or Display, that switches between the LCD and the viewfinder.

2. Use the **left button** to move to the previous picture you took or use the **right button** to display the first picture on the camera. Keep pressing left or right to move forward or back through your photos.

3. With a single photo on-screen, press the **Wide (W) button** to display an index of thumbnails (smaller versions) of several photos at one time, as shown in **Figure 2-5**. Use the **left or right buttons** to select a picture and then press **OK** to see the picture full-screen.

4. With a single photo on-screen, pressing the **Zoom/ Telephoto (T) button** enlarges the photo, showing you details. **Figure 2-6** shows a photo zoomed in 2.3 times, as

you see in the figure itself. Two squares appear in the lower-left corner of **Figure 2-6**. The small white square represents the enlarged area visible on the LCD, whereas the larger gray square represents the area of the entire photo. Use the **left and right buttons** to pan over the enlarged photo. Zoom out with the **Wide button** to return to the full-screen or the thumbnail display.

Press W for more thumbnails, or press T to zoom into one photo.

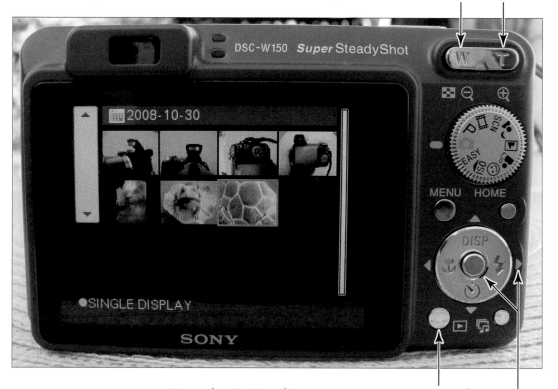

Press the Review button to see one or more photos.

Use arrow keys to move through photos. Press the OK button to see one photo.

Figure 2-5

Amount of zoom

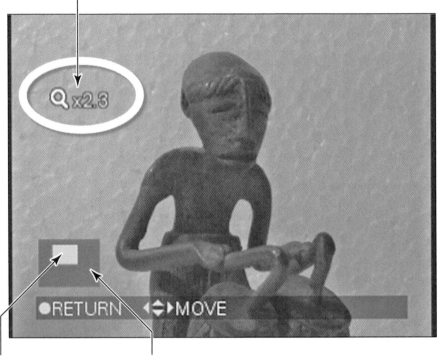

The zoomed-in area versus the entire photo.
Figure 2-6

Delete Photos from Your Camera

1. To delete photos from your camera, put your camera in Review mode (discussed earlier in this chapter).

 Before you delete a photo, be absolutely certain you won't miss it — you cannot undelete a photo from your camera without a computer and special software. Practice by taking photos you intend to delete.

2. Move left and right through your photos to find the one you intend to delete.

3. Press the **Delete button**. If you don't have a Delete button, press the **Menu button** and choose Delete from the menu. See **Figure 2-7**.

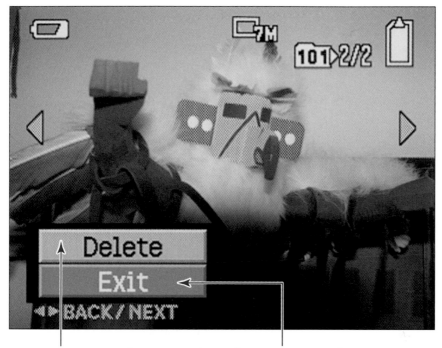

Use up arrow and OK to Delete, down arrow and OK to exit.
Figure 2-7

4. Select **Delete** and press the **OK** button to confirm or
select **Exit** and press OK to cancel without deleting the
selected picture.

 In Chapter 8, you'll copy your photos to a computer.
It's safest to copy your photos before you delete any.

Shoot a Video

1. Most cameras take videos, as well. Indoors or outside,
choose **Movie or Video mode** on your camera. (The
Movie mode icon might look like a frame of film with
sprocket holes on both sides or a camera that looks a lit-
tle like Mickey Mouse.)

2. Pointing the camera at the subject you want to record,
press and release the **Shutter Release button**. This starts
the video recording. A **red dot** or **REC** may appear on

your LCD to indicate you are recording. You may also see the time elapsed in this movie and the time available remaining on the memory card. See **Figure 2-8**.

3. Slowly turn the camera left or right to record another area of the scene.

4. After a few seconds or minutes, press the **Shutter Release button** again to stop recording.

 Too much movement of the camera during recording tends to make people a little seasick. Keep the camera stationary (a tripod helps) or move the camera very slowly. Try zooming slowly in or out while recording. Note that your camera may not zoom while recording movies.

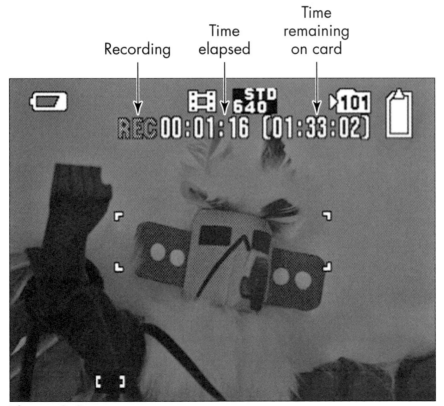

Figure 2-8

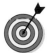 Video also records audio, so keep that in mind and avoid unnecessary noise.

View Your Photos and Videos on TV

1. If your camera has a Video Out connection, you can use a cable to show your photos and videos on TV. Locate the **Video Out connection** on your camera. It's a single socket, possibly colored yellow. This connection is different from the USB port and the external power connection.

2. If your camera came with a cable, connect the end with a single connection to the correct socket on the camera body.

3. The TV/DVD end of the cable has two connections. Connect the yellow **video cable connection** to the yellow video input on your TV or DVD player. See **Figure 2-9**. To play movies or slideshows with sound, connect the **black or white cable** to the white input on the TV or DVD player (labeled Left/Mono).

4. Turn on the camera and switch to Review mode.

5. Turn on your TV and switch to the **Video In option**. (You may have to press the TV remote's Input button a few times to switch through other possibilities.) You should eventually see your most recent photo or movie. Remember that you can zoom out with the **W (Wide) button** to view an index of all photos on the camera, as shown in **Figure 2-10**.

Yellow Video In cable
and connection

Optional white or black
Audio In cable

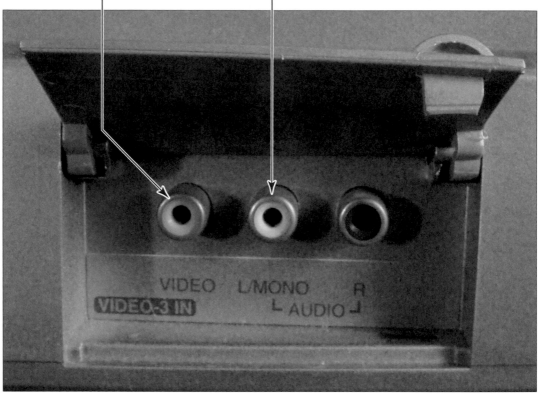

Figure 2-9

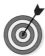 Some cameras have a Slideshow button or feature. Some play music, as well. A few have remote controls so you can sit back and enjoy the show.

The camera The thumbnail index on TV

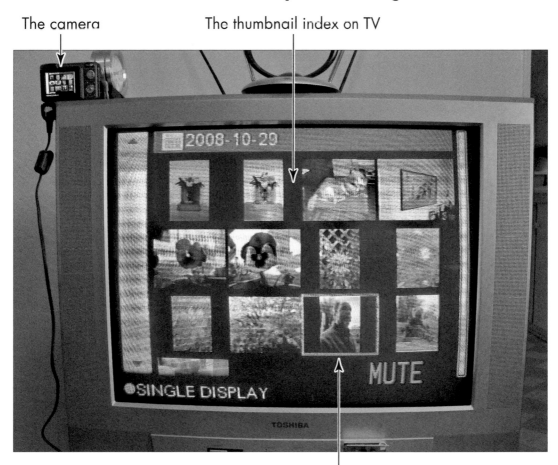

Select a photo with arrow keys and press OK to view it.

Figure 2-10

Using Your Camera's Setup Menus

*Y*our camera has external controls for specific functions, such as the power button, the Shutter Release button, and the Zoom control. Your camera also uses internal menus to enable you to change settings that affect various functions, making your camera somewhat programmable. For example, from a menu, you can specify the size of your photos in *pixels* (dots). Large photos are great for printing, but they are less useful for e-mail. Small photos store quickly and take up less space on the camera, but they limit your options for editing, particularly cropping to emphasize a smaller area of the photo.

Other menu options control the brightness of the LCD (and, thereby, its power-consumption), the sounds your camera makes, and more. Not all cameras have exactly the same settings, but I show you the most likely and most useful in this chapter.

You might never need to change some of your camera's settings, or you may make a one-time change. Take the time to consider your options, and note what the original setting is before you make a change. That way, you can easily change back if you don't like the new setting.

Explore Menu Options

Your camera's setup menu may consist of groups of settings as sub-menus. You may need to step through a menu several levels deep to find the setting you intend to change. A few buttons (as shown in **Figure 3-1**) will come in handy as you explore:

➡ **The Menu button:** This button displays the menu on the LCD or electronic viewfinder. Press it once to see the menu. Press it again to dismiss the menu.

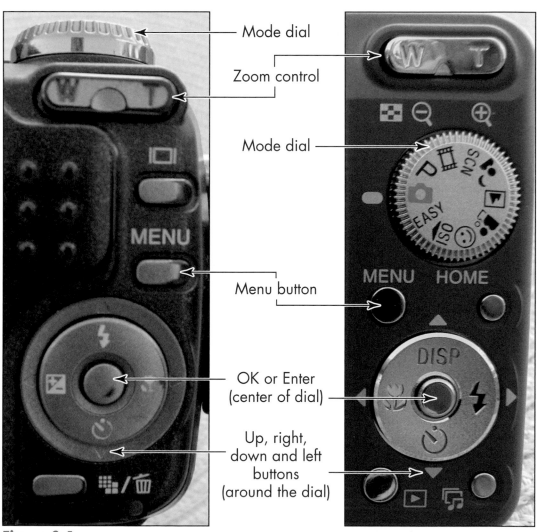

Mode dial

Zoom control

Mode dial

Menu button

OK or Enter (center of dial)

Up, right, down and left buttons (around the dial)

Figure 3-1

➡ **The left, right, up, and down buttons:** Use these buttons to scroll through menu settings and options. These buttons often appear clockwise around the edge of a circular button at 12 o'clock (up), 3 o'clock (right), 6 o'clock (down), and 9 o'clock (left). Use the **up and down buttons** to move between settings and options. The **right button** will move you deeper into the menu or into the options for a particular setting. The **left button** will move you out of the menu one level.

➡ **The OK button:** This button is sometimes labeled with a dot and is often in the center of the larger, circular button. Use the **OK button** to select a highlighted option.

 Most cameras don't have a Cancel button. If you change your mind in the middle of a step, leave the original option highlighted as you step back with the left arrow or the Menu button.

As you explore your camera's menus, be aware of these points:

➡ Although a few functions are common and consistently named, there is no single standard for camera menus. Every menu is nearly unique in its options and the organization of those options. There is more consistency in menus between recent models from the same manufacturer than between different manufacturers. Consider whether that consistency is important when you buy your next camera. If you don't like learning new menus, you may want to keep buying cameras from the same manufacturer — although even a single manufacturer eventually changes menus as new features are added.

➡ The settings available on menus may change, depending on other settings. For example, Automatic mode may have fewer menu choices than other modes — after all, you want the camera to make more of the

decisions in Auto mode. Movie mode may have different options from the other modes. Review mode may offer unique menu options, such as to rotate or resize a photo. Some cameras have two separate menu buttons, in which case, one will bring up a menu that applies to the specific mode you have set and the other (perhaps, labeled Home) will bring up a larger menu of all options regardless of mode.

 If you can't find a function on your camera that is mentioned in this book, then your camera may not have that function. Or, your camera may call that function something else. Or, that function may also be available only in some modes.

 A function guide describes options on the LCD as you make selections. If your camera has a function guide or help, that feature is turned on automatically. You may find a setting to turn this on or off. Leave it on while you're getting familiar with your camera.

Change the Date or Time

1. Press the **Menu button**.

2. Use the **up** or **down button** to scroll to the **Clock setting**, as seen in **Figure 3-2**.

3. Use the **left and right arrow keys** to move between digits for the month, day, year, hour, minutes, and AM or PM. For each number, use the **up and down arrows** to increase or decrease that value. The current date and time will be recorded with each photograph. Having the correct date and time helps you find and organize your photos. Cameras know nothing about time zones or daylight saving time, so you may want to change the time setting as needed.

4. Use the appropriate arrow key to select **OK** to keep your changes or select **Cancel** to reject changes. Press the **OK button**. Press the **Menu button** to clear the menu, if necessary.

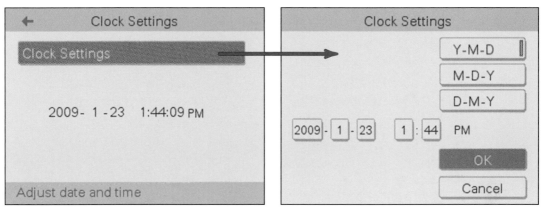

Figure 3-2

Control Camera Sounds

1. Press the **Menu button**.

2. Scroll to the **Beep setting**, which may be labeled **Sound**. (See **Figure 3-3**.) Some cameras control separately the sound made as you press any button and the shutter sound made when you take a picture. (Other button presses won't make a sound.)

3. Select an option to turn sound on or off. A quiet camera is less likely to be noticed by people or animals, although you may be less sure you actually pressed a button. If your camera offers a volume level, you can try louder or softer sounds.

4. Press the **OK button** to save your selection. Press the **Menu button** to clear the menu.

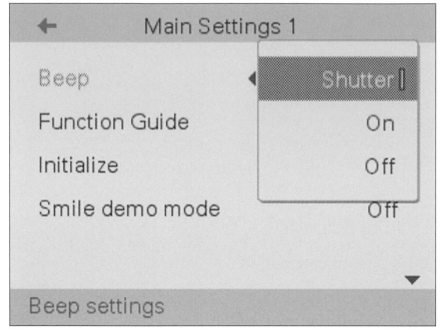

Figure 3-3

Set the Image Size

1. Press the **Menu button**.

2. Scroll to the **Image Size setting**, which may be labeled Picture Quality or Image Resolution. **Figure 3-4** shows two versions of this setting.

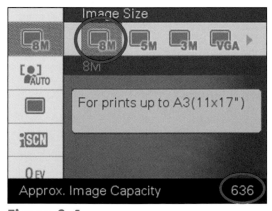 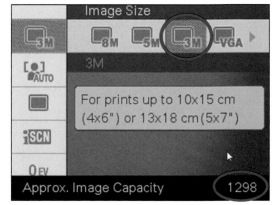

Figure 3-4

3. Select an image quality from those available:

- The highest, finest, or largest value — up to the maximum megapixels for your camera — will produce the largest photos. This is the best choice for printing and editing, such as cropping an area of the picture. The help message on the left of **Figure 3-4** indicates 8M (megapixels) is suitable for prints up to 11 x 17 inches. However, each picture will consume more space on the memory card than for a lower value. Larger files also take longer to save and to copy to your computer than small files take, although the difference is a matter of seconds per photo. In **Figure 3-4**, selecting 8M displays 636 as the approximate number of photos the current memory card can store.

- The lowest or smallest value will produce the smallest photos, which may be ideal for embedding in an e-mail or viewing on-screen, but not as good for printing and editing. The help message on the right of **Figure 3-4** indicates 3M is a suitable size for prints up to 4 x 6 inches. However, with small photos, you'll be able to fit more photos on your memory card. In **Figure 3-4**, selecting 3M displays 1298 as the approximate number of photos the current memory card can store. That's a lot of photos!

- If your camera offers a choice of *aspect ratio* (see **Figure 3-5**), that refers to the ratio of the photo's width to its height. Aspect ratio affects printing and on-screen viewing, including digital frames, as discussed in Chapter 15. Differences between the aspect ratio of a photo and a print may cause part of the photo to be cut off or blank space to appear on either side of the print. A similar problem can occur on digital picture frames or computer screens. Many digital photos have a 4:3 ratio, which is the same ratio as pre-HD (high-definition) TV.

Some cameras, especially DSLRs, use the same ratio as 35mm film — it's 3:2, which is the ratio used for most standard prints. For photos that you intend to view on an HDTV or a wide-screen computer monitor, a 16:9 ratio produces an image more likely to fill the screen. Keep the standard aspect ratio until you find a reason to change it.

In **Figure 3-5**, selecting 16:9 (HDTV aspect ratio) displays 677 as the approximate number of photos the current memory card can store.

4. Press the **OK button** to save your selection.

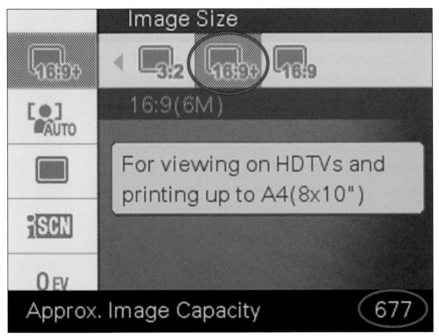

Figure 3-5

Select a File Type

1. Press the **Menu button**.

2. Select the **File Type** or **Format setting.**

3. Highlight one of these file formats, which appear in a list like the one shown in **Figure 3-6**:

- **JPG or JPEG:** This option is the standard photo file type. If you don't have a file type setting, your camera probably takes JPEGs automatically. The JPEG file format was designed for photographs by the Joint Photographic Experts Group and is a good choice for most photographs. Your camera may offer more than one version of JPEG, in which case you should choose the super-high quality, highest, or finest option.

- **RAW:** This option appears on some bridge cameras and most DSLRs (see Chapter 1 for more on types of cameras). The RAW format stores much more information about the picture than does JPEG, such as more color and brightness information. This extra info may be useful with powerful photo-editing software to make adjustments to your photos that aren't possible with JPEG. However, you'll have to convert from RAW to JPEG to share your photos with most other people. RAW files are much larger than JPEG, so fewer RAW files will fit on your memory card.

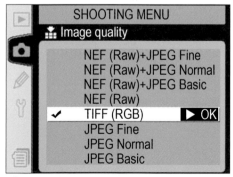

Figure 3-6

- **RAW+JPEG:** This option produces two files at once. The JPEG file is convenient and versatile, and the RAW file expands your editing options. You'll get even fewer pictures on your memory card because you're creating two files per photo.

- **TIF or TIFF:** This option produces a file with more information than JPEG but less than RAW. The *Tagged Image File Format* can be used with more photo-editing programs than RAW.

4. Press the **OK button** to save your selection.

 If you have a choice of file format, use the finest or highest JPEG selection until you learn more about using photo-editing software in Chapters 10 and 11.

Fine-Tune Auto Focus

1. Press the **Menu button**.

2. Locate these options that change how auto-focus works:

- **AF mode:** This setting specifies whether the camera automatically focuses only when you press the shutter release (*single*) or *continuously*, which appears as Monitor in **Figure 3-7**. Continuous AF assures you a quick focus. However, continuous AF also uses more battery power and may be distracting as you move the camera around to frame the scene.

- **AF Illuminator:** Your camera may use a colored or an infrared light to assist auto-focus in low light. This assist light should be set to **On** or **Auto**. If you find the light disturbing, you could turn it off, but you'll have more trouble focusing in low light. See **Figure 3-8**.

3. Press the **OK button** to save your selection.

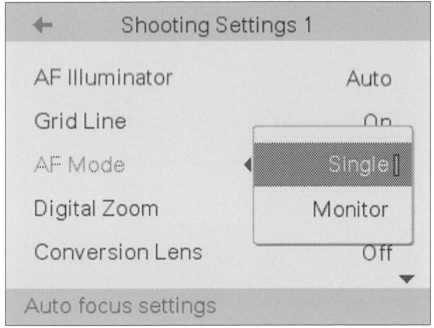

Figure 3-7

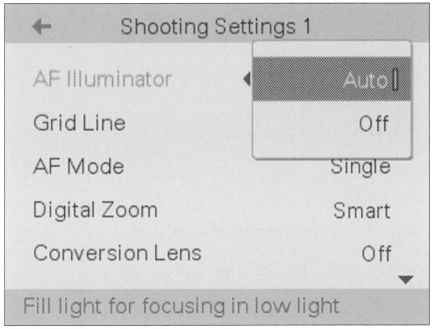

Figure 3-8

Enable Red-Eye Reduction

1. Press the **Menu button**.

2. Select **Red-Eye Reduction** to reduce the red that reflects from the back of people's eyes when you use a flash. Note that this is a separate option from a red-eye reducing flash. You can use both or either. You can also fix red-eye in editing. **Figure 3-9** shows an example of red-eye on the left and the setting on the right.

3. Press **OK** to save your selection.

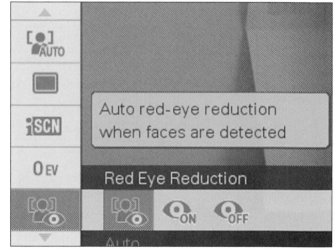

Figure 3-9

Change Other Settings

Many more settings are available on some cameras. Some of the settings I mention here are covered in greater detail in later chapters. For now, you may want to look for these settings:

➡ **LCD and electronic viewfinder brightness:** This setting makes the LCD more or less bright. When the LCD is bright, you can see whatever is on it more

easily, especially outside on a bright day. However, the brighter the LCD, the more battery power it consumes. You may have a separate option if you have an electronic viewfinder, which consumes very little power, even at the brightest setting.

➠ **Power-saving:** This setting controls how long the camera will stay on if you're not actively using it. You may find separate settings for the LCD and the entire camera. If you set this for too short a period, you may have to turn the camera on more frequently. If you set this for too long a period, you may be wasting battery power.

 To keep your camera from going to sleep while you wait to take a picture, press the **Shutter Release button** halfway every so often.

➠ **Auto-review:** This setting controls whether you see the latest picture you took on the LCD immediately after you take it. While the picture appears, you can't use the LCD to compose the next shot, so you may want to turn this off or shorten the duration, if available.

 Use the **Review button** discussed in Chapter 2 to see any of the pictures in your camera.

➠ **Format Memory Card:** This option prepares a memory card for use in your camera. Newly purchased cards are preformatted and should not require further formatting in your camera. You could use this option on a card you've used for other purposes or in another camera. Be aware that this option wipes out any data on the card.

Part II

Taking Better Digital Photos

The 5th Wave By Rich Tennant

"There is no 'Pretty' button."

Following Basic Guidelines

*W*ith camera in hand, you're ready to go snap-happy — and you should. Take lots of pictures but show people only your best and most interesting.

Photography is more than 150 years old. The technology you hold is new, but you may find long-established techniques and guidelines useful as you take pictures. For example, positioning the subject dead center in the frame may be dead wrong. And if it looks like a tree branch is coming out of your friend's head, you should probably move to a new position to take the picture.

Of course, you have at least one big advantage over photographers of an earlier era: Your camera has scene modes designed to take the best pictures under different conditions. For example, Landscape mode assures the whole vista is sharp; Portrait mode focuses on the nearby subject and blurs an otherwise-distracting background. Use these scene modes to adjust your camera settings quickly and easily.

Work with the Essential Elements of Photography

The subject is the reason for the photograph, as may seem obvious. However, sometimes the subject is the entire scene, such as a grand vista. Sometimes, though, the subject is a person, an animal, or an object, and the surrounding scene is irrelevant. And, sometimes, the subject is both an individual and the larger scene. I make this distinction here because your choice of subject affects how you take the picture. Do you move in close or back away? How do you position your camera to frame the subject? Forgive the anthropomorphism, but how does the camera *know* what the subject is? If the camera is mistaken, will you get the photo you want?

Photographs capture a mixture of light and dark. Regardless of what you see, your camera may record a scene that is lighter or darker than what you expected it to be. Settings within the camera may make the subject dark and the background bright or vice versa. *Exposure* is the term to describe the brightness of the scene. The longer the exposure, the brighter the picture. Your camera should avoid overexposing (too bright) or underexposing (too dark) the photo, although you can use either for artistic effect. **Figure 4-1** shows a challenging exposure of a high desert landscape involving light reflected off water and white sand flanked by dark cliffs. The camera did what it could automatically.

The other essential element of photography is *focus*. As with exposure, your photo may have some areas that are in focus and some that are out of focus. With few exceptions, you want the subject of the photo to be in focus, whether it is a person or object. Focus can be used to emphasize the subject and to diminish the surrounding scene. Your camera can be set to focus in the center of the scene or elsewhere, but most cameras automatically focus on multiple areas within the scene. Look for indicators on the LCD, such as one or more boxes around the area of focus. Focus indicators often turn green when focus is set by the camera.

Figure 4-1

Your camera is programmed to choose settings that will produce an *acceptable photo:* one in which no area is too dark or too light and, in most cases, the entire scene is in focus. This programming is a calculation based on averages. Although it's very reliable, your camera's programming isn't perfect. Keep reading to see how to improve upon the camera's capabilities through the decisions you make about the camera's settings.

Use Scene Modes

It's hard to beat the simplicity of Automatic mode. Leave your camera in Auto mode and let it take care of all the settings for you. However, you

may get better photos by using the scene modes in your camera. Here are descriptions of some scene modes and suggestions for using them:

➡ **Landscape:** This mode often appears on the scene dial as triangular mountain peaks. Use Landscape mode for outdoor shots in which the entire scene is the subject, especially for large areas, such as mountains, fields, or cityscapes. The whole picture will be well exposed with this setting.

➡ **Portrait:** On the scene dial, Portrait mode often appears as a round head over curved shoulders. Use Portrait mode for close-up photos of individual people or animals. This setting tends to blur the background of the photo for emphasis on the subject.

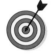 *Landscape* and *portrait* each have another common meaning. *Landscape orientation* is wider than it is long — the way you normally hold your camera. *Portrait orientation* is taller than it is wide, like when you turn your camera 90 degrees. The orientations and the modes are independent, although it is common to use them together.

➡ **Landscape plus Portrait:** The symbol for this combines the portrait symbol in front of the landscape symbol. As you would guess, this mode is for photographing a person in front of a vista. Settings adjust to evenly expose near and far.

➡ **Sport or Action:** Represented by a running stick figure, this mode freezes motion, assuring the subject will not be blurred as it moves. Use Sport or Action mode for any moving subject, including wildlife.

➡ **Twilight:** The twilight symbol may be a partial-moon shape or a star. At the edges of the day, light is soft and warm, and changes quickly. Use Twilight mode to prepare the camera for less light outdoors.

➡ **Backlight:** Generally, a subject that is in front of a light source, including light reflected by water or snow, is difficult to expose properly. Backlight mode causes the camera to adjust appropriately so that the subject isn't too dark or the backlight source too overexposed.

➡ **Night Scene:** Like Twilight mode, Night Scene mode may be represented by a partial moon. The less light available, the more time the camera needs for an adequate exposure. Use this mode at night. Try to stay still and keep the subject still until the shot is complete. See "Use a Tripod" later in this chapter.

➡ **High Sensitivity or ISO:** Usually marked with ISO (for reasons that go back to film cameras), this is an alternative to Night Scene mode for use outdoors or indoors in very low light. ISO mode increases the camera's sensitivity to light, allowing other settings that wouldn't work in low light. Even a good exposure may show dots or other artifacts called *noise*. See "Use the Flash" later in this chapter.

➡ **Party or Indoor:** I haven't found a consistently used symbol for this mode. Use this mode indoors, where there is less natural light plus artificial light, which tends to affect color in photos.

Figure 4-2 shows two examples of a scene modes dial.

Some cameras have just a few scene modes, and others have dozens of these modes. In some cases, you may choose a mode, such as Landscape, and then refine your choice further by specifying what kind of landscape. For example, your camera may have a beach setting that adjusts for brighter blue or a snow setting that adjusts for extreme white. Other cameras, like the one on the right of Figure 4-2, have a unique Scene setting (SCN, in this case). You choose Scene mode and then select the kind of scene you want from a menu that appears automatically.

ISO mode Night mode Other scenes

Night Portrait mode

Landscape mode

Portrait mode

Landscape mode

ISO mode Portrait mode

Sports mode Smile Shutter mode

Night Portrait mode

Figure 4-2

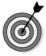 Experiment by taking more than one photo of the same subject with different scene modes. Then compare these test shots to see what effect the different modes had.

Focus on the Subject

1. Turn on your camera, removing the **lens cover**, if necessary.

2. Aim the camera so that the subject of the photo is in the center of the scene without anything between the subject and the lens.

3. Press the **Shutter Release button** halfway. On the LCD, you may see one or more boxes or outlines. These indicate where the camera is focusing, as shown in **Figure 4-3**.

4. Release the **Shutter Release button**. (You can take the photo, if you want to.)

5. Move the camera slightly so that the subject is no longer in the center of the scene but still on the LCD.

Squares indicate multiple areas of focus.

Anti-shake and automatic scene selection (iSCN) are on.

Flash is off.

Figure 4-3

6. Press the **Shutter Release button** halfway and see what areas the camera is focusing on. The subject should still be highlighted by a box or other indicator. However, the camera may be focusing on something else.

7. If your camera indicates that it's not focusing on the intended subject, release the **Shutter Release button** and move the camera to put the subject in the center. Press the **Shutter Release button** halfway to lock the focus on the subject; then move the camera so that the subject is where you want it in the frame.

8. Press the **Shutter Release button** the rest of the way to take the picture.

 Brains focus differently than cameras. When you're watching a bird in a tree, you don't even notice the twig in the foreground that the camera focuses on, blurring the bird. Try focusing on another object an equal distance from the camera to the subject, lock focus, and then move the camera to the subject.

Compose Your Photo

Remember: It's your camera, and you're taking the pictures — anything goes. Enjoy yourself. Above all, don't feel constrained by rules and expectations. That being said, here are a few considerations to composing a pleasing photo:

➠ **The Rule of Thirds:** This venerable guideline suggests that the subject of your photo should not be dead center, nor should any lines that cross the entire frame do so across the center. Instead, mentally divide the frame into thirds horizontally and vertically. **Figure** 4-4 shows a photo with the subject placed according to the Rule of Thirds. A grid is superimposed to show the lines. Here's how you take pictures using the Rule of Thirds.

 • Position any major horizontal line crossing the frame, such as the horizon, itself, along one of the horizontal thirds. Put the horizon along the lower third to emphasize the sky or along the upper third to emphasize the ground.

 • Position any major vertical line, such as a flagpole or building, along one of the vertical thirds.

 • If you have a specific subject — such as a person or an object — the subject should be placed where two of the thirds intersect — where one horizontal third meets one vertical third.

There are four of these sweet spots. Many people see this very careful off-centeredness as interesting and pleasing as well as emphasizing a subject within the scene.

Figure 4-4

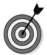 Your camera may have a grid setting that displays the thirds on the LCD. This can be very helpful for applying the Rule of Thirds. Gridlines also help you make sure the photo is straight.

➠ **Leading lines:** Just as the imaginary lines of the Rule of Thirds help you compose your shot, you can use real lines to lead the eye across the photo. Generally,

lines should lead from left to right and from bottom to top. Lines may lead to the subject or merely give depth to the scene, especially if they appear to converge, like train tracks into the distance or the road in **Figure** 4-5, which leads the eye into the center of the photo and off to the left.

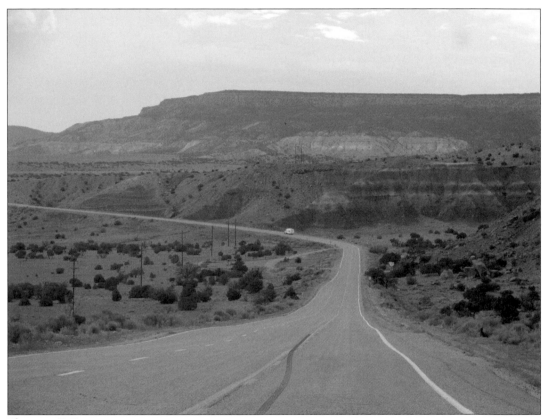

Figure 4-5

 Don't obsess, but the time spent composing a photo may save time you spend editing it. Still, with photo-editing software, you can transform a less-than-perfect photo into a great shot. See Chapters 10 and 11 for information about editing your photos.

Consider the Context

Most photos include something around the subject. Extreme close-ups are a dramatic exception, where the subject fills the frame completely. If you aren't taking such a close shot, consider what you want to include of the background and foreground, such as the following:

→ **Avoid including distractions.** For a photo of someone on a park bench, avoid including the nearby trash can. Consider whether you want the whole bench or just part of it — which is more distracting? How much of the park belongs in the photo? Including other park goers may distract the eye, but omitting them may give a sense of isolation to the subject.

→ **Carefully observe the area between the camera and the subject.** It's easy to overlook a plant or a stick that may interfere with the focus or obscure part of the subject.

→ **Consider how much space to include in front of and behind the subject.** Including more space in the foreground creates more distance between the subject and the camera. Angling the camera up slightly puts the subject in the foreground but now includes more space above or behind the subject. Move the camera closer or farther from the subject or use the zoom for a similar effect.

→ **Scan the background beyond the subject for other distractions.** Look for anything that may appear to stick out in a photo. For example, it's easy to miss the tree branch that will look like it comes out of someone's ear. (Photo nerds call this a *merger.*) Move a little either side of your subject to remove background distractions. In Chapter 5, you learn how to blur the background and foreground to minimize distractions.

Observe the Natural Light

Outside, the sun should provide all the light you need for most photographs, even on a cloudy day. Immediately after dawn, the light is golden; and at such an angle, it passes through plants, setting them aglow. Very early, you can still catch dew or frost for highlights.

Clouds add depth and character to the sky and also diffuse the light for a softer effect than what you see on a cloudless day.

The middle of the day, especially close to noon, presents harsher light and starker shadows. Mid-day is especially difficult for photographing people, who squint and fidget, or who hide behind sunglasses and under hats that cast shadows over their faces.

 Outdoors, people generally look best in indirect, even light. Find a lightly sheltered spot that is neither in shade nor in sun. Suggest that your subjects remove their hats and sunglasses (although those do look cool sometimes).

Closer to sunset, you'll again catch that angle of light that passes through plants and spotlights more solid objects, like the walls of Chaco Canyon in **Figure 4-6**. You may find the late light warmer and redder than at dawn. The waning light poses new problems along with new opportunities. Remember to switch to a twilight or low-light setting as it gets darker.

Night is not the end of photography outside. Look for different sources of light, from the moon to the street light. Use a low-light setting, like Night Scene or ISO. Keep absolutely still while you shoot.

 You can use a flash (in the next section) outdoors to help even out the light, if you can get close enough to the subject.

Inside, you can use natural light as it streams in through windows, skylights, and doors, especially if you can move the subject closer to an opening. Watch out for backlighting, though: Put your subject with the light source to one side or the other, but not behind the subject.

Figure 4-6

Natural light indoors lends a warmth to the subject and avoids the color distortion that often accompanies artificial light, whether incandescent (yellow) or fluorescent (blue). You may have to turn off your flash to suppress it from interfering. Try Auto mode or any indoor or low-light scene mode.

Use the Flash

1. Turn on the camera.

2. Press the **flash button** to choose one of these options:

- **Auto:** The camera determines how much light is available and flashes if exposure requires more light.

- **On:** The camera flashes with every photo taken. This is also called a *forced* or *fill* flash. Use this to add light to a subject that is backlit. (In Auto flash mode, the camera might not flash because, over all, there is enough light.)

- **Off:** The camera will not flash. For distant shots, such as landscapes, the flash does no good, but Auto flash mode might still flash.

- **Red-eye reduction:** The flash flashes twice. The first contracts the subject's pupils to reduce red-eye, and the second flash creates the exposure.

A flash has an effective range of about 12 feet (check your camera's manual). Get close enough to the subject for the flash to reach the subject. If you're less than one foot from the subject, turn off the flash to avoid blinding brightness and complete washout.

3. Compose your photo and take your shot. There may be a brief delay before you can use the flash again.

If you leave your flash set to Auto, you let the camera decide when it needs the flash. I prefer to leave my flash off to avoid unnecessary flashes, but then I miss some shots because I forget to turn on the flash.

Use a Tripod

1. A tripod allows you to shoot in low light, where even slight camera movement may blur a photo. Extend the legs of your tripod and lock them in place with the provided mechanism. The lock may twist or snap to keep the legs from collapsing. Don't trip over the legs as you move around the tripod.

 For maximum comfort, extend the tripod so that your camera will be at eye level. However, if the subject is short or lower to the ground, you may not want to fully extend the tripod. And to compensate for uneven ground, you may want to extend the legs appropriately.

2. Attach your camera to the tripod by screwing the connection at the top of the tripod into the tripod mounting hole at the bottom of the camera body, as shown in **Figure** 4-7. Tighten the connection securely but don't over-tighten.

3. If your tripod's head tilts or swivels, make appropriate adjustments to position the camera and tighten each connection to prevent any movement.

4. Turn on the camera and choose an appropriate scene mode. For landscapes in daylight, turn the flash off. For portraits in low light, turn on the flash or set it to Auto.

5. Compose your shot. If necessary, move the tripod or adjust the tilt and swivel. Take the photo.

6. If you're going to take other shots with the tripod, you may want to leave it extended. If you leave the camera attached to the tripod, be careful to avoid knocking the camera against anything as you move the tripod.

7. When you're finished with the tripod, detach the camera. Collapse the legs and lock them in place.

 A tripod is very helpful for self-portraits or any photo you want to jump into — you can't do that with a monopod (see Chapter 1). Set up the shot and use the timer.

Screw the tripod
into the bottom
of the camera body.

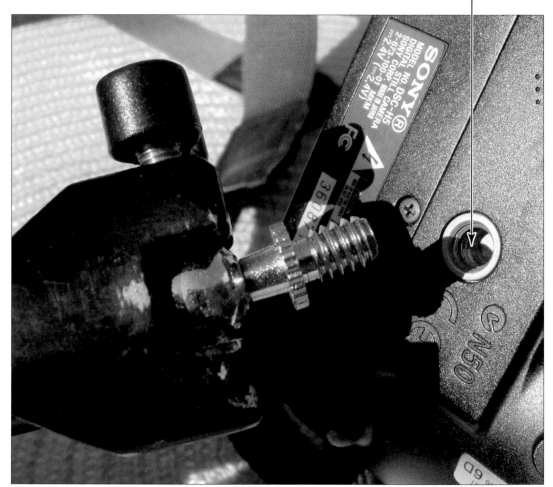

Figure 4-7

Shoot from Unexpected Angles

Everyone has a unique perspective. Change your perspective to see
things differently. In the process, you may discover a new angle on
photography. Here are a few suggestions:

➥ **Kneel, crouch, squat, or sit.** If your subject is a child
or pet, get down closer to the subject's level, instead

of looking down on the subject. And if you can't crouch down, it's time for that yoga class.

➡ **Get way down for ground-level subjects.** Flowers and small creatures, like the box turtle in **Figure** 4-8, look very different at their own level. If you can't crawl on your belly — and get up again — put the camera on the ground or use a very low mini-tripod.

Figure 4-8

➡ **Get above it all.** To shoot over obstacles or for an interesting angle, stretch your arms over your head. It helps to have a fold-out LCD that remains visible when the camera is above or below eyelevel. Look for safe ways to gain a little height, including standing with your feet on the sill of your open car door. Look around for nearby bleachers or steps to rise to the occasion.

➠ **Look for unconventional angles on the subject, including profiles.** People don't look at the backside of flowers, but with light shining through from the front, the view may be quite interesting. **Figure** 4-9 shows a one-inch chocolate flower from the back.

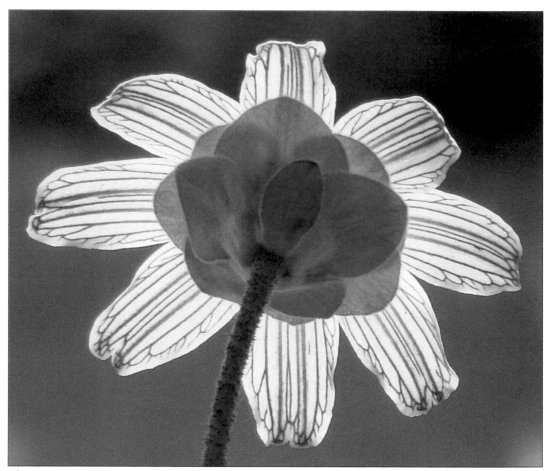

Figure 4-9

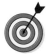 Don't get bent out of shape over these suggestions. The slightest change of angle can dramatically alter a photograph. Shooting from a car window or a chair is still a departure from the standard 5' to 6' angle.

Taking Photos of People, Animals, and Flowers

A *portrait* is a photo in which the subject is a person, an animal, or an object. Often, in a portrait, the *subject* is the primary interest, and the area around the subject matters less, if at all. In most portraits, the subject is an individual, but a portrait could also be of a couple, or a group of people, such as a sports team.

In contrast, landscapes, scenery, cityscapes, and other large areas make for very different subjects, as you'll see in Chapter 6.

With portraits in mind, you want to emphasize the individual. You want faces in focus, smiles where appropriate, and a sense of the character of the person and the emotion of the moment.

You can take portraits of animals as well as people. A pet makes a great subject, especially if you capture some aspect of its individuality. Wild animals, including birds, reptiles, and bugs, can make good portrait subjects, especially if your timing is good. Even flowers deserve a good, tight close-up.

You can follow the steps in this chapter using the most common controls on your camera. In Chapter 7, you dig deeper into manual settings to capture pictures you may miss under difficult circumstances.

Enable These Settings for Portraits

Before you shoot portraits of people or animals, check the following settings, using your camera's scene settings or menus. See Chapter 2 for information on locating controls.

➥ **Portrait mode:** This may seem obvious, but choosing Portrait mode is probably a good choice for portraits of one or two people. Portrait mode tends to blur the background and those areas more than a few feet from the subject, emphasizing the subject and diminishing distractions. When the subject is more than one person or some part of the surrounding scene needs to be in focus, though, don't use Portrait mode — or, if you do use Portrait mode, take another photo with Automatic mode, as a backup. **Figure 5-1** shows a sample camera setting, plus a portrait with a blurred background.

Portrait icon Portrait menu item Sharp subjects and blurred background

 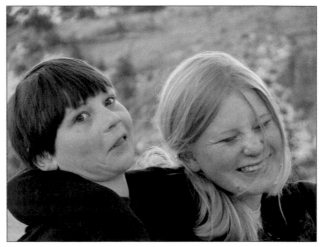

Figure 5-1

⟶ **Face Recognition:** With this function enabled, the camera will identify faces in the scene. You'll see boxes around each face on the LCD or in the electronic viewfinder, if your camera has one. The camera will focus on and then properly expose for those faces. You may never need to turn off this feature. Some cameras allow you to specify children's faces or adults' faces as more important, and a few cameras allow you to identify specific faces to focus on. **Figure 5-2** shows the camera settings and the face recognition boxes around three faces. The fourth face on the left may not be recognized because of the sunglasses, shadows, or the angle of the face to the camera.

Face detection Boxes around three of four faces

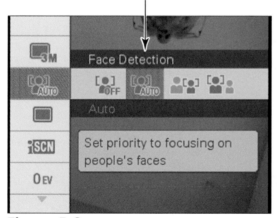

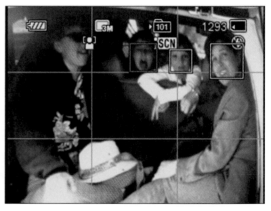

Figure 5-2

⟶ **Smile Detection:** Using this function goes a step beyond face recognition and detects whether people are smiling. When you use this function, pressing the **Shutter Release button** may not take the picture immediately, as the camera waits for smiles. Keep the camera steady until the shot is complete. Using a tripod helps when you use this function.

➡ **Red-Eye Reduction:** Using this function reduces glowing red retinas caused by your flash. Your camera may have a separate flash setting for red-eye reduction. If you end up with red-eye in a photo, you can learn how to fix it in Chapter 10.

➡ **Flash mode:** Although using the **flash** ensures full exposure, it can create harsh shadows. Set **Flash mode** to **Auto** to let the camera choose when to flash. Set flash to **On** to force a flash to even-out the exposure, even if the camera doesn't need it, such as shooting in a shady area on a bright day. Turn off the flash to use only available light. Adequate natural light works wonderfully for portraits. **Figure 5-3** shows sample camera settings. The lightning bolt in **Figure 5-3** is the standard flash indicator. The symbol to the left of the lightning bolt in the upper-right corner shows the camera recommends turning on the flash (but it is on!). Each of the other symbols indicates different settings, such as the full-charged battery in the upper left and the number of photos (1298) that will fit on the memory card.

➡ **Burst mode:** If **Burst mode** is enabled and you press and hold down the **Shutter Release button**, the camera will shoot multiple pictures in rapid succession. The symbol for Burst mode is usually a stack of rectangles, like several photos in a stack. Using **Burst mode** is very handy when your subject is moving, or when you're trying to capture "that look" someone gives you after she thinks you've taken the picture.

➡ **Timer:** Using a **timer** provides a delay between pressing the **Shutter Release button** and when the picture is taken. Some cameras have short (say, 2 seconds) and long (say, 10 seconds) timer settings. Press the **Timer button** once for the longer time and again for the shorter time; a third press turns the timer off. Use the long timer for self-portraits to provide plenty of time for you to get into the scene. Use the short timer to reduce the movement that may accompany pressing the **Shutter Release button**; use the brief delay to steady your hold on the camera. **Figure 5-4** shows sample camera settings.

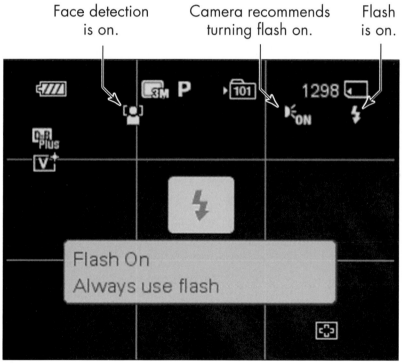

Figure 5-3

Face detection is on. Camera recommends turning flash on. Flash is off.

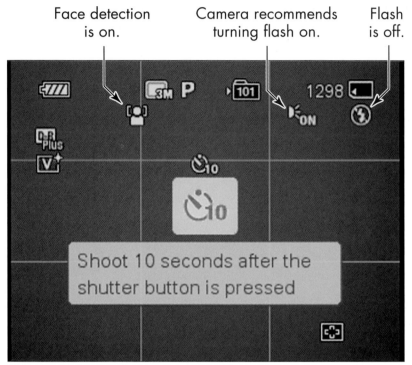

Shoot 10 seconds after the shutter button is pressed

Figure 5-4

Shoot a Posed Portrait

1. Ask the subject of the portrait to sit or stand comfortably in a suitable setting. It's okay to strike a pose for the ages in a formal portrait. Think about photos from around 1900 or portraits taken in a mall photo studio.

2. If light shines directly on the subject, ask her to move — or move yourself — to place the light off to either side over your shoulder. Avoid light shining directly in the subject's face or shining directly behind the subject.

3. Look on the LCD beyond and around the subject for things that will be a distraction in the photo, such as poles or tree limbs that appear to grow out of the

subject's head. Move a little to either side to change the background behind the subject. Check for other distractions between the camera and the subject, as well.

4. If you want to minimize the background by blurring it, choose your camera's **Portrait mode** (look for a round head and shoulders symbol). Some cameras have Portrait mode variations, such as portrait in front of a landscape. (Look for a symbol combining the portrait and landscape symbols.) As I mentioned earlier, you can take a portrait without using Portrait mode; try moving in close and using **Automatic mode**, instead.

5. If the scene is less than bright or the brightest light is behind the subject, set the **flash** to **On** to force the flash and guarantee a good exposure. If your flash has a **Red-Eye Reduction option**, choose that. If your flash doesn't have this option, though, don't fret. Red-eye is very easy to fix with photo-editing software. See Chapter 10 for more information on fixing red-eye.

6. To help the subject relax, ask her to tell a story that doesn't require you to pay close attention — your mind is on the photo, while hers should not be.

7. Use *portrait orientation*. Turn the camera body 90 degrees left or right, to fill the frame with a person's head or body, while minimizing the space around the person. See **Figure 5-5**.

Use *landscape orientation* — the way you normally hold the camera — if you want to include the space around the subject.

Figure 5-5

Take a Casual Portrait

For a casual portrait, take more time with the subject. Let her move about and engage in some activity, such as cooking, gardening, hiking, or watching someone else. **Figure 5-6** offers an unusual perspective.

Figure 5-6

Here are a few other tips to help you capture casual, spontaneous portraits:

➡ Get someone to distract the subject from noticing the camera.

➠ Shoot from a distance, using a **zoom lens** to get close without alerting the subject. Using a zoom tends to blur the background, just like taking a close shot in **Portrait mode**.

➠ Photograph something else for a while (or pretend to) so that the subject doesn't expect a picture.

➠ Talk to the subject if that relaxes her or if gentle direction helps with the pose. However, a casual picture often depends on the subject forgetting that you're there.

Snap a Self-Portrait

1. Position **the camera** on a level, secure surface such as a table, flat stone, or tripod. Avoid using an uneven or unsteady surface.

2. Look at the scene on the LCD or in the viewfinder. Move the camera — or zoom in or out — to include what you want of the surrounds and to fit everyone into the shot, if others are involved. Plan where you will sit or stand. And, if others are in the picture, tell them exactly where you'll go so they don't have to move when you join them after you set the camera's timer.

3. Set the camera's **timer**. Look for a button labeled with a dial with a second hand, as in **Figure 5-4**. Press the **Timer** button. You should see the same time symbol on the LCD. Use the longest option available to give yourself time to move into the scene and settle into place.

 Some cameras have a remote control you can use instead of a timer.

4. Just before you're ready to move, press the **Shutter Release button**. Most cameras blink a red light to indicate the time is ticking. Move quickly but carefully to your planned position. Smile!

5. You may see the blinking light stop. You may see a flash, if the flash is on and the scene requires the flash. Wait a second longer than you expect, just in case.

6. If you have **Smile Detection** enabled, the camera may delay longer until everyone is smiling. If you have **Burst mode** on, the camera will take several pictures at once.

7. If other people are involved, have them wait in position until you're satisfied with the photo. Take another photo just in case.

 For a casual self-portrait, aim the camera toward yourself while you hold the camera at arm's length; then snap a picture. Use the short timer, if you can't press the **Shutter Release button** at arm's length. Don't use the zoom. With some practice and luck, the resulting picture can be spontaneous and fun. You can also use a mirror or other reflective surface, like plate glass or water, for a self-portrait, as shown in **Figure 5-7**. Don't use the flash when you shoot close to glass or mirrors — the flash will white out the shot.

Figure 5-7

Grab a Group Portrait

1. Pose the members of the group so that each face can be seen clearly. Some can kneel or sit while others stand. Arrange people on stairs, on bleachers, or seated on a picnic table and benches to position them close together. The closer together everyone sits, the closer you can get to ensuring that everyone's face will be recognizable.

2. If costumes, uniforms, or musical instruments are part of the subject, make sure there is enough distance between group members to show their paraphernalia.

3. Unless the group is very small and close to the camera, turn off the **flash** because it won't do any good. The use of a flash in **Figure 5-8**, though, helps isolate the dancers from the wallflowers.

4. For a large group, don't use **Portrait mode** because some of the group members may appear out of focus.

5. Although you can take a group photo without a tripod, you may want to use a **tripod** if it will take a long time to arrange people and set up the shot, especially if you're going to take several photos of the group.

6. Compose the photo on the **LCD**. Is everyone in the frame and unobstructed? See the task "Shoot a Self-Portrait" earlier in this chapter if you plan to jump into the group.

7. Take a couple of photos and review them before you let the group disband.

 As you get ready to take a group portrait, use your **zoom lens** to catch casual close-ups of individuals in the group or pairs interacting while they wait. Most people won't realize you're zoomed in on just them.

Figure 5-8
photo by Merri Rudd

Plan Photos at a Big Event

A big event is a great opportunity to take pictures of people. Birthday parties, graduations, weddings, or sporting events bring people together in celebration. Some events are very casual and comfortable. Others, such as weddings, follow a strict itinerary that may limit your movements but also help you plan your shots. Keep these things in mind:

➠ **Plan some of your movements.** Where do you expect people to be at various times in the event? How will they move from one area to the next? How much time will you have to photograph each stage of the event? Weddings, as in **Figure 5-9**, provide slow, predictable progression, even as they limit your freedom

of movement. (In **Figure** 5-9, moving in close enough to use a flash might have evened out the afternoon sun on the bride's arms or the shadow on the groom's face. Not everyone welcomes the distractions a photographer can make. And, the bride had a knife.)

➡ **Use your camera's Automatic settings** unless you're comfortable with the other choices. Better to blame the camera than the photographer for missing a once-in-a-lifetime photo.

➡ **Use your camera's Action setting** for fast-moving events, such as a game or a race. Look for a running figure or other sports symbol.

Figure 5-9
photo by Merri Rudd

➡️ **Turn off the flash** if it will be a distraction or if the action is too far away to benefit from the flash.

➡️ **Turn on the flash** if the scene is in low light and the subjects are close enough to the flash (about 12 feet or less). If the background is dimly lit, using the regular **flash** will make the background seem blacker, and you can use that effect to minimize the background in low light. However, if you want the background to show in the picture in low light, set the flash to *slow-synchro*, which leaves the shutter open a little longer to expose the background. Slow-synchro works best if everything stays perfectly still; you may want to use a tripod.

➡️ **Use your zoom** — if the scene is well lit — to get close-ups without intruding. Using a zoom is less effective in darker situations.

 Watch out for other photographers so you can stay out of each other's photos.

Get an Extreme Close-Up of Flowers or Bugs

1. Turn on **Macro mode.** (Look for a button with a flower icon.) Make sure the lens is zoomed out to normal (toward Wide, W; and not Telephoto, T).

2. Position the **camera** close — ridiculously close — to the subject. Without a macro setting, most cameras will blur subjects closer than a couple of inches. When using a macro setting, though, you may get a sharp picture with the lens a fraction of an inch from the subject. Get in the face of those posies! Watch out for a shadow cast by the lens or camera, however. (If your camera has a lens hood — an extension to minimize light directly striking the lens — remove the hood to avoid a shadow.) Back off a little or change your angle.

3. Capturing moving subjects, such as bugs, is trickier.
Figure 5-10 shows a lady bug larva that seems as large as
an oil tanker next to dozens of tiny aphids, but the larva
is only about a quarter-inch in size. Try to catch insects
and other small critters at rest or anticipate their move-
ments. Use **Burst mode** — hold down the **Shutter
Release button** — to shoot multiple shots in a row of
moving subjects.

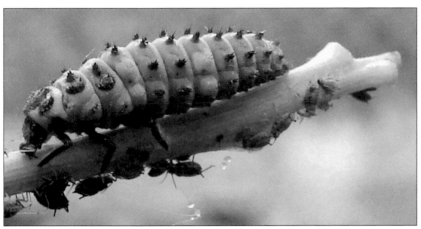

Figure 5-10

 Wind plays havoc with close-ups of flowers. Wait for a
pause or shield the flower with your body.

 If you can't get close enough to use your camera's
macro lens, leave the macro setting off and zoom in,
instead.

Bag Birds in the Backyard

Birds are beautiful subjects, especially if you can catch one in a close-
up. Because birds are almost constantly in motion, though, you may
want to create a setting that encourages them to gather and linger. For
example, you could try any of the following:

➡ If you have the time and means, create habitat. Plant trees and shrubs, especially those that bear fruit or seeds that birds eat or that provide places for birds to perch, hide, and nest. **Figure 5-11** shows a robin carrying nesting material.

➡ Hang bird feeders, suet, and seed bells close enough to windows that you can get really close with a zoom lens but not so close that you scare away birds when you stand at the window. Most cameras focus through relatively clean glass. If the glass is dirty enough, or if you're shooting through screen, the camera may focus on the wrong spot.

➡ Put perches, such as lattice, near food to encourage birds to sit and pose.

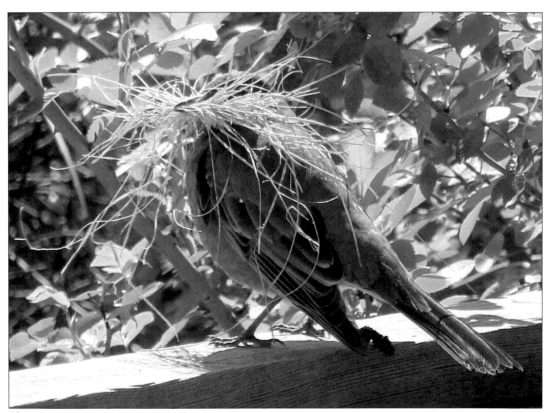

Figure 5-11

➠ Put water in a shallow, wide pan. Birds will drink and some will bathe. (Robins love to bathe.) Add water every day and clean the bath at least once per week. Add a bird bath heating element to your water source in winter.

➠ Use **Burst mode** to take several shots in rapid succession to catch birds in different positions.

➠ Park a comfortable chair near a window with your camera, binoculars, and a bird book nearby. Or look outside every time you pass a window.

Capture Animals at Home and in the Wild

Animals are great photographic subjects. Many of us share our lives with dogs, cats, and other pets. Depending on where you live or travel, you may encounter less-domesticated animals, from livestock to the truly wild. Here are some points to consider when photographing animals:

➠ **Turn off your flash.** The burst of light will is likely to frighten an animal.

➠ **Use your camera's Action or Sports mode.** Using these modes increases your chances of catching animals in motion.

➠ **Photograph your furry friends.** You'll never tire of these photos (although your human friends may have limits). Catch your pet in a characteristic pose or maybe something a little unusual (like the time my dog, Lucky, tried to climb a tree).

➠ **Go where the animals are.** That may be your own backyard or a neighborhood park, or it may mean venturing out into fields and forests. **Figure 5-12** shows elk foraging. (Okay, I admit: I snapped that

from pavement.) A reliable water source, such as a stream or lake, usually attracts wildlife throughout the day and night.

➡ **Stay safe.** Rangers in Yellowstone National Park tell of parents smearing peanut butter on a child's face to get a cute picture of a bear licking the child. Need I say it? Don't do that! Keep some distance from all wild creatures for their safety, as well as your own. Use a **zoom lens** to get closer. (Wildlife photography benefits from using an ultrazoom of 12X or greater.)

➡ **Fake it.** Go to a zoo. Use a zoom lens to get in close and to hide cages and bars. Photograph animals watching people watching animals or vice versa. Most of us will never get closer to lions and tigers and bears.

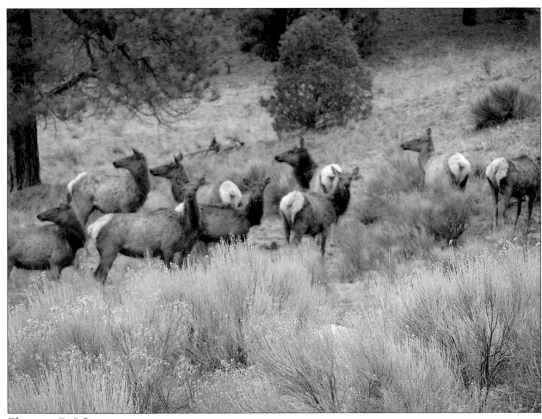

Figure 5-12

Taking Photos of Places and Scenery

We are small upon the face of the Earth. We move through landscapes that often overwhelm the human scale. The land, sky, and sea are immense subjects that warrant special effort to capture in photographs.

Occasionally, the creations of humans rise to a truly large scale: the pyramids of Egypt and the Americas, the Great Wall of China, our best and worst cities — all of which are big challenges to photograph well.

A hallmark of landscape photos is sharp focus throughout, from near to far. Sharp focus comes naturally when the subject (the *focal point*) is far away, especially in a bright scene. If the day is cloudy or the subject is close, you may have more work to develop deep focus.

The settings and techniques for capturing the large scale are the subject of this chapter. See Chapter 5 for information on portraits and more personal scenes.

Get ready to . . .

Enable Settings for Scenery

Before you shoot pictures of landscapes and other large areas, check the following settings on your camera:

⟶ **Landscape mode:** Of course, Landscape mode is a good choice when composing landscape photos. This mode sets the camera to optimize exposure in the entire frame. Take a few shots in **Automatic mode** for comparison.

 Don't use **Portrait mode** for landscapes. Portrait mode tends to blur some part of the scene. For most landscapes, you want every part of the picture sharp. However, your camera may have a mode that combines Landscape and Portrait modes for photos of people in front of vistas.

⟶ **Beach, Snow, and Night Sky modes:** These modes, which are suited for shooting large areas, adjust the camera for difficult exposures (too bright or too dark). **Figure 6-1** shows sample camera settings. For the camera shown in the figure, I select Scene mode (the label SCN on the mode dial of this camera does not appear in the figure). Then, I use the **Menu** button for these settings: Twilight, Beach, Snow, and Fireworks (from left to right). More scenes are available if you scroll with the right arrow on the menu dial.

⟶ **Panorama mode:** A *panorama* is an image that covers an especially wide area. For example, a normal photo of the Grand Canyon may not do justice to the tremendous expanse of its convolutions. The details of a large building may be lost if you squeeze them into a single shot. Panoramas are usually created by combining two or more photos — sometimes as many as half a dozen or more. If your camera doesn't have a Panorama mode, you can use photo-editing software

to stitch photos together into a panorama. See the task, "Capture a Panorama," later in this chapter.

⇒ **Burst mode**: Because Burst mode captures many shots in rapid succession while you hold down the **Shutter Release button**, you may not need it when shooting (slow-moving) landscapes. Still, clouds move, the wind rearranges the scene before you, and even the light shifts from moment to moment. Burst mode may help you catch a special moment.

⇒ **Flash mode**: Odds are that using a **flash** will be useless for most landscape shots because a flash has a limited range. However, if the flash is set to **Auto**, it may flash even when it does no good. Turn off the flash for landscapes, unless you're including a person or object close enough to benefit from additional light.

Specify scene: Night, Beach, Snow or Fireworks

Figure 6-1

Take a Landscape Photo

1. Select **Landscape mode** on your camera (usually represented by a couple of triangular mountains).

2. Press the **flash button** repeatedly until the flash is off.

3. If your camera has zoom capability, start at the widest view (least amount of zoom) — press the **W (Wide)** end of the zoom switch, not the **T (Telephoto)** end. (Most cameras start at the widest view each time you turn on the camera. A few cameras, though, remember the zoom setting from the previous use.) See the task "Capture a Panorama" if you're shooting an especially expansive scene.

4. Frame your photo. If you can't make out details on the LCD, use the viewfinder, if you have one. Press the **Finder/LCD switch** to toggle the display between the LCD and the viewfinder. If you must use the LCD in bright light, look for landmarks within the frame to help compose your photo.

5. If the subject is the sky, including clouds, place the horizon about one-third up from the bottom of the frame so that you have one-third Earth and two-thirds sky. If the subject is the Earth, including mountains, place the horizon about one-third down from the top of the frame so that you have one-third sky and two-thirds Earth. This is part of photography's venerable Rule of Thirds. You can read more about this in Chapter 4.

6. Take a photo or a few. Consider moving to change your perspective. Try zooming in slightly — press the **T** (Telephoto) end of the zoom switch. Zoom in all the way

for particularly distant shots. **Figure 6-2** shows a landscape taken with the widest setting and again zoomed in closer to the peak.

Some landscapes work well in *portrait orientation,* where you rotate your camera left or right vertically 90 degrees. (Remember that portrait and landscape orientations are not the same as Portrait and Landscape modes.) A portrait orientation of a canyon or ridge that recedes from you may draw the eye into the picture more than the same scene in landscape orientation. Mix it up.

Zoom in

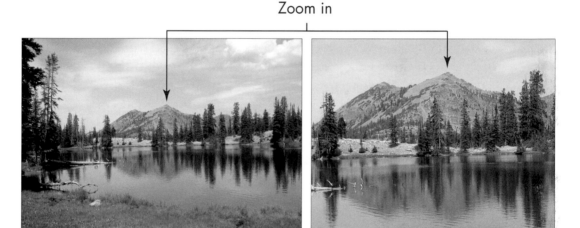

Widest setting Zoomed in

Figure 6-2

Shoot a Sunrise or Sunset

Be ready long before sunrise or sunset begins. Stay with the transition beyond twilight to full morning or night.

 See aa.usno.navy.mil/data/ or www.sunrise sunset.com for rise and set times for the sun and the moon.

➥ Position the horizon about one-third of the way up the frame — one-third Earth, two-thirds sky.

➥ Don't shoot directly at the sun, especially when using the zoom — you'll just fry something in the camera. Place the orb off-center, one-third of the way from the left or right edge of the frame or off-frame altogether.

➥ If it's light enough to see details around you, use **Landscape mode** or **Automatic**. As details fade, try the **Twilight** or **Low Light setting**. If it's too dark to make out details, use Night Scene mode.

➥ If you're shooting a subject in front of the light, strong backlighting may cause the camera to *underexpose* the subject (making your photo too dark). If the subject is within range of your flash (about 12 feet), turn on the **flash** to force it to illuminate the subject. (Auto-flash mode may not trigger a flash if the camera is tricked by the bright background.)

➥ Look in the opposite direction of the sun. Sometimes, the best light at sunset or sunrise is on the objects behind you, such as trees, mountains, or buildings. **Figure 6-3** shows the sunset tinting aspens red.

Figure 6-3

Take Photos at Night

Night offers real challenges for photographers. How do you capture what little light there is from the moon or street lights? How do you avoid blurring a photo in the process, which is a common problem in photos taken in low light?

⟹ Use a **tripod** unless the area you're photographing is very well lit or in reach of your flash. The photo in **Figure 6-4** was taken with a tripod. Even an iron grip might have blurred that photo, if taken hand-held.

Figure 6-4

⟶ Use the **short timer** (or a **remote control**) along with a tripod to eliminate any movement from depressing the **Shutter Release button**.

⟶ Use Night Sky mode (often represented by a crescent moon icon) or other low-light modes.

⟶ If you use a flash for a close subject at night, the background tends to be black. If the background has details you want to include in the shot, your flash may have an option called slow-synchro, which adjusts settings to give more time to capture the background.

⟶ See Chapter 7 for more information on manual options you might find useful in very low light.

Snap City Scenes

Every town has its showcase architecture. Look for public squares and plazas, museums, libraries, courthouses, and schools, as well as parks. Don't be shy about looking like a tourist, even in your hometown. **Figure 6-5** shows two cities hemispheres apart (Quito and Louisville).

Figure 6-5
photos by Merri Rudd

⟶ Use **Landscape mode** or **Automatic** to focus on the entire scene.

⟶ Get some distance to take in a large area of a cityscape: Shoot from a boat, a bridge, a skyscraper.

⟶ Include crowds and traffic to convey the hustle and bustle of urban life.

⟶ Shoot above crowds by setting the **short timer**. Press the **Shutter Release button** and hold the **camera** above your head at arms' length, while the timer takes the picture. (It helps to have an LCD that flips down in this case, so you can frame the photo.)

➠ Use a **monopod** in crowded settings where your camera needs extra stability but a tripod won't work.

➠ See "Capture a Panorama" if you're shooting a particularly large building or other structure.

Capture a Panorama

Many large subjects, such as landscapes or a building, look puny in a photo. Squeezing the full expanse of some scenes into one little frame seems to squeeze the essence out of the subject. In such cases, you may do better taking several pictures of portions of the scene. Later, in editing, you can stitch those photos together into one large photo that may better capture the majesty of the original. The key step is to overlap those multiple photos.

➠ Begin a panorama by planning where you will start and end taking pictures. You will take two to six photos in succession as you create the panorama. (A 360-degree panorama could involve a dozen or more photos.) Each photo must overlap the previous photo; that is, you'll include 20 to 30 percent of the same area in both photos.

➠ Use a **tripod** or keep the camera very steady and level throughout the shooting. Minimize vertical movement as you move the camera from left to right or right to left to take each shot for a horizontal panorama. If you're taking a vertical panorama (say, of a tall building), minimize horizontal movement as you move from the top down or the bottom up, overlapping each photo with the prior one.

➡ If your camera has a **Panorama** or **Panorama Assist mode**, select that mode from the scene dial or the menu.

Some cameras assist you in framing a panorama. You may see a grid. You may see arrows indicating the direction you should move after you take each photo. Some cameras show a portion of the previous photo as an overlay to help you align the next photo with the previous. If you're using Panorama mode, press the **menu** or the **OK button** after you take the last photo to turn off Panorama mode.

➡ If your camera doesn't have a Panorama mode, take the individual photos as previously described. Be sure to overlap areas in each photo roughly 20 to 30 percent.

➡ As you take each photo, don't change any settings. Don't change the zoom, either.

➡ Some cameras automatically stitch the overlapping photos together to produce the panorama in the camera after you take a set number of photos or turn off Panorama Assist. With most cameras, you have to stitch the photos together yourself on a computer, using photo-editing software. See Chapter 11 for the steps.

➡ **Figure 6-6** shows a panorama stitched together from four photos. Many people crop the resulting panorama to eliminate the ragged areas above and below to make the panorama look more like a single photo, but I like the effect as you see it.

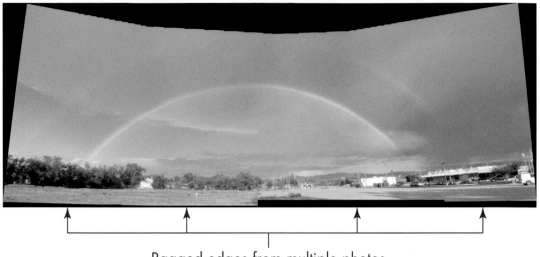

Ragged edges from multiple photos

Figure 6-6

Using Manual Controls

Automatic mode works well in many situations. When you choose a particular scene mode, such as Landscape, you adjust the camera's settings further without much effort. Many cameras have a few more modes you may want to consider, though. With these alternative modes, you may take better pictures under difficult circumstances.

Using the functions in this chapter will open new photographic possibilities for you. Not everyone needs these options, but you may find them useful. Even if you don't ever use these functions, reading about them will help you understand and appreciate what your camera does automatically. Don't be afraid to experiment — after all, that's how you learn — but don't try these functions for the first time in a once-in-a-lifetime moment. Practice first.

Shift Out of Automatic Mode

Cameras use two major settings in concert to expose a picture: the *aperture* size (lens opening) and shutter speed. In Automatic mode — as well as in all scene modes — the camera adjusts both the size of the aperture and the speed of the shutter automatically.

Consider the mechanics behind how these two work in tandem. First, the aperture setting determines how much light strikes the image sensor that records the photo. It does this by adjusting the width of the lens opening. Then, when you press the Shutter Release button, the shutter briefly opens to let light pass through the aperture. How long the shutter stays open (the *shutter speed*) determines how long light, admitted by the aperture, strikes the sensor.

Thus, the balance between shutter speed (how long the sensor receives light) and aperture (how much light can enter during that time) — creates an *exposure*. **Figure 7-1** shows the arrangement of lens, aperture, shutter, and image sensor, each of which plays a role in capturing images.

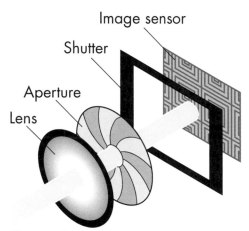

Figure 7-1

Shutter speed is typically measured in fractions of a second. (I say "typically" because a low-light exposure may use a full second or two.) A shutter speed of 1/2 (one-half second) is open much longer ("slower," in photography lingo) than 1/1000 (one one-thousandth of a second). A *fast* shutter speed (like 1/1000) leaves the shutter open for a very short time; you can do the math and see that less light will enter.

Shutter speed is important, depending on what you're shooting. For example, in a bright setting, using a fast shutter speed makes sense so you don't wash-out or overexpose the shot. Too, using a fast shutter

speed freezes action pretty well, like when you're shooting sports. Flip the table, and it makes sense that when using a slower shutter speed, the shutter stays open longer and lets in more light, which is better suited for low-light situations or if you want your subject to move within the scene and create blur in the photo. **Figure 7-2** shows the blurring effect a slower shutter speed (on the right) can have on flowing water.

1/40 second 1/5 second

Figure 7-2

Aperture settings are important, too, for creating a good exposure. Using a wide aperture — a wide-open lens — lets in more light than using a more narrow aperture. In a bright setting, a narrow aperture is adequate; using a wider aperture might overexpose the scene, making it appear white or washed-out. Conversely, in a dimly lit setting, using a narrow aperture might underexpose the photo, making it too dark; using a wider aperture would let in more light.

Aperture is measured in increments called *f-stops*. In **Figure 7-3**, the blue area represents the lens opening (aperture).You'll see f-stops written like f/2, but on the camera LCD, you're more likely to see them written like F2. The f-stops are fractions. F2 is really 1/2. F16 is really 1/16. And, so, F2 is a larger aperture, letting in more light, than F16.

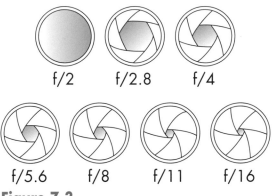

Figure 7-3

Before you consider juggling aperture and shutter speed, there is one more interesting property that aperture affects: depth of field. *Depth of field* refers to the area of the picture that's in focus. This isn't the area to the left or right of the subject, but rather the area between the camera and the subject as well as beyond the subject. *Shallow depth of field* means only a little of the area in front of and behind the subject will be in focus, while anything outside that shallow depth of field — closer or farther — will be out of focus or blurred. *Deep depth of field* means that more of the area between the camera and the subject, as well as beyond the subject, will be in focus. Using a narrow aperture, like F16, increases depth of field; using a wide aperture, like F2, reduces depth of field.

Visualize depth of field as a cone with the narrow end at the lens, widening as you go out farther. For that reason, the depth is not equal in front and behind the subject (the focal point). Instead, the depth of field is roughly one-third in front of the subject and two-thirds beyond.

 Because of the compact size of digital cameras, they tend to have a greater depth of field compared with traditional film cameras and larger DSLRs. Therefore, it's more difficult to reduce the depth of field with a compact digital camera than with larger cameras. This can be a bit of a mind shift if you're used to using a 35mm SLR.

Recall that using your camera's Portrait scene mode tends to blur the background — and that's attributable to a reduced depth of field. Portrait mode makes that blur by widening the aperture. Landscape mode, by comparison, keeps near and far in sharp focus by using a more narrow aperture. By choosing specific scene modes instead of using Automatic mode, you guide the camera to choose the appropriate combination of aperture and shutter speed for the scene.

If nothing else, you should appreciate the scene modes at this point. If you don't yet, you soon will. Further, this helps explain why it's easy to take sharp photos in bright light: You can use a smaller aperture and a faster shutter speed together, producing a picture in which everything near and far is sharp and objects in motion don't blur. In turn, it's more difficult to produce a sharp photo in low light with a wide aperture and a slow shutter speed, both of which increase blurring. (Image stabilization or anti-shake functions are less effective in lower light. You may need to use a tripod.)

So, you have these two functions, aperture and shutter speed, that have to be adjusted by the camera, or by you, as shooting conditions change. As the scene gets darker, you need to use a wider aperture or a slower shutter speed to avoid underexposing the photo. But, the wider aperture reduces the depth of field, and the slower shutter speed increases blurring of movement, including any movement of the camera from unsteady hands.

Think about this for a minute: For the amount of light in any scene, there is more than one combination of aperture and shutter speed that will produce exactly the same exposure! However — and this is the

trick — using different combinations won't give you the same picture in terms of sharpness throughout. For normal exposure, as shutter speed increases, aperture widens: Action freezes, but more of the scene may be out of the depth of field. As shutter speed decreases, aperture narrows: More depth is in focus but motion will blur.

 Two more variables affect depth of field. First, the closer the subject (the *focal point*) is to the camera, the more shallow the depth of field is. Every time you move toward or away from the subject, the depth of field changes. With a macro shot (an extreme close-up), the depth of field may be fractions of an inch. If the subject is far away (and how "far" varies with different lenses), you get maximum depth of field without any change in settings. Second, when you zoom in on a subject, you reduce depth of field. So, in addition to moving toward and away from the subject, play with the zoom.

When you want to take control of aperture or shutter speed, choose a mode other than **Automatic**. In **Portrait mode**, the camera sets a wide aperture. In **Landscape mode**, the camera sets a narrow aperture. In **Sports mode**, the camera sets a fast shutter speed.

For more direct control, your camera may also have these settings: **Aperture Priority mode** and **Shutter Priority mode**. With either, you directly set one and the camera automatically sets the other to assure an adequately bright exposure. When you select one of these priority modes, you use the up and down arrow keys to increase or decrease numbers for the setting.

Imagine that you're photographing a field of flowers. Here are some creative options before you:

➠ **If you want the entire field in equal focus,** use **Landscape mode** or **Aperture priority** with a narrow aperture (say, F8).

➠ **If you want to freeze the birds and bees flitting about,** use **Sports mode** or **Shutter priority** with a fast shutter speed (say, 1/2000).

➠ **If you want only a patch of the flowers in sharp focus** (surrounded by blurred flowers), use **Portrait mode** or **Aperture priority** with a wider aperture (say, F2.8).

➠ **If you want the flowers sharp but the motion of the birds and the bees artistically blurry,** use **Shutter priority** and a slower shutter speed (say, 1/250). (Most cameras don't have a scene mode designed to blur motion.)

Or, wait for the light to change. As the sun sets, blurring is easier — and harder to avoid.

 Some bridge cameras and all DSLRs have two more modes that involve setting aperture and shutter speed. In **Program mode** (P), you choose from pairs of aperture and shutter speed settings the camera will accept, as the camera eliminates combinations that will underexpose the scene. In **Manual mode** (M), you have complete control over all settings, including aperture and shutter speed. With Manual mode, you can adjust settings in ways no other mode allows.

Set the Shutter Speed

1. You want to use a fast shutter speed to freeze action or use a slow shutter speed for intentional blurring of figures in motion (or to blur camera movement as you move the camera to follow a moving object). To set the shutter speed, choose **Shutter priority mode** on your camera's mode dial (S, SP, or Tv). That then lets the camera choose

an appropriate aperture for an even exposure with that shutter speed. (Remember: The camera's choice of aperture also determines depth of field.)

2. Use the **up and down arrows** on the camera's menu wheel to increase (larger denominator, like 1/1000) or decrease the shutter speed (smaller denominator, like 1/2). When you increase the shutter speed for fast-moving subjects (such as sporting events or wildlife), the camera increases the aperture. This lets in more light to avoid underexposure but also reduces the depth of field. Decrease the shutter speed for still subjects in low light. The camera reduces the aperture, which reduces the risk of overexposure but also increases the depth of field. Your camera may highlight settings in green (acceptable) or red (not recommended).

3. Take several shots of the same scene, varying only the shutter speed. (This is called "bracketing." This is a manual version of setting the camera in bracketing mode, which I talk about later.) Then view these photos on a computer screen to see differences that won't show on the camera's LCD. See Chapter 8 for information on moving photos to your computer.

Control the Aperture

1. You want to use a wide aperture for softening the foreground and background and use a narrow aperture for sharp focus near and far. Choose **Aperture priority mode** on your camera's mode dial (A or AP). Then, you control the aperture but let the camera choose an appropriate shutter speed for an even exposure. (The camera's choice of shutter speed determines the blurring of movement, if any.)

2. Use the **up and down arrows** on the camera's menu wheel to increase (smaller denominator, like F2) or decrease the aperture (larger denominator, like F8). When you increase the aperture to blur the background and

foreground, the camera increases the shutter speed to reduce overexposure. When you decrease the aperture for greater depth of field (such as for a landscape on a sunny day), the camera automatically decreases the shutter speed to allow more time to reduce underexposure. Your camera may highlight settings in green (acceptable) or red (not recommended).

3. Take several shots of the same scene, varying only the aperture settings. It can be difficult to see all the details in a camera's LCD screen, so look at these photos on a computer screen to see the differences. See Chapter 8 for information on moving photos to your computer.

Consider These Additional Options

In any mode other than Automatic, you may be able to adjust the following settings for even more control over exposure and focus. (On some cameras, even Automatic mode allows you to adjust these settings.)

➥ **Metering mode:** Most cameras have three types of metering. (**Figure 7-4** shows a camera menu item for metering.)

- **Multi-point metering:** Most of the time, you use this type of metering, with which your camera calculates exposure settings by averaging the amount of light in numerous areas of the frame. Caution: For a backlit subject, using multi-point metering underexposes the subject, based on averaging the light and dark areas.

- **Center-weight metering:** With center or center-weight metering, your camera still averages exposure for the frame but places more emphasis on the exposure of the center 30 percent of the frame. Center-weight metering exposes the centered subject better than multi-point metering, although perhaps not bright enough.

- **Spot metering:** If your camera has spot metering, then only the center spot (10 percent of the frame) is used to determine exposure settings.

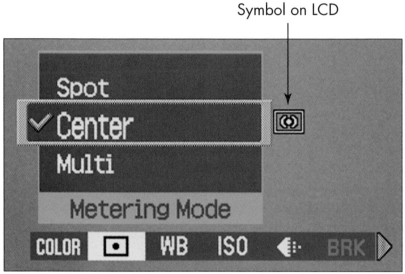

Figure 7-4

⟹ **Focus mode:** Most cameras have four types of focus:

- **Multi-point focus:** With this (most common) kind of focus, the camera focuses on multiple areas within the frame. This ensures that most of the scene is in focus.

- **Center-point focus:** This type of focus allows you to limit the focus to the center of the frame. Areas outside the center may not be in focus, which can be used as an intentional effect.

- **Flexible-point focus:** Flexible-point focus allows you to pick an area for the camera to focus on. It may be easier and faster to lock the focus on an object in the center of the scene by holding the Shutter Release button halfway down. Then you

can move the camera slightly to reframe the scene without having to use flexible-point focus.

- **Manual focus:** Manual focus leaves the focus entirely in your hands. Choose manual focus and then set a distance in feet or meters to the subject you are focusing on.

 Watch for brackets on the LCD to indicate the areas of focus. When the camera is in focus, those brackets may turn green.

➡ **Color modes:** Use the following color modes to alter the way the camera records color:

- **Normal mode:** Color is not altered.

- **Vivid color (V) mode:** This mode intensifies color, making the colors brighter and — surprise — more vivid.

- **Sepia color (S) mode:** This mode alters color to a range of soft browns, like an antique photo.

- **Black and white (B&W):** This color mode converts all color to black or white.

 Remember which color mode you're using, in case you need to switch. Look for letters on the LCD indicating which color mode you are using (other than Normal). Generally, keep the camera in Normal or Vivid except for occasional shots. **Figure 7-5** shows a Color mode menu item with Vivid selected.

➡ **White Balance:** Use the **White Balance (WB) function** to adjust shots taken in a room with incandescent (yellowish) or fluorescent (bluish) lights or with a flash (intense white). White balance adjusts color recording so that those off-white colors are closer to true white.

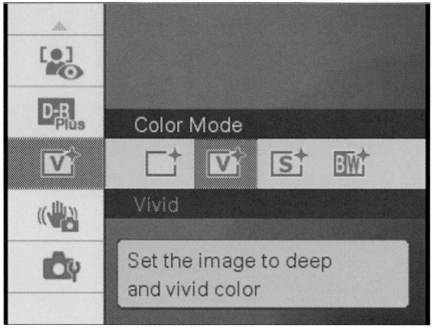

Figure 7-5

⟶ **Exposure compensation:** Use this function to change the camera's settings slightly for more or less exposure than the camera chooses. In either Priority mode, you adjust aperture or shutter speed in standard increments. Exposure compensation allows you to fine-tune adjustments in smaller steps. For example, for a photo of a crow in the clouds, the camera might automatically try to darken the too-bright clouds, making the crow even darker. Adjusting the EV (exposure value) up increases the exposure. The crow will be less dark, and some details in the bird will be less obscure.

⟶ **ISO mode:** Use this mode to increase or decrease your camera's light sensitivity. For example, when shooting in very low light without using a flash, increase this setting. A higher ISO setting allows you

to use aperture or shutter speed settings that would otherwise be underexposed if using a lower ISO. For example, at twilight, the camera might choose a wide aperture or slow shutter speed for adequate exposure, but either of those may blur part of the photo. Increase the ISO to increase the sensitivity of the camera to low light. Then you can still get a good exposure with a faster shutter speed or narrower aperture that would be underexposed at a lower ISO. Unfortunately, using a higher ISO setting tends to make photos look grainy (an effect that's called noise).

⟶ **Bracketing:** With bracketing turned on, your camera takes multiple exposures each time you click the **Shutter Release button** once. The additional shots use slightly different exposure settings. Bracketing increases the odds that you'll get a decent photo under difficult circumstances, especially if one of your manual settings isn't quite right. If your manual choices are way off, though, bracketing can't help because it uses very small adjustments. Bracketing differs from Burst mode, which also takes multiple shots at once but uses the same settings and only lasts for as long as you hold down the Shutter Release button.

 The settings you use when you take a photo are recorded with the photo. You can review this information later to better understand the effect these settings have on your photos. Examine these photo properties in Chapter 9.

Shoot in Black and White

1. Look for **Color Mode** or **Special Effects** in your camera menu. Select the **Black and White** option.

2. Compose your photo. Pay particular attention to areas in the scene that are very light or very dark. These areas will be white and black.

3. Take your photo and review it on the LCD. **Figure 7-6** shows a scene in color and then in black and white.

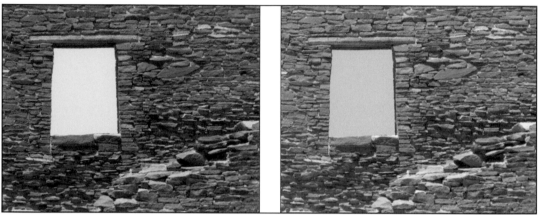

Figure 7-6

 You can convert a color photo to black and white using a photo-editing program. See Chapter 11.

Avoid Problems with Light Indoors

1. Notice the type of light in the room when you shoot indoors. Use your camera's **menu** to change the **White Balance setting** to Incandescent (for traditional light bulbs) or Fluorescent, including compact fluorescent bulbs. **Figure 7-7** shows a too-yellow scene on the left, with the white balance corrected on the right.

Figure 7-7

2. Set the flash to **Auto**. If the subject is in front of the light source, set the flash to On.

3. Take several photos as you change your position relative to the subject. Review your photos.

Part III
Editing Photos in the Digital Darkroom

The 5th Wave By Rich Tennant

Principal

"I found these two in the multimedia lab morphing faculty members into farm animals."

Moving Photos from Your Camera to Your Computer

Although you don't have to use a computer to enjoy digital photography, a computer makes many things possible. Instead of laboring over your camera's controls to delete some photos from its memory card or buying a new memory card each time you fill your camera's old one, you can move your photos from your camera to your computer and free up the space those photos take on the memory card to use for your next photos.

Photo organizing software enables you to move photos from your camera to a computer. Further — as the name implies — such software helps you organize your photos, so that you can find specific photos when you want to. (See Chapter 9 for more information on using software to organize your photos.)

With photo organizing software, you can easily arrange your photos into folders or by name, date taken, location taken, and so forth. With the right photo organizing software, you can also add titles, comments, and even ratings to your photos.

Get ready to . . .

In this chapter, you select a photo organizing program and install it on your computer. Then you use that program to copy your photos from the camera to the computer, so you can enjoy them more.

Choose a Photo Organizer Program

Photo organizing software helps you manage your photos. With an organizer, you can find, copy, move, rename, and delete photos. Most organizers also include some photo editing tools, so that you can rotate, crop, and fix photo problems — check out Chapters 9 and 10 for more on organizers and photo editing.

The following organizers are free or included with certain cameras or computers:

➡ **Your camera's software:** Some cameras include a disc with software for viewing, organizing, and editing your photos. If a disc came with your camera, you may want to install the included software. If you decide to use a different program, you do not need to install the disc that came with your camera or you can uninstall the included software if you switch to another program.

➡ **Windows Live Photo Gallery:** This software is available for free as a download from Microsoft for Windows XP and Windows Vista users. I show you how to install and use Photo Gallery in this chapter. If you have Windows Vista, you may already have Windows Photo Gallery, which is the predecessor to Live Photo Gallery. Live Photo Gallery has a few improvements over the older program, including more editing options. See **Figure 8-1**.

 If you already have Windows Photo Gallery (the one without Live it its name), you can follow many of the steps in this book. If you run into something you can't do, then you can download and install the Live version.

View, sort, and find photos in an organizer.

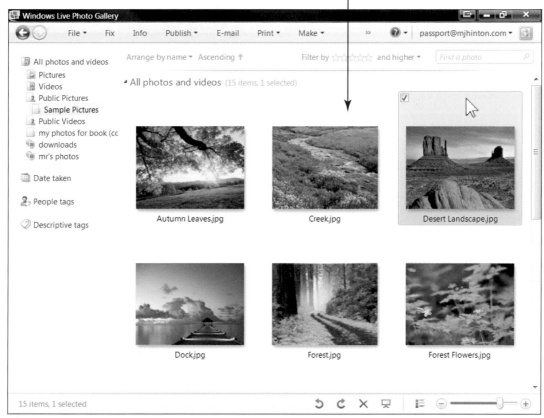

Figure 8-1

⟶ **Picasa:** This program is free from Google. Picasa is very popular and a good choice as a photo organizer. I think Picasa is slightly harder to use than Photo Gallery because of the way Picasa presents its many options. (As a nerd, I'd say, "Picasa has a busy, non-standard interface.") See **Figure 8-2**. Picasa does have some interesting features beyond Photo Gallery's, including an easy way to add text directly to photos.

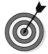 Google released a Mac version of Picasa just as this book went to press, making Picasa the only free photo organizer I know of that works on both Windows and Mac. See www.picasa.com for information and the download.

Picasa has many options for viewing and editing photos.

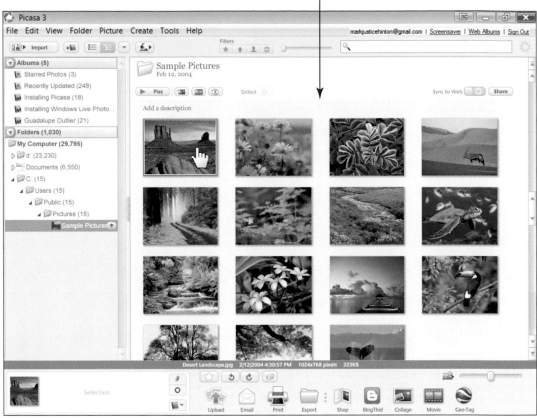

Figure 8-2

◖◗ **iPhoto:** This program is included on Macs as part of
the iLife suite of programs. iPhoto is not available for
Windows users. See **Figure 8-3**.

Of course, there are other choices for photo organizers. A very popular
program is Adobe Photoshop Elements, which costs money, unlike the
programs I've already listed. Elements is a powerful photo editor with
organizer features.

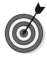 You can use any organizer and photo editor or even
more than one. They all have some functions in com-
mon, including those covered in this book. I chose
Photo Gallery for this book because I use it every day.

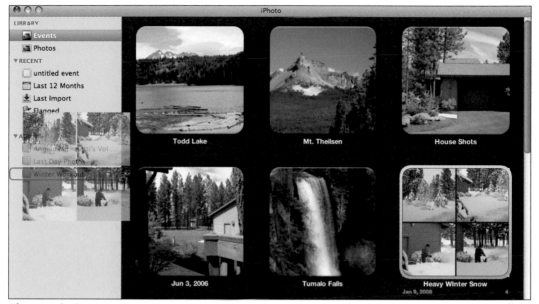

Figure 8-3

Install Windows Live Photo Gallery

1. In your Web browser (Internet Explorer or another), type **download.live.com/photogallery** (without www in front). Press the **Enter** key to browse to that address. **Figure 8-4** shows the Web page you will see.

2. On the Photo Gallery Web site, click the **Download** button. In the File Download - Security Warning dialog box (as shown in **Figure 8-5**), click the **Save** button. (Do not click the Run button here!)

3. In the Save As dialog box, select a place to save the file — any location will work. Click the **Save** button. The next dialog appears to show the time remaining in the download process, as shown in **Figure 8-6**.

4. When the download is complete, click the **Run** button as shown in **Figure 8-7**.

Download Photo Gallery for free.

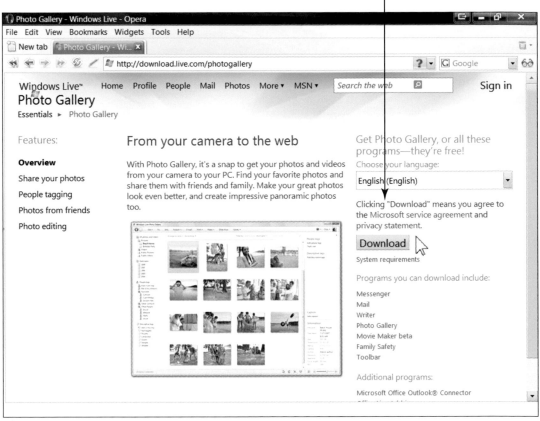

Figure 8-4

Click the Save button.

Figure 8-5

Estimated time left for download

Figure 8-6

Click the Run button.

Figure 8-7

5. If you are using Windows Vista, you see the User Account Control shown in **Figure 8-8**. Click the **Continue** button. Almost there!

6. A screen appears indicating Windows Live is loading.

7. On the next screen, choose the programs you want to install. Uncheck everything except Photo Gallery. See **Figure 8-9**. Then, click the **Install** button. (If you want, you can install the other Live programs later by rerunning the program you downloaded earlier.)

Vista users should click the Continue button.

Figure 8-8

Uncheck all except for Photo Gallery.

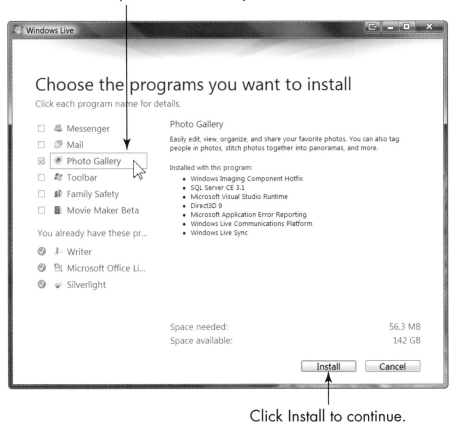

Click Install to continue.

Figure 8-9

8. As the install process runs, a few information screens appear.

9. Eventually, you see the screen shown in **Figure 8-10**. I recommend you uncheck the options that would change your search provider and your browser home page. You may want to check the option to help improve Windows Live — no personal data will go to Microsoft. Click the **Continue** button.

10. If you receive a message to restart your computer, make sure you have closed any other programs you are currently running and then come back to this screen and click **Yes**.

Uncheck all except for Help Improve Windows Live.

Click Continue.

Figure 8-10

11. After you restart, you see one last screen from the installation program (finally!). As you can see in **Figure 8-11**, this screen provides a link to sign up for a Windows Live ID. You do not need an ID unless you are going to use Photo Gallery to publish photos to the Live Web site. You can get an ID later, if you want. Click the **Close** button.

Skip Windows Live Sign Up until later.

Click Close.

Figure 8-11

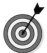 If you would rather use Picasa, see the steps for installing it on the book's Web site: www.mjhinton. com/dpfs/.

Explore Windows Live Photo Gallery

1. If Photo Gallery isn't running, click the Start button in the taskbar. In Windows Vista, type **live photo** in the Start search box at the bottom of the Start menu and the program name will appear in the menu, in which case, you can click on the program name. In Windows XP or Vista, you can use **Start** ⇨ **All Programs** ⇨ **Windows Live** ⇨ **Windows Live Photo Gallery**.

2. If you have not run Photo Gallery before, you may see a dialog box regarding how to handle different picture file types (JPG, TIF, PNG, and others). Use this dialog box to determine which file types Photo Gallery can open. Check the option that says **"Don't show me this again for these file types."** Click the **Yes** button.

3. **Figure 8-12** shows the Photo Gallery screen. In the largest area of the screen, you see small versions of your photos. These small photos are called thumbnails. You may see different pictures in the main display area than appear in **Figure 8-12**. Photo Gallery displays photos from all over your computer regardless of what folder the photos are stored in. This makes it very easy to see all your photos at once. Explore the areas around the photo thumbnails, moving clockwise from the far left.

4. Click on the word **Videos** in the column on the left side of the screen (the Navigation bar) to display only the videos or movies Photo Gallery has found on your computer. Then click on **Pictures** or **Public Pictures** to see just the photos found. Click on **All photos and videos** to see everything. Even if you haven't copied your own photos to the computer, you will see sample photos and videos.

In the Navigation pane, click a location, date taken, or tag.

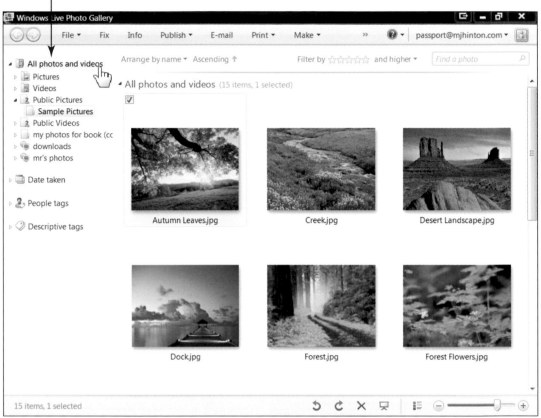

Figure 8-12

5. Click on any year under the heading **Date taken** in the Navigation bar to see just the photos taken in that year. Months appear below the year. You can click on any month to see just the photos taken in that particular month.

6. Across the top of the screen, you see menu items: File, Fix, Info, Publish, E-mail, Print, Make, Slide show, and Extras. Some of these items may only appear if you click on the >> symbol. Click on the little triangle next to an item to display a drop-down menu. Items without the triangle perform a specific function.

Click the **Info** menu item to open the Info pane on the far right side of the screen, as shown in **Figure** 8-13. What you see in the Info pane depends on whether or not any photos are selected in the main area of the screen. Click on one photo to see the Info pane display information about that one photo.

7. Click the check box in the upper-left corner of the photo to select that photo. Click the check box for another photo to select it at the same time. The Info pane displays info that applies to all the photos you select.

Click for info.

Info pane

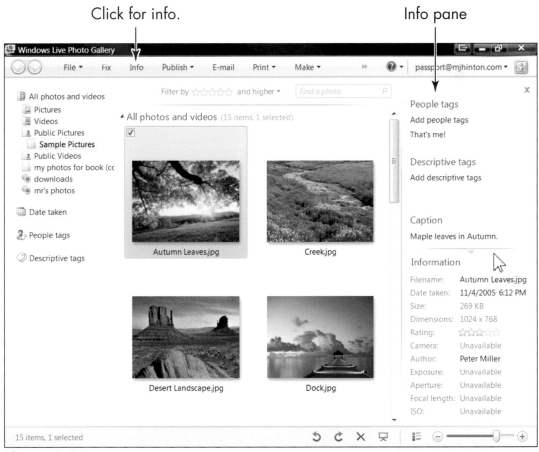

Figure 8-13

8. In the lower-right corner of the screen, to the right of the red X button (that's Delete — be careful) is the View button that switches between Details view (the button looks like an outline) and Thumbnail view (the button looks like a checkerboard). Click the **View** button a couple of times to see the change in the display of the photos.

Figure 8-14 shows Details view. Details view displays a small thumbnail plus the filename, date and time taken, file size, image size in pixels, and a star rating, if any.

Details view

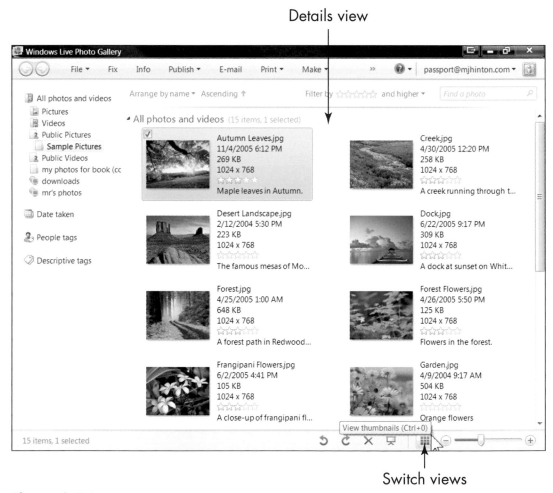

Switch views

Figure 8-14

Figure 8-15 shows Thumbnail view. Thumbnail view shows a larger thumbnail than Details and less information about the photos.

9. To the right of the View button that switches between Details and Thumbnail views is a slider. Click and drag the object between the blue and white areas of the slider to increase (zoom in) or decrease (zoom out) the size of your photo thumbnails or details. Instead of clicking and dragging the slider, you can just click in the blue or white areas to adjust the zoom level to show more, smaller thumbnails or fewer, larger thumbnails (or details).

Thumbnail view

Switch views

Figure 8-15

Configure Windows Live Photo Gallery

1. Before you copy photos from your camera into Photo Gallery, you should examine the settings the program uses. If Photo Gallery is not running, click the **Start** button in the taskbar. In Windows Vista, type **live gallery** and the program name appears in the menu, where you can click on the program name. In Windows XP or Vista, you can use **Start** ⇨ **All Programs** ⇨ **Windows Live** ⇨ **Windows Live Photo Gallery**.

2. In Photo Gallery, use **File** ⇨ **Options**. In the dialog box that opens, click the **Import** tab at the top (see **Figure 8-16**). Use these options to control how your computer copies photos from the camera, including where the photos will be placed and how the photos will be named.

3. Click the option to the right of **Settings for** and choose **Cameras** from the list that appears.

4. Use the **Import to** option to specify a main folder on your computer into which to copy your pictures. The default option of Pictures is a good choice for most people, but you can use the **Browse** button to select a different folder.

5. Choose the **Folder name** option if you want Photo Gallery to create a new sub-folder under the main folder each time you copy photos from your camera. Doing so helps you keep photos separated into smaller groups, which may make your photos easier to find, review, and manage. Photo Gallery offers various ways to name the new folders it creates. See **Figure 8-17**. Most of these methods prompt you for some text that will become part of the folder name. Several options will also use the date on which you actually copy the files as part of the folder name. Other options use the date the photos were taken, instead.

Import tab

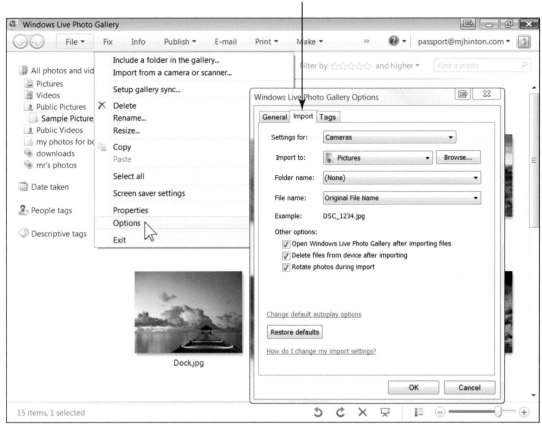

Figure 8-16

Here's the breakdown:

- **Date Imported + Name:** With this option, the date you copy (import) files from the camera to the computer will be the first part of the folder name and the second part will be any text you enter when you copy your photos. For example, if you copy photos on **9-14-2009** and enter **birthday** when you are prompted, all the photos will be in a folder named **2009-09-14 birthday**.

- **Date Taken + Name:** This option creates folders using the date the photos were taken plus text you enter when you copy the photos. If photos taken on more than one day are on the camera, separate folders will be created

for each day. For example, if you take photos on
5-18-2009 and **5-19-2009** and copy those photos on
5-20, entering **birthday** at the prompt, you'll have two
new folders named **2009-05-18 birthday** and
2009-05-19 birthday (and 5-20 is irrelevant).

- **Date Taken Range + Name:** This option also uses the
 date taken and text you enter. However, photos from
 multiple days, such as your vacation, are copied to one
 new folder with the date range in the name. For exam-
 ple, if you take photos on **5-18-2009** and **5-19-2009** and
 copy those photos on 5-20, entering **Colorado vacation**
 at the prompt, you'll have one new folder named
 2009-05-18 - 2009-05-19 Colorado vacation.

Choose a location for photos.

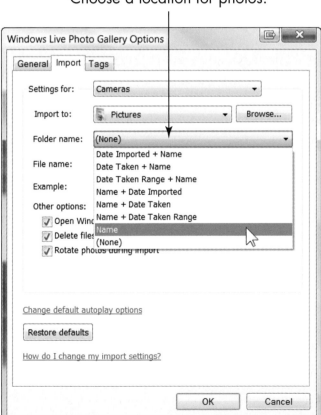

Figure 8-17

- **Name + Date Imported:** This option puts the text you enter first, followed by the date you copy the files to the computer, such as **birthday 2009-05-20**.

- **Name + Date Taken:** This option puts the text you enter first, followed by the date the photos were taken. Multiple days create multiple folders, each with the same text in front, such as **Colorado vacation 2009-05-18** and **Colorado vacation 2009-05-19**.

- **Name + Date Taken Range:** This option puts the text you enter first, followed by the range of dates the photos were taken. Multiple days are all placed in one folder, such as **Colorado vacation 2009-05-18 - 2009-05-19**.

- **Name:** This option just uses the text you enter and ignores the date you copy the photos or the dates the photos were taken. However, you can enter date information manually as part of the text, such as **Colorado vacation**. This is the option I recommend to most people unless you feel strongly about including dates in the name. (Photo Gallery makes it very easy to find photos by date without including the date in folder or file names.)

- **None:** This option copies your photos into the main folder and not into a sub-folder. If you take a lot of pictures, this option does not help you organize your photos. If you don't do anything, you'll end up with one huge folder stuffed with photos you've taken over the years — the digital equivalent of the old shoe box full of prints and negatives. I use this option, but I spend a lot of time rearranging photos, manually creating sub-folders.

6. Regardless of the options you choose for folder names, you can also specify how Photo Gallery should name each individual photo as it copies it from the camera into folders on your computer. Click to the right of File Name to see the following options shown in **Figure 8-18**.

Choose an option for naming each photo.

Windows Live Photo Gallery Options

| General | Import | Tags |

Settings for: Cameras

Import to: Pictures Browse...

Folder name: (None)

File name: Original File Name

Example:
Name
Original File Name
Original File Name (Preserve Folders)
Other options: Name + Date Taken
☑ Open Wind Date Taken + Name
☑ Delete files from device after importing
☑ Rotate photos during import

Change default autoplay options

Restore defaults

How do I change my import settings?

OK Cancel

Figure 8-18

- **Name:** The Name option uses the same text you entered for the folder name, if any. Each photo also has a unique number starting with 001. For example, **birthday 001**, **birthday 002**, and so forth. I recommend this option for most people.

- **Original File Name:** This option uses the name your camera gives to each photo, which is usually letters and numbers, often the sequence number for the photo (for example, **DSC00047** or **PB000047**). I use this option because I'm more interested in other information about the photos. See Chapter 9 for information on tagging photos.

- **Original File Name (Preserve Folders):** This option also uses the in-camera file name and copies folders you have created on the camera's memory card. I don't recommend this for most people because of the extra work to create folders on the memory card.

- **Name + Date Taken:** This option uses the text you enter and the date the photo was taken plus a serial number. For example, **birthday 2008-09-14 001**.

- **Date Taken + Name:** This option uses the date the photo was taken followed by the text you enter and a serial number, such as **2008-09-14 birthday 001**.

7. You're almost ready to copy photos. You never have to go through these options again unless you change your mind about naming photos as they are imported. However, you should consider the Other options on the Import tab (see **Figure 8-16**):

- **Open Windows Live Photo Gallery after importing files:** Check this box to start Photo Gallery automatically after you import photos.

- **Delete files from device after importing:** Check this option to have Photo Gallery delete photos from the camera memory card after Photo Gallery successfully copies those photos to your computer. This is a sensible option to keep from filling up your camera's memory card and to spare you from having to manually delete those photos on the card.

- **Rotate photos during import:** If you turn your camera 90 degrees vertically when you take photos, you'll want to rotate those photos to stand up correctly. Check this option to let Photo Gallery try to rotate only those photos that need rotation. This option depends on information the camera provides, so often it doesn't work. You can manually rotate photos anytime. See Chapter 9.

- **Change default autoplay options:** This link opens a dialog box to choose what happens when you connect your camera to your computer, if Photo Gallery doesn't automatically copy your photos as described in the task "Copy Photos Directly from Your Camera to Your Computer." You can click this link and locate the Pictures option to choose **Import pictures and videos using Windows Live Photo Gallery.**

- **Restore defaults:** This button puts all options back the way they were when you installed the program. You shouldn't need this unless you want to start over.

- **How do I change my import settings?** This link will open a Web page from `help.live.com` with more information about this topic and Photo Gallery, in general.

8. After you have made your changes to the Import options, click the OK button. You're ready to use Photo Gallery to copy your photos from your camera (the next task).

 You can also use the **Settings for** option at the top of the Import tab of the Options dialog box to choose settings for video cameras, music album downloads, and CDs and DVDs. The CDs and DVDs option is useful if you receive discs from friends or from a photo processing service. For example, if you still shoot film, some film developers provide discs with digital versions of your photos.

Copy Photos Directly from Your Camera to Your Computer

1. If you have a cable that connects your camera to your computer, plug one end of the cable into the computer with the computer on. See **Figure 8-19** for the typical USB

connection. Your computer will have USB connections in the back (thin rectangular sockets), but you may also find connections on the front of the computer tower or on your monitor or keyboard.

Computer end of cable

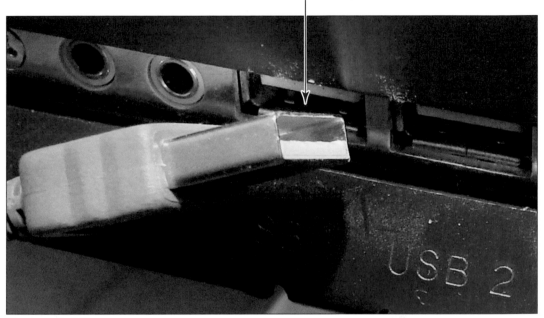

Figure 8-19

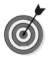 If you have to use the USB sockets in the back, buy a USB extension cable or a small box called a hub, which provides additional USB connections. Plug the extension cable or hub into the back of your computer. Then you can more easily plug devices into the extension or hub, which you place for easy access.

2. With the camera off, plug the other end of the cable into the camera as shown in **Figure 8-20**. Look for the socket on the side or bottom of the camera. The socket might be covered with a small plastic or metal piece that slides or pops open.

Camera end of cable

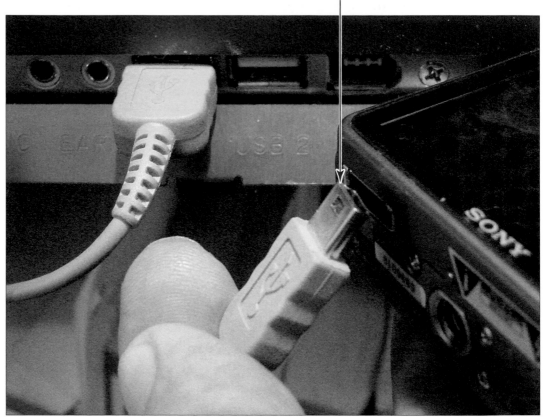

Figure 8-20

3. Once the cable is connected to the computer and the camera, make sure your computer and camera are turned on. The computer detects the camera automatically. The first time you do this, you may see the AutoPlay dialog box in **Figure 8-21**. To follow along with the book exactly, choose **Import pictures and videos using Windows Live Photo Gallery**. In the AutoPlay dialog box, don't choose **Import pictures using Windows** because that would use a different program. If you choose another organizer, such as Picasa, you have to adapt the steps in the book. If you do not want to use any organizer, choose **Open folder to view files using Windows Explorer** (this is not shown in Figure 8-21— scroll to bottom of the dialog box) to copy photos from the camera to your computer.

4. If you choose Photo Gallery in AutoPlay, the Import Photos and Videos dialog box appears, as in **Figure 8-22**. Choose **Import all new items now**. In the box, type the text you want to use in naming folders and photos. (You can use the **More options** link to confirm or change the Import settings discussed in the task "Configure Windows Live Photo Gallery.") Ignore the other options on this screen for now.

5. Click the **Import** button to begin copying your photos. You'll briefly see each photo as it is copied. See **Figure 8-23**. The **Erase after importing** option should be checked to remove the photos from your camera's memory card after they have been copied successfully to your computer. (Otherwise, you have to delete those photos on your own.) You see the erasing process after the importing completes.

Click this box...

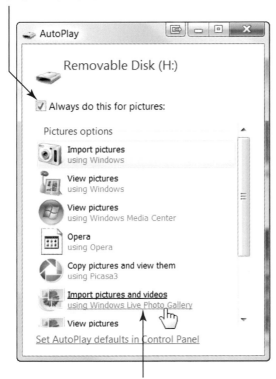

...then click on Photo Gallery.

Figure 8-21

Type text for folder and filenames.

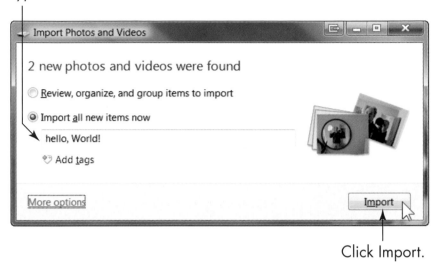

Click Import.

Figure 8-22

Check Erase After Importing.

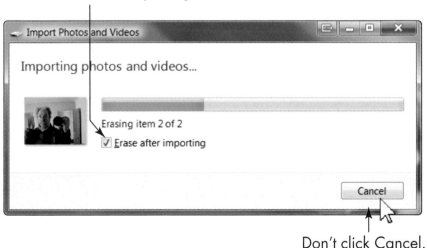

Don't click Cancel.

Figure 8-23

6. After the copying is done, Photo Gallery will start up. Your newly copied photos should appear on your screen. If you do not see your photos, click **Pictures** on the left side of the screen.

Copy Photos from a Memory Card to Your Computer

1. Instead of connecting your camera to the computer, you can use a memory card reader to copy photos from your camera to the computer. A memory card reader is a small device into which you directly insert memory cards. (There is no advantage in using a reader if you also have a cable for your camera.)

2. Locate your memory card reader. It may be a small slot built into the front or edge of the computer, as is often the case with laptops. If the memory card reader is a separate device, plug it into a USB port. If you haven't used the memory card reader before, Windows may install a device driver the first time you use it.

3. With your camera off, remove the memory card. Open the cover in the bottom or side of the camera. Some cards are held in place by a small latch you move out of the way. If the card doesn't pop out, gently push in against the card. Let go and the card should pop out partway. Do not pull or pry the card out if it does not pop out when you push and release. Gently pull the card out the rest of the way, noting how it was inserted, so you can put it back later.

4. Gently push the memory card into the appropriate slot in the memory card reader. Some readers have multiple slots, so you may have to guess which slot to use and the correct way to insert it. Keep your thumb on the card's label with metal contacts away from your hand. Push the card into a likely slot until it clicks and stays in place when you let go of it. If it doesn't go after applying slight pressure, take the card out, rotate it, and put it back in.

5. If the computer detects the card, Windows should run the AutoPlay function automatically. You may be able to choose **Import pictures and videos using Windows Live Photo Gallery**. If you do not want to use any organizer,

choose **Open folder to view files using Windows Explorer**. Either Photo Gallery or Explorer may open automatically without giving you a choice.

If you are using Photo Gallery with your memory card reader, see Step 4 under the task "Copy Photos Directly from Your Camera to Your Computer."

6. If you are using Windows Explorer, it opens showing the contents of your camera's memory card, as in **Figure** 8-24. You can copy any folders, but you may want to open folders until you see photos (start with a folder named DCIM), then copy the photos. Select everything you want to copy by pressing the key combination **Ctrl+A** (select all). Press **Ctrl+X** (cut). You can use **Ctrl+C** (copy) instead, but then you'll have to delete the photos from the camera later. **Ctrl+X** will move the photos, instead of copying them. Open your Pictures folder by clicking on it on the left side of Explorer or by using **Start** ⇨ **Pictures**. (If you want a new folder for these photos, use **Organize** ⇨ **New Folder**. Type a name for the folder and press **Enter**. Press **Enter** a second time to open the new folder.) Press **Ctrl+V** (paste) to put the copies in the folder. The photos you copy will have the filenames the camera gives them.

Open your camera like any other disk in Windows Explorer.

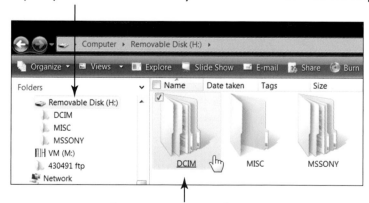

Photos are in this folder.

Figure 8-24

Organizing Your Photos

As you amass more photos, photo organizing software helps you find and enjoy them. Photo organizing software presents your photos as one huge album, if you want to see all your photos at once. You can look at a screen full of small photos called *thumbnails* or view any single photo larger.

With a click of the mouse, you can see just the photos taken on a particular day or those photos you took at a particular event, such as a vacation or birthday. View any group of photos as a slideshow with the click of a button.

With the right software, you can add titles, comments, and even ratings to your photos. Such information may be useful if you need to search for a particular photo, especially when you can't remember when you took the photo.

Further, you can use photo organizing software to display photos by tags. *Tags* allow you to easily categorize your photos, such as vacation, birthday, or the names of people and pets in the photos. These tags act as individual photo albums, showing you just what you want to see at the click of a mouse button.

In this chapter, you use Windows Live Photo Gallery to view and organize your photos.

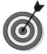 See Chapter 8 for information on choosing photo organizing software, as well as installing Windows Live Photo Gallery and moving photos from your camera to your computer.

View Your Photos Onscreen

1. Start Photo Gallery. Use **Start⇨All Programs⇨Windows Live⇨Windows Live Photo Gallery**. See **Figure 9-1**.

Click >> for more menu items.

Navigation pane

Info pane

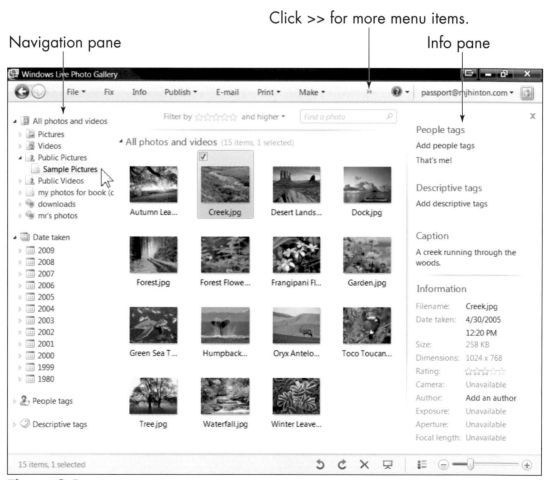

Figure 9-1

2. Your most recent photos may appear automatically. If you haven't copied your own photos to the computer, you'll see some sample photos. To view different photos, use the Navigation pane on the left to select Pictures. Then choose a folder under Pictures. You can instead choose the year the photos were taken under Date taken. You can then select the Month, if you want to see photos from one particular month instead of the full year.

3. To view more photos onscreen, hide the Info pane by clicking the **Info** menu item at the top of the screen. (That displays or hides the **Info** pane, depending on whether it was already showing.) Click Info as many times as necessary to hide it. Alternatively, if you see the Info pane on the right, you can also click the small **X** at the top of the Info pane to close it (not the larger X above it in the upper-right corner — that closes the whole program).

4. To view one photo, double-click that photo. The photo appears larger and the Navigation pane disappears, as in **Figure** 9-2. You may also see the Info pane or the Fix pane to the right of the photo.

5. To zoom in to enlarge the photo, click in the white area of the slider at the bottom right corner of the screen. You can also click and drag the slider control right or left to change the enlargement.

6. To see the whole photo again, click the control just to the left of the slider (not the red X). This button alternates between reducing the photo to fit to the window area and the picture's actual size, which may be much larger. If you are viewing actual size or have used the slider to zoom in, you can use the mouse to click and drag in the photo to move it around (*pan*).

Zoom in and out.

Figure 9-2

7. To see the next photo, click the button at the bottom of the screen that looks like a triangle with a line to its right. To see the previous photo, click the button that looks like a triangle with a line to its left. You can browse through all your photos one at a time with these controls. You can also use the left (previous) or right (next) arrow key on your computer keyboard.

8. To see all your photos, click Back to Gallery in the upper-left corner of the screen.

 Regardless of the photo organizer you use, you can also view photos using Windows Explorer (or Finder, on the Mac). Use **Start⇨Pictures** to open your photos folder. Use the View menu to select Extra Large Icons. There are many other ways to view, sort, and search your photos through Windows Explorer. Click or double-click a photo to open it in your default photo viewer. If you need more information on working with Windows Explorer, check out my book *PC Magazine Windows Vista Solutions*, published by Wiley, or *Windows Vista For Dummies*, by Andy Rathbone, also published by Wiley.

Rotate a Photo

1. If you took a photo while holding your camera vertically instead of horizontally, that photo appears onscreen sideways, so you'll need to rotate it. **Figure 9-3** shows a photo before and after rotating.

From the camera

Rotated right

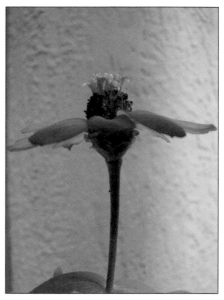

Figure 9-3

2. Select a photo you want to rotate in Photo Gallery. (This works with thumbnails, details, or single photo view, as in Figure 9-3.) At the bottom of the screen, click one of the two curving arrows. The first arrow points left and rotates the photo 90 degrees to the left, or counterclockwise, each time you click it. The second arrow points right and rotates the photo 90 degrees to the right, or clockwise, each time you click it. To rotate the flower on the left of Figure 9-3, I clicked the second arrow once to rotate the photo 90 degrees to the right (clockwise). If you click the wrong button or the correct one too many times, just keep clicking until the picture is upright.

 To rotate more than one photo at a time, first select each photo by clicking the small check box in the upper left of the photo in Details or Thumbnail view. Uncheck any photos you do not want to rotate. One click of the Rotate button rotates all the selected photos at once.

Delete Photos from Your Computer and Get Them Back

1. Odds are, you'll take some photos you want to get rid of. Photo Gallery makes this easy — maybe too easy. When you click the button to delete a photo (or a hundred photos), Photo Gallery doesn't ask you to confirm the deletion. Take that as a warning. Photo Gallery also can't undo a deletion. If you change your mind about a photo you deleted, you have to use Windows Explorer to get the photo back.

2. Select a photo you're willing to delete. Come on, it's not that hard! If you can't part with any photos, take an intentionally bad photo before you proceed and copy it to your computer as your test case.

3. Before proceeding, be certain that only one photo is selected because *all* selected photos will be deleted. To confirm that you have only one photo selected, click once on the photo you want to delete. When you single-click anywhere on a photo other than the check box in the upper left, you select only that one photo.

4. At the bottom of the screen, click the red X between the Rotate buttons and the slider. See **Figure** 9-4. (This works with thumbnails, details, or single photo view.) Poof: Your photo is gone immediately!

 To delete more than one photo at a time, select each photo by clicking the small check box in the upper left of the photo in Details or Thumbnail view. Uncheck any photos you do not want to delete. One click of the Delete button deletes all the selected photos at once. That's dangerous, but handy.

Click the red X to delete this photo.

Figure 9-4

5. Practice undeleting or restoring a photo using Windows
Explorer, so you know what to do if you delete a photo or
other file by mistake. Open Windows Explorer using
Start⇨Computer or, using the keyboard, press the
Windows logo key (which looks like a little flag) and the
letter E at the same time. On the left under Folders, click
on the Recycle Bin at the bottom of the folders. If you have
trouble locating your deleted photo, click once on the but-
ton labeled Date Deleted. See **Figure 9-5**. Click on the
photo you want to restore (or undelete). If the Properties
dialog box opens, click the Restore button. Otherwise,
click the **Restore This Item** button above the photo. Do
not click **Restore All Items** because that restores things
that you probably want to leave in the trash.

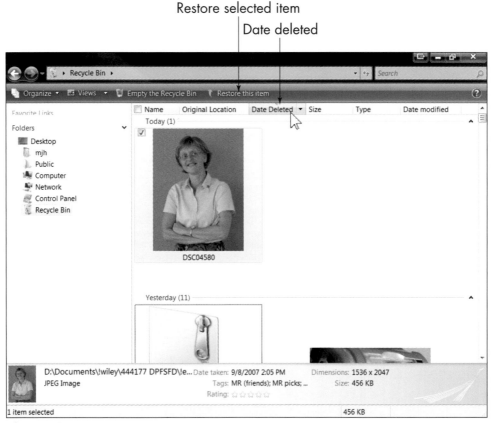

Restore selected item

Date deleted

Figure 9-5

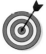 To restore more than one photo — or any other type of file — at once, click the little check box in the upper left of each photo or file that you want to restore or hold down the Ctrl key as you click each file. Then click **Restore the Selected Items**.

Watch a Slideshow

1. To view a slideshow, select the photos you want to see by clicking in the Navigation pane on the left. Click **All Photos and Videos** to see everything. Click **Pictures** to see all your photos and none of your videos. Click on any folder or date taken to limit the slideshow to just those pictures. You can also select individual photos using the little check box in the upper left of each photo.

2. After you have selected which photos to view, press the F12 function key at the top of your computer keyboard or press the Alt key and the letter S at the same time. You can also click the Slideshow button at the top of the screen. (You may have to click the >> in the menu to see this button. Refer to Figure 9-1 if you're having trouble finding the >> button.)

3. After a brief delay in which the screen goes black, the slideshow begins. Just sit back and enjoy the show. To move forward or back through the slides without waiting for the slideshow to change photos automatically, press the left or right arrow key on the keyboard.

4. Move your mouse. You may see the control shown on the left of **Figure 9-6**. If you do not see that control at the bottom of the slideshow, click the right mouse button to reveal the menu that appears on the right side of Figure 9-6. (Your computer's graphics card determines which of these you'll see.)

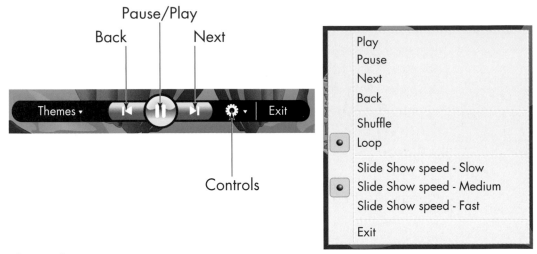

Figure 9-6

- Using the menu, you can pause or play, show the next or previous (back) photo. You can also shuffle photos so that they appear in a random order. Loop causes the slideshow to repeat until you exit the show. You can set the slideshow speed to slow, medium, or fast — variations of a few seconds.

- Using the control, click the big center circle to pause or play, and the arrow on the left for the previous photo or on the right for the next one. Click the Themes button for a list of variations on backgrounds and transitions. (Try Collage or Fade.) Click the little gear to the left of Exit to change the speed to slow, medium, or fast, and to turn shuffle or loop on or off. The gear also has an option to mute sound to silence videos in the slide show.

5. When you are done with your slideshow, press the Esc key on your keyboard. You can also click Exit from the control or from the menu that appears when you right-click your mouse.

See Chapter 16 for information on other kinds of slideshows you can play.

Add Descriptions to Your Photos

Use the Info pane to add or change the following information to one or more selected photos, in Details, Thumbnail, or Single Photo view, as in **Figure 9-7**. If the Info pane does not appear on the right side of your screen, click the Info menu item at the top of the screen to bring it up. Click on one of your photos to select it. The information you can change appears in black.

You can change black text and rating.

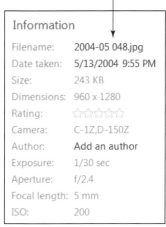

Figure 9-7

➡ **Add Caption:** Click on this text and type in a caption for your photo. You can use upper- and lowercase letters, numbers, and spaces in the title. One reason to title photos is that you can later search for photos based on text in the title.

➡ **Filename:** Click on the current filename if you want to change it. The filename can be used to search for and sort photos. If you have multiple photos selected when you enter a new name, Photo Gallery adds a number to distinguish them, such as **my photo**, **my photo (1)**, **my photo (2)**.

➧ **Date Taken:** You can change the date and time the photo was taken. This is an odd capability. (By the way, if you're up to something nefarious, don't count on fooling legal authorities with this feature.)

➧ **Rating:** Rate your photos with one, two, three, four, or five stars (the best). You can use a star rating to find photos. After you have rated some photos with stars, you can display just photos with that star rating or higher. See the task "Find Photos on Your Computer" later in this chapter.

➧ **Author:** The author is actually the photographer. Enter your name here.

The remaining information in the Info pane appears in gray and cannot be changed here. However, information about the file and the camera settings may be useful to you. Consider this information:

➧ **Size:** How big the photograph is in bytes. Larger files take up more disk space and take longer to send with e-mail. You find out how to change file size in Chapter 10.

➧ **Dimensions:** This is the width and height of the photo in pixels. Dimensions up to 800 wide x 600 high are good for e-mail. Dimensions up to 1024 x 768 are good for Web pages. Larger dimensions are better for printing. You find out how to change these dimensions in Chapter 14, as well.

➧ **Camera:** Your camera records its model number with each photo.

➧ **Exposure:** This is the shutter speed used by the camera for this photo, whether set automatically or manually. You can learn more about the effects of camera settings by observing this information on the photos you take.

➡ **Aperture:** This is the size of the lens opening when the photo was taken. These are fractions, so f/2 (or F2 on your camera's LCD) is wider (more open) than f/16, which admits less light.

➡ **Focal length:** This number identifies the amount of zoom in use at the time the picture was taken. For the camera in this example, 5mm is the wide angle setting and 15mm is the maximum zoom. (This camera has a 3X zoom, because 15mm is 5mm times 3.)

➡ **ISO** (from the French name of the International Organization for Standardization): This number describes the light sensitivity of the image sensor, which records the photo. The greater this number, the more sensitive the sensor is to light, but the lower the quality of the resulting image. Standard ISO is 100, and your camera automatically adjusts ISO as needed.

For more information on how and why to change exposure (shutter speed), aperture, focal length (zoom), and ISO as you take pictures, see Chapter 7.

Add Tags to Your Photos

Tags are categories you assign to your photos, such as the subject or location of the photo. If you took photos of city sights and wildlife while on vacation in Canada, you might tag all the photos as Canada, the city photos as Jasper or Banff, and the wildlife photos as moose or sasquatch. With these tags, you can easily see just the photos of moose or all the photos from Canada, among other variations. In a sense, tags are like separate photo albums or collections of photos, except that one photo can be in more than one collection.

Because any photo can have many tags and any tag can be assigned to many photos, tags provide a very useful way to organize your photos. With tags, you can quickly display a specific set of photos regardless of

where on the disk they are stored. Indeed, photos in different folders can be brought together using tags. In effect, if you use tags, it doesn't matter where your photos are stored.

One way to add tags to photos is to do it as you import them. See Chapter 8 for information on importing photos. In the process, you see a dialog box like the one in **Figure 9-8**.

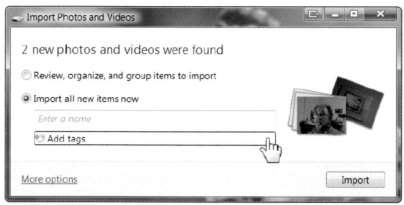

Figure 9-8

Below the box where you enter text that will be added to the folder name and filenames, you see another box for tags. As you enter more than one tag, use semicolons to separate them. If you tag other photos from other occasions with any of the tags you enter here, you can quickly display all similarly tagged photos by clicking on that tag under **Descriptive Tags** in the Navigation pane. Then click **the tag you want** under Tags for photos with that tag.

 If you see a photo under more than one tag, you do not have more than one copy of that photo. A single photo can be under many different tags. Don't delete a photo just because it doesn't belong under a tag: You'll be deleting the only copy you have. Instead, just remove that tag from that photo. (I tell you how to do that coming up.)

After your photos have been imported into Photo Gallery, you can tag them anytime. There are several different methods for tagging in Photo Gallery:

⇒ You can drag and drop photos onto the tag you want to give to the photo. Select multiple photos using the small check box in the upper-left corner of each photo. Then click and hold down the left mouse button as you drag the photos to the left. Hover the mouse pointer over the tag you want to give to the photo(s). You'll see a pop-up message that says Apply (the tag you hover over). Release the left mouse button to finish the process.

⇒ Instead of drag and drop, select one or more photos and display the Info pane by clicking **Info** at the top of the screen. Click **Add Descriptive Tags** in the Info pane and type a tag. As you type, Photo Gallery displays tags that match what you are typing, if any do. You can type in brand-new tags this way or select an existing tag from the list that pops up.

You can remove a tag from one or more selected photos. In the Info pane on the right, hover over the tag you want to remove. A small X appears to the far right of that tag. Click the **X** to remove that tag from the selected photo(s). This does not delete the tag, which may still be applied to other photos.

 Under **Descriptive Tags** in the Navigation pane on the left, you can click the right mouse button over a tag to rename or delete it. If you rename a tag, say, from **friend** to **friends**, that tag changes in every photo it was assigned to. If you delete a tag, you remove it from every photo that was assigned that tag, but you don't delete those photos or other tags. You cannot undo deleting a tag from the Navigation pane.

You can even put tags under other tags. Under **Descriptive Tags**, click **Create a New Tag** and type **Southwest**. Then click **Create a New Tag** again and type **New Mexico**. Click and hold the left mouse button as you drag the New Mexico tag over the Southwest tag and release the button to drop one tag on the other. Now New Mexico is under Southwest. Repeat the process for Arizona. See **Figure 9-9**. Tag one or more photos with New Mexico and one or more different photos with Arizona. You can quickly see all your New Mexico photos by clicking on that tag. To see all your photos from New Mexico and Arizona at once, click on Southwest. Again, the photos themselves may be from different times and stored in different folders on the computer. Tags bring them together.

Create categories of tags within other tags.

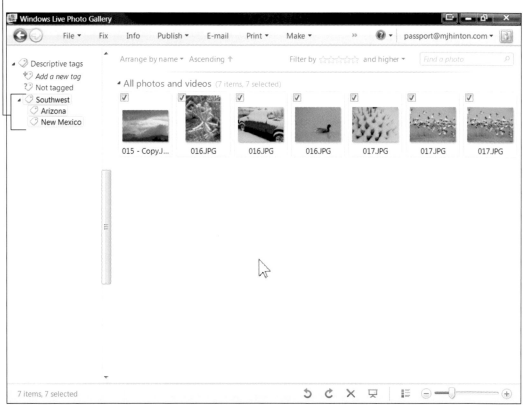

Figure 9-9

Finally, Photo Gallery has a separate category of tags called People tags. With a photo of people selected, you may see a link that says **1 Person Found** or **2 People Found** (or more). Click that link to view the photo. Photo Gallery draws a box around each face in the photo. (Sometimes, Photo Gallery does not recognize faces that are at an odd angle or are shadowed by hats or sunglasses. You can draw a box yourself around any faces that Photo Gallery misses.) Click the box or the **Identify** link on the right and select a name or type in a new name. **Figure 9-10** shows the single photo view with the face box selected. If the selected face is your own, click **That's me!**

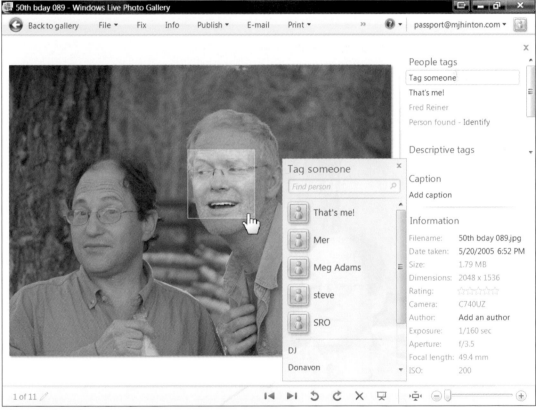

Figure 9-10

Using People tags is similar to using the other descriptive tags. You can click on a person's name to see all photos containing that person, no matter when or where the photo was taken or where the photo is stored, as in **Figure 9-11**. As with the other tags, you have to add people tags manually. However, face recognition is advancing, and it's likely that a future update to Photo Gallery will use the people tags you've already applied to guess who the unidentified people in your other photos are.

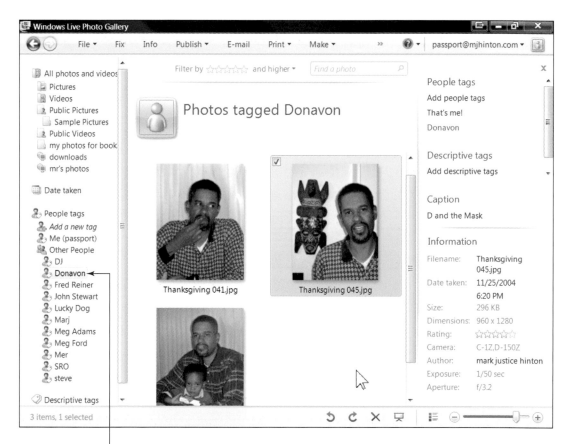

Display people you have tagged.

Figure 9-11

Find Photos on Your Computer

There are several ways to find a specific photo or group of photos. Of course, it helps if you are organized from the beginning, but, eventually, everyone has to search. Try these options:

➠ **Use the Search Box:** The search box appears in the upper-right corner of Photo Gallery. Type some text associated with the photo you are looking for, such as part of the filename or any of the descriptive information you entered, such as title or comment. (See the task "Add Descriptions to Your Photos" earlier in this chapter.)

➠ **Use Tags:** In the Navigation bar, under Descriptive tags or People tags, click on the tag you may have used with the photos you are searching for. This option is most effective if you get in the habit of tagging as you import and as you browse your photos. (Click **Not Tagged** to see those photos without any tags. Add tags to a few of these photos at a time.)

➠ **Use Date Taken:** If you have an idea which year you took a photo, click on that year under Date Taken in the Navigation pane. Click on the month you think the picture was taken. Under that month, click on the likely day. This works best for memorable events like birthdays, graduations, wedding, or vacations.

➠ **Look in Folders:** In the Navigation pane, click **Pictures**. Click any folder name that you think may contain the photos you are looking for. The more folders you have, the more of a needle in a haystack this is, especially if you use generic folder names such as Vacation or Birthday when you import your photos.

➡ **Arrange, Filter, Sort and Group:** You may be able to force the photos you are looking for to appear by using other tools in Photo Gallery, as in **Figure 9-12.** Click on the **Arrange By** button near the top of Photo Gallery to sort by name, date, rating, type, tag, or person. To the right of **Arrange By**, click the **Descending** or **Ascending** button to reverse the sort order. Farther to the right, you can filter your photos by a specific number of stars you've assigned to them. Click the box to the right of the stars for "and higher," "and lower," or "only." To clear your star filter, click on the words **Filter By.**

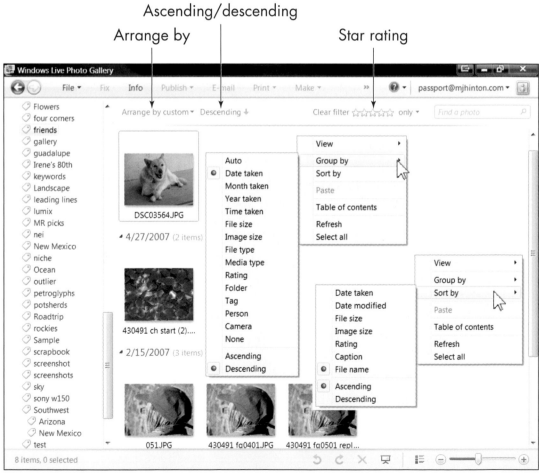

Figure 9-12

You can also click the right mouse button within the photo area for options to sort files in more ways than the arrange by button provides. Finally, you can also group files. For example, I usually group by date taken descending and sort by date taken ascending. As a result, my most recent photos are first, but for any specific day, they are in order taken (morning first, evening last).

 Windows Vista users can search for names and tags from the Start menu's search box or from the search box in the upper-right corner of Windows Explorer.

Move Your Photos

1. As you import photos from your camera, you will probably place those photos in new folders according to the settings you change in Chapter 8. Because Photo Gallery shows photos regardless of their location on the disk, you may never need to move the photo files to new locations. However, if you want to, follow these steps.

2. Locate a photo in Photo Gallery that you want to move. Click the right mouse button with the mouse pointer over that photo. From the context menu that appears, choose **Open File Location**. This opens Windows Explorer, showing the folder containing that file, which will be selected automatically.

3. If you want to move more photos, select them by holding down the Ctrl key as you click on additional photos. Use **Ctrl+X** to cut the selected photos. (Cutting actually moves the photos, as opposed to simply making copies of them.)

4. Use the Folders on the left to navigate to a new location. If you want to create a new folder, use **Organize⇨New Folder**. In the folder you want to move those photos to, press **Ctrl+V** to paste the photos. Voilà, you have moved your

photos. The moved photos still appear in Photo Gallery in the same way as far as date taken and tags are concerned.

Add a Folder to Photo Gallery

If Photo Gallery does not display photos that are on your computer, you don't have to move those photos to get them to show up there. Instead, you can include the folder that contains the missing photos in Photo Gallery in one of two ways:

In Photo Gallery, choose **File⇨Include a Folder in the Gallery**. See **Figure 9-13**. In the dialog box, browse to the folder you wish to include in the Gallery. Select that folder and click **OK**. Photos and videos in that folder will be included in the Photo Gallery. Note that you have not moved the folder, just added it to those folders that the Gallery uses.

Select the folder you want to add and click OK.

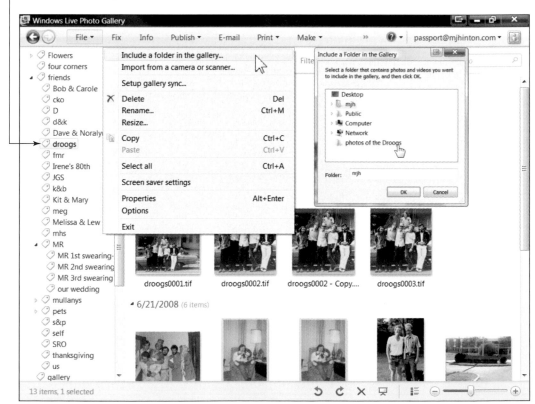

Figure 9-13

In Windows Explorer (Start⇨Computer), browse to the folder you want to include in the Photo Gallery. Locate a photo or video in that folder. Double-click the photo or video to display it in the Photo Gallery. In the upper-left corner of the screen, click **Include Folder in the Gallery**. See **Figure 9-14**.

The Photo Gallery

Figure 9-14

Examine Photo Properties

You've seen and changed information about your photos using the Info pane in Photo Gallery. (If you haven't for some reason, see the task "Add Descriptions to Your Photos" earlier in this chapter.) That information is formally called *metadata*, as well as EXIF (exchangeable image file) data. The metadata is a part of the photo file itself, so that

when you copy photos, send them by e-mail, or upload them to the Web, that information goes with the photo.

Photo metadata can be displayed and changed through Windows Explorer. To see it, see **Start⇨Pictures**. Select one of your photos. In Windows Vista, look at the Details pane at the bottom of Windows Explorer, as shown in **Figure 9-15**. You can see and change information here, including tags, star rating, title, author (photographer), and comments.

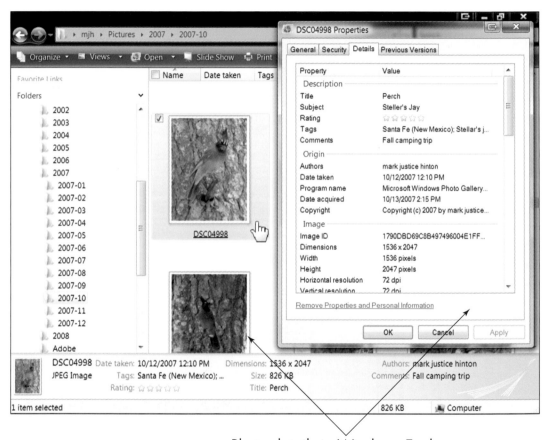

Photo details in Windows Explorer

Figure 9-15

Figure 9-15 also shows the photo properties on the right side. In Windows XP or Vista, click the right mouse button over any photo and choose Properties from the bottom of the context menu that appears. Then click the Details tab to see and to change some of this metadata. More information about the photo, including exposure (shutter speed) and aperture, appears lower in the Properties, if you scroll down.

Touching Up and Fixing Your Photos

Chapter 10

Odds are that some of your photos can benefit from editing. Whether the camera or the photographer slips up, you can fix mistakes and accidents after the fact using photo editing software. In the digital darkroom, you can change a photo from *blah* to *ah*!

Perhaps you have a photo with something distracting from the subject within the frame. Often, it's not until you review a photo later that you see a pole, a passer-by, or a tree limb that ruins the photo. At the time you took the photo, you could have zoomed in on the subject or moved to keep that distraction out of the frame. After the photo is taken, is it too late? No. You can *crop* a photo around the subject, discarding distractions.

Cropping allows you to save a photo in which one person looks great and another person's eyes are closed. Crop the photo to turn it into a portrait of one.

A tightly cropped photo in which the subject completely fills the frame can be very dramatic. Or you might lightly crop the frame to shift the subject a little to one side or the other. (See

Chapter 4 for a discussion of the Rule of Thirds as a guide for placing the subject in the frame. Cropping can make a photo comply with the Rule of Thirds.)

What happens if a great photo is marred by glowing retinas? Fix red-eye with photo editing software.

Before you do anything to your photos, prepare for recovering from mistakes or changing your mind. In this chapter, you find out how to undo and redo changes to your photos.

The steps in this chapter involve using Windows Live Photo Gallery. However, any photo editing software, such as Picasa or Mac iPhoto, enables similar editing.

Choose a View

You work in Photo Gallery in one of two views: Gallery and Preview. The view you are in may determine what you can do. Choose a view:

➡ **Gallery view:** This view is the one you see when you start Photo Gallery. Multiple photos appear in the largest area of the window. Photos display with details (see **Figure 10-1**), such as date taken and size, or as thumbnails of various sizes (see **Figure 10-2**). Hover the mouse over a photo for a larger thumbnail. The Navigation pane appears on the left side of the screen. Use Gallery view to see more than one photo at a time and to select multiple photos by clicking the check box in the upper left corner of each photo.

➡ **Preview:** You open this view, which could also be considered single photo view, by double-clicking a photo. In Preview, you see one photo at a time. There is no Navigation pane on the left. Use the next and

previous arrows at the bottom of the screen to move through the photos you selected in Gallery view (or all photos, if only one or none were selected). See **Figure 10-3**. Return to Gallery view by clicking **Back to Gallery** in the upper left corner of the screen. Use Preview to view or change a single photo at a time.

Navigation pane Details Hover for larger thumbnail

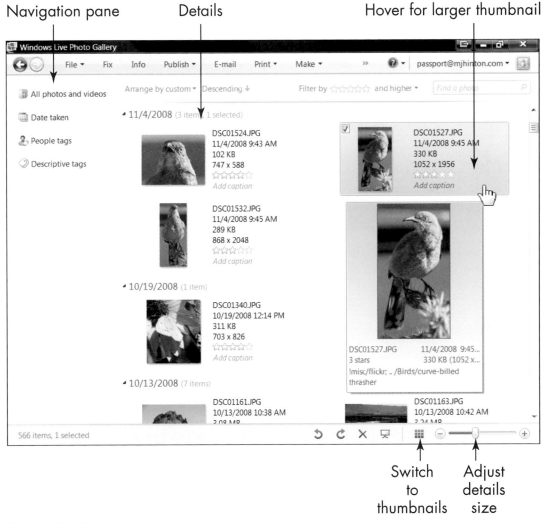

Switch
to
thumbnails

Adjust
details
size

Figure 10-1

Navigation pane Thumbnails Hover for details

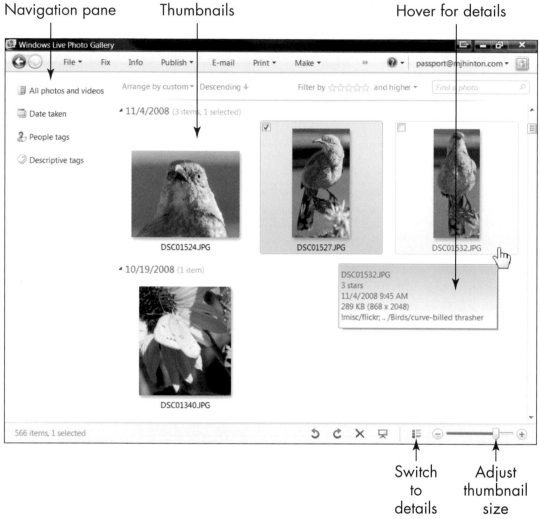

Figure 10-2

A few functions are available in either of these views. For example, you can display or hide the Info pane by clicking the Info menu item at the top of the screen in either view. However, a few functions are available in only one view or the other. You work with some of these functions in this chapter and the next.

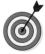 If you can't find a particular function in Photo Gallery, switch to the other view (double-click a photo for Preview or click **Back to Gallery** for Gallery view).

Click to return to Gallery view.

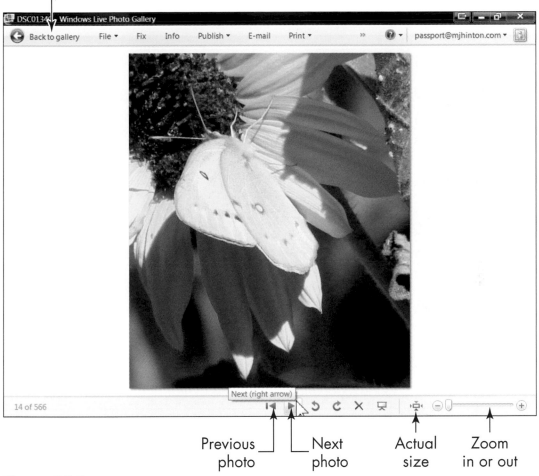

Previous photo | Next photo | Actual size | Zoom in or out

Figure 10-3

Back Up Your Photos

Many people are afraid to explore software because they may create a problem they can't undo. Even the most experienced computer users make mistakes, a fact that may not reassure you. Photo Gallery has several features that help you undo changes, as you will see in this chapter. However, you may want to prepare for problems before you even start Photo Gallery. Create a backup of some or all of your photos so

that you can recover from any mistake or other problems. Consider one of these approaches to backing up photos before you make changes:

➡ **Use a backup program:** Your computer has backup software you can use to back up large numbers of photos at once. In Windows Vista, click the **Start** button and type **backup** for a list of installed programs. Other programs are available for downloading from the Web. A backup program provides many options for selecting folders to backup to an external USB hard drive, flash drive, or DVD. Most backup software can schedule a backup to run regularly and automatically.

➡ **Copy folders directly:** You can copy folders using Windows Explorer (or Finder, on the Mac). Use Start⇨Pictures to see all your photo folders (unless you have copied photos to some other location). Insert a flash drive or connect an external hard drive to a USB port. (Cancel Autoplay, if that dialog box pops up.) Click the right mouse button over a folder containing photos and choose **Send To** on the context menu that pops up. See **Figure 10-4**. Your flash drive appears in a list with other locations (look for D:, E:, F:, and so on— your flash drive is probably the last letter in the list). When you click on the flash drive in the Send To list, the folder you selected is copied to the specified drive. If you repeat this later to back up changed files, Windows Explorer asks whether you want to replace existing copies. For files that you haven't changed, you don't need to replace the copies. For files that you have changed, choose **Copy and Replace** to replace the original with the changed file or **Don't Copy** to leave the original alone and the changed file not backed up. Windows Vista offers a third option: **Copy, But Keep Both Files**. If you choose that option, the changed file has the original name plus a number in parentheses, such as **my file (2)**.

Right-click over photo folder.

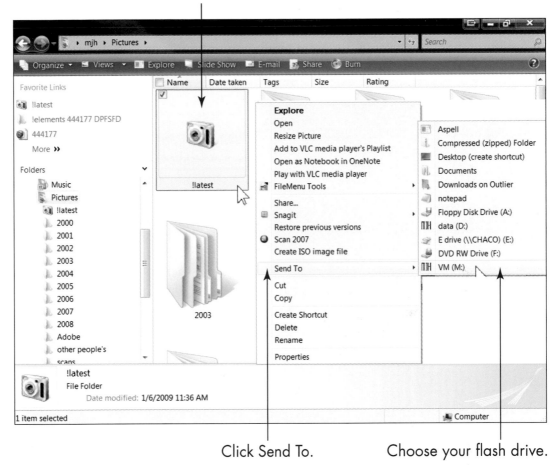

Figure 10-4

Click Send To. Choose your flash drive.

⟾ **Copy individual files as needed:** Although Photo
Gallery makes it easy to copy individual files (see the
task "Make a Copy"), you can also copy individual
files in Windows Explorer. One method is to use the
Send To option described previously for individual
files. You can also select one or more individual pho-
tos in Windows Explorer and press Ctrl+C (copy) on
the keyboard, and then Ctrl+V (paste) to create a copy
in the same folder (or choose another folder on the
left side of Windows Explorer before pressing Ctrl+V).
If you create a copy in the same folder, the copy has
the original file name plus "- **Copy**" at the end.

 Although you do not have to take any of these steps in order to edit your photos, having a backup of your photos provides peace of mind and additional options if problems arise later.

Select a Photo to Edit

1. In Gallery view, select a single photo to edit by clicking once anywhere on that photo except in the check box in the upper left. This click selects one photo.

2. At the top of the screen, click the **Fix** menu item. Your selected photo appears in Preview and the Fix pane appears on the right, as in **Figure 10-5**.

Click Fix to show or hide the Fix pane.　　　　　　　　The Fix pane

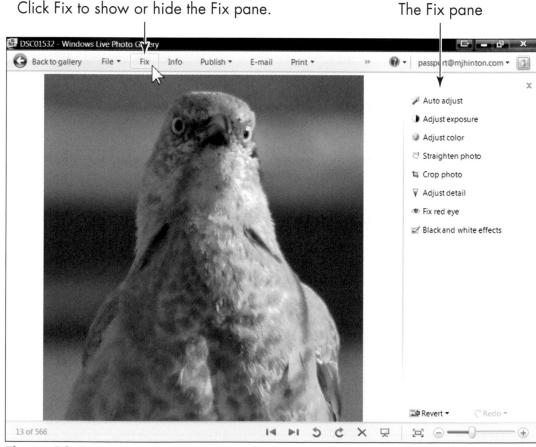

Figure 10-5

3. Without making any changes, click **Back to Gallery** in the upper left of the screen.

4. For an alternative method, in Gallery view, double-click any photo to select it and open that photo in Preview. If you do not see the Fix pane on the right, click **Fix** at the top of the screen.

Make a Copy

1. When you edit a photo, you do not need to save the changes you make. Photo Gallery automatically saves changes when you leave Preview. If you know you want both the original and the edited photo, you need to make a copy before you edit. Double-click the photo in Gallery view to open the photo in Preview.

2. Use File⇨Make a Copy in the menu at the top of the screen. (This menu item does not appear in Gallery view.) A dialog box appears with the folder selected that contains this photo and a filename based on the original filename plus a number in parentheses. See **Figure 10-6**. Click OK to accept the current location and filename. Use Browse Folders if you want to choose a new location. You can type in a new filename if you want to rename the copy.

3. Any changes you make apply to the photo on-screen. The copy contains the photo as it is before you make changes.

 You can make a copy at any time and more than once. If you want multiple versions of a photo, especially if you are experimenting with editing, use **Make a Copy** between changes. However, you never have to use **Make a Copy** if you never want multiple versions of a photo.

Click File. Click Make a Copy.

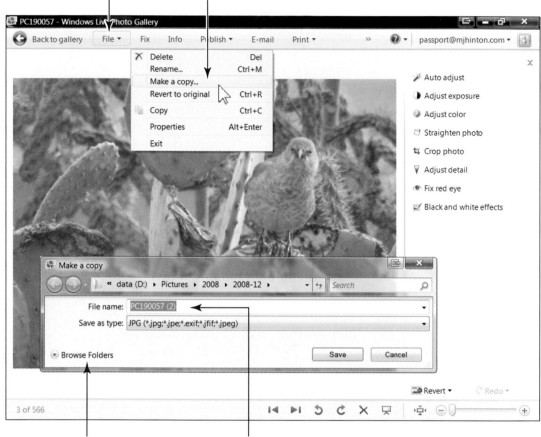

You can change the location. You can change the filename.

Figure 10-6

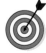

If you forget to make a copy before you edit a photo, but you still want both the original and the edited photo, make a copy after you finish editing. The copy has all the edits. Then undo all your changes to restore your original to its pre-edited condition. See the task "Undo and Redo Changes."

Crop a Photo

1. Crop photos to remove distractions and to emphasize the subject of the photo. To crop a photo, double-click the photo in Gallery view.

2. In Preview, if the Fix pane doesn't appear, click the **Fix** menu item at the top of the screen. In the Fix pane, click **Crop Photo**. A box appears over part of your photo. See **Figure 10-7**. The box includes the area that will remain when you are done. Everything outside the box is deleted.

Move and resize the crop box. Click Crop Photo first.

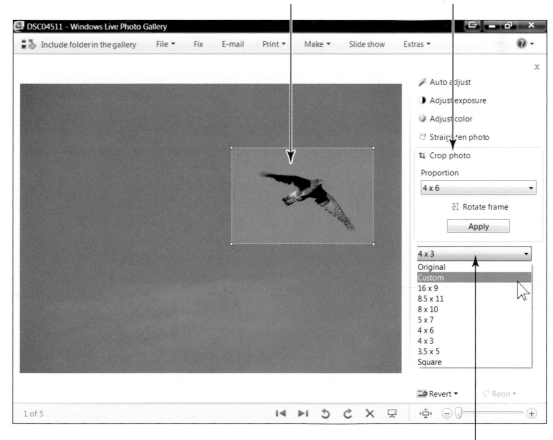

Choose proportions for crop box.

Figure 10-7

3. In the Fix pane, click under Proportion for a drop-down list of predefined crop areas. If you intend to print this photo, the predefined areas listed in this box help you choose a good proportion of width to height for printing or displaying on a digital picture frame (4 x 6 is ideal for standard prints). See Chapters 12 and 13 for information on printing and Chapter 15 for information on frames. Proportions matter less for e-mail or posting on the Web. The Custom proportion lets you size the box any way you choose.

4. Click the **Rotate Frame** button above the **Apply** button if you want to flip the crop box between horizontal and vertical.

5. To resize the crop box, position the mouse over any of the four handles (small white squares) in each corner of the crop box. (If you choose Custom under Proportion, handles also appear in the middle of each side of the crop box.) When the mouse pointer turns into a double-headed arrow over one of the four handles, click and drag toward the middle of the box to reduce the size of the area that will remain; click and drag away from the middle of the box to increase the size of the area.

6. To move the crop box over a different area of the photo, position the mouse anywhere within the box (but not over a handle). When the mouse pointer has arrow heads that point in four directions, click and drag the crop box. Move the box to include the part of the photo you want to keep.

7. When you have selected the area you want to keep, click the **Apply** button. Everything outside of the box is gone. To cancel instead of applying the crop, click on the **Crop Photo** button a second time. **Figure 10-8** shows the original photo cropped to put all the emphasis on the Cooper's hawk.

The original photo cropped to make the Cooper's hawk stand out.

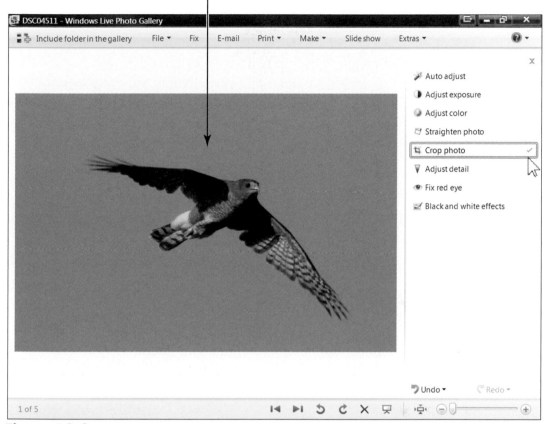

Figure 10-8

8. To adjust the cropping after you apply the selection, click the **Crop Photo** button again. The original photo reappears with the box as you last sized and positioned it. Make any adjustments and click **Apply** again.

9. You do not have to save your changes. When you click **Back to Gallery** or the next or previous arrows at the bottom of the screen, Photo Gallery automatically saves your changes, replacing the original photo with the changed photo. See the task "Revert to the Original Photo" for information on getting back the photo prior to all changes.

Remove Red-Eye

1. In Gallery view, single-click on a photo that has red-eye, which is a red dot in the middle of a person's eyes. This selects the photo.

2. Click on the **Fix** menu item at the top of the screen to open Preview with the Fix pane on the right of the screen.

3. In the Fix menu, click on the **Fix Red Eye** button. See **Figure** 10-9.

Draw a box over the red-eye area. Click Fix Red Eye first.

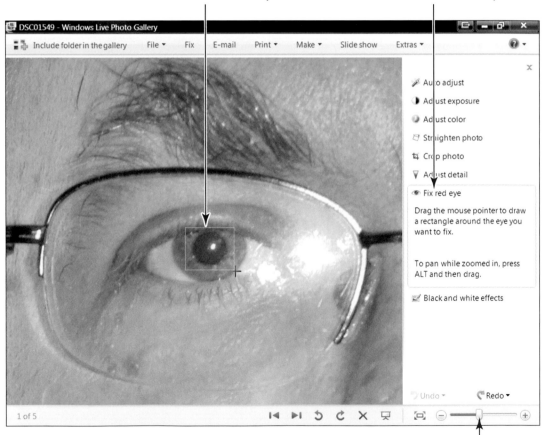

You may need to zoom in with the slider.

Figure 10-9

4. Move your mouse pointer near the red-eye area. Click and drag to draw a box around an instance of red-eye. When you release the left mouse button, anything red within the box you draw turns black. (Don't include red that is not part of the red-eye, such as in glasses frames or masks. Draw as small a box as possible to select just the red-eye problem.)

5. You can zoom in to the photo to see a larger area of red-eye by clicking the right side of the slider at the bottom of the Fix pane or by clicking the Actual Size button to the left of the slider.

6. If you need to move the zoomed in picture during red-eye repair, hold down the Alt key as you click and drag the photo. (The Alt key activates the panning hand, which allows you to click and drag the photo without drawing a box when you are in red-eye repair mode.)

7. If there is more than one eye with a red-eye problem, draw separate boxes one at a time around each occurrence. When the last red-eye is fixed, click on **Fix Red Eye** in the Fix pane to end the process.

8. You do not have to save your changes. When you click Back to Gallery or the next or previous arrows at the bottom of the screen, Photo Gallery automatically saves your changes, replacing the original photo with the changed photo. See the task "Revert to the Original Photo" for information on getting back your original photo prior to all changes.

Undo and Redo Changes

As you edit a photo, you can undo any and all changes until you leave that photo to return to Gallery view or to preview another photo. If

you undo one or more steps, you can redo any undone step. See these buttons at the bottom of the Fix pane:

⟹ **Undo:** Click the **Undo** button at the bottom of the Fix pane. (The **Undo** button is gray if there is nothing you can undo.) Each time you click **Undo**, you undo the previous change you made. Multi-level undo enables you to click the **Undo** button repeatedly to reverse a series of changes. Click the triangle to the right of **Undo** for a list of all the changes you can undo at once. See **Figure 10-10**. If you click on a change in the Undo list, you undo that change and all changes that preceded it. You can also undo all changes at once using the **Undo All** item.

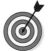 If you use File⇨Make a Copy before you undo changes, the copy has the changes and the photo you are working on does not.

⟹ **Redo:** Click the **Redo** button at the bottom of the Fix pane. (The **Redo** button is gray if there is nothing you can redo.) Clicking **Redo** reinstates the previously undone change. Multi-level redo enables you to click the **Redo** button repeatedly to reapply a series of changes you have undone. Click the triangle to the right of **Redo** for a list of changes you can redo altogether. See **Figure 10-11**. If you click on a change in the Redo list, you redo that change and all changes that followed it. You can also redo all changes at once using the **Redo All** item.

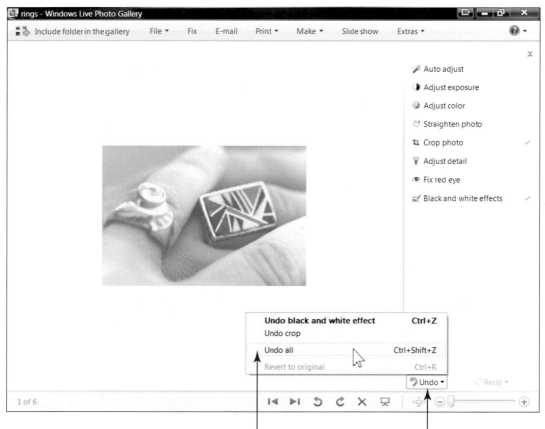

Click drop-down arrow
to select steps to undo or all.

Click the Undo button
one step at a time.

Figure 10-10

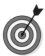 The keyboard shortcut for Undo is Ctrl+Z. Redo is
Ctrl+Y.

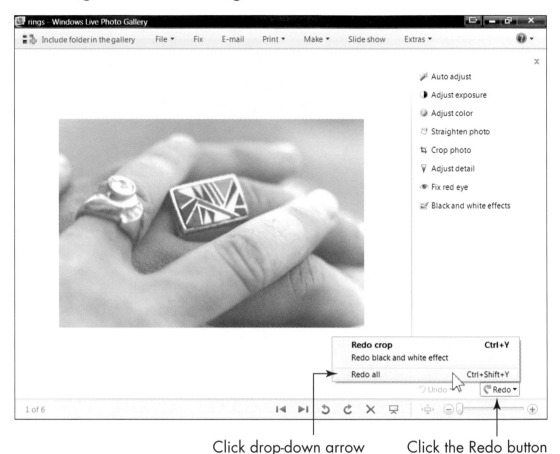

Click drop-down arrow
to select steps to redo or all.

Click the Redo button
one step at a time.

Figure 10-11

Revert to the Original Photo

Although you can undo any changes you make to a photo, when you leave that photo to return to Gallery view or to preview another photo, Photo Gallery automatically saves your changes, replacing the original photo with the edited photo. Automatic saving is meant to make editing faster and easier. However, be careful! Automatic saving also means you can just as easily save an edited photo *unintentionally*. Your original photo is no longer visible. However, you may be able to recover the original photo with one of these techniques:

➠ In Gallery view, select the edited photo. Click the **Fix** menu item. In Preview, you may see the **Revert** button at the bottom of the Fix pane, where **Undo** normally appears. See **Figure 10-12**. If you have made more changes, **Revert to Original** appears at the bottom of the menu you see when you click the triangle to the right of the **Undo** button.

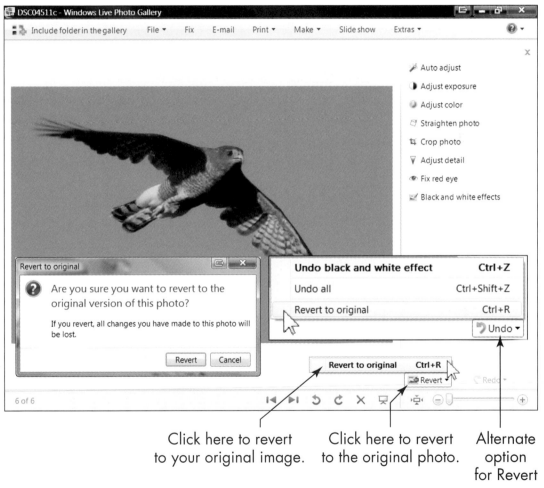

Click here to revert to your original image. Click here to revert to the original photo. Alternate option for Revert

Figure 10-12

If you click Revert or Revert to Original (Ctrl+R), you see the dialog box in **Figure 10-12**. Click **Revert** in the dialog box if you want the original photo back. You lose all changes you made to this photo if you click **Revert**. The Redo option is not available.

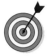 To keep the changes you've made and revert to the original, use File⇨Make a Copy in Preview before you revert. See the task "Make a Copy." The copy you make will have all the changes. Then revert to the original.

➡ If **Revert** isn't available or doesn't revert to the oldest version of a photo you've edited on several occasions, look for the original in your backup files. (See the task "Back Up Your Photos".) Use Start⇨Computer to browse the flash drive or hard disk on which you put backup files. Copy the backup or open it in Photo Gallery and use **Make a Copy** to save a new copy with your photos.

➡ If you can't revert and you don't have a backup, Windows Vista may have automatically created a backup copy. Use Start⇨Pictures. In Windows Explorer, click the right mouse button over Pictures under Folders on the left. (If the changed photo is in a different folder, right-click over that folder.) Choose Properties from the context menu that appears. If you have the Business or Ultimate edition of Windows Vista, you see a tab labeled Previous Versions. Click on that tab. Copies of the selected folder that were created automatically by Vista appear in the dialog box, as in **Figure 10-13**. You may have a choice of backups. If so, choose a date and time that you think will take you back to the original photo. Select the previous version you want to open. Click the **Open** button at the bottom of the dialog box. Windows Explorer opens to the selected backup. Work your way through that backup to find the photo you want

to recover. If you find the desired photo, click or double-click to open the backup in Photo Gallery. Use File⇨Make a Copy to put a copy of the backup into your Pictures folder (browse to your Pictures folder in the Make a Copy dialog box). See the task "Make a Copy." You can also select multiple photos and use Ctrl+C to copy the back-ups and click in the folder where you want the photos before pressing Ctrl+V to paste those copies.

Right-click over a photos folder.

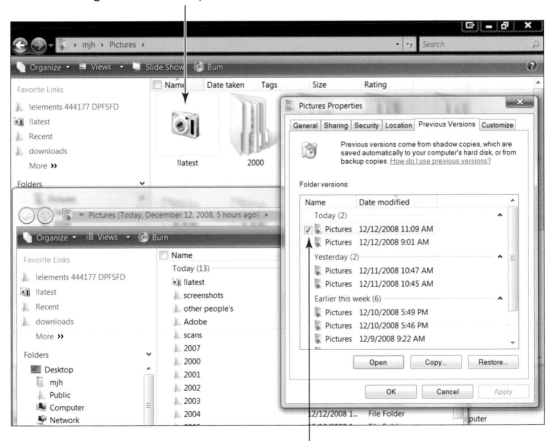

Select and open the backup you think might have your original photo.

Figure 10-13

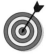 The **Copy** button recovers copies of all your photos, which is likely to be more than you need. The **Copy** button might be appropriate to recover one folder of photos, instead of all your Pictures folder. Be sure to avoid using the Restore button: It replaces the current photos with back-ups and cannot be undone.

Fine-Tuning a Photo

*Y*our camera determines the *exposure* — the mixture of light and dark — of a photo, whether in Automatic mode or with more guidance from you through the scene modes and manual options. Statistically, this process works quite well, with the majority of photos turning out neither too bright nor too dark. However, using photo editing software, you can adjust exposure that is less than perfect or even awful.

By fine-tuning the exposure and colors of a photo, you can save a photo you thought beyond hope or simply tweak a photo to look a little better. In the process, you may come to wonder: What did the scene look like when I took this photo?

See Chapter 10 for information on backing up photos, making copies, and how to undo changes you make to your photos.

Fix a Photo That Is Too Dark or Too Light

1. In the Photo Gallery, double-click a photo you want to adjust. The photo opens in Preview.

2. If you do not see the Fix pane on the right, click the **Fix** menu item at the top of the screen. See **Figure 11-1**.

3. At the top of the Fix menu, click **Auto Adjust**. Photo Gallery automatically adjusts the various aspects of exposure. **Figure 11-2** shows the adjusted photo. Overall, this wedding photo is brighter.

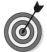 Use **Undo** or **Ctrl+Z** to undo this step and see the original exposure. See Chapter 10 for information about Undo, Redo, and Revert.

Click here to bring up the Fix pane.

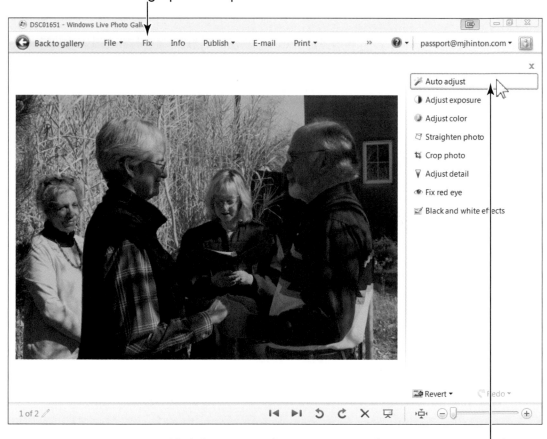

Click here to make automatic adjustments to your photo.

Figure 11-1

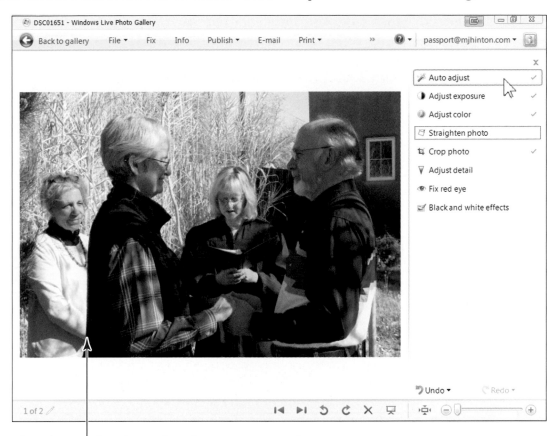

The photo is brighter after the automatic adjustments.
Figure 11-2

4. If you are satisfied with the change and you are done editing this photo, click the **Back to Gallery** button in the upper left corner or use the left or right arrow key on the keyboard to preview the previous or next photo, respectively.

Adjust Exposure Further

If the exposure of a photo needs further adjustment after you click **Auto Adjust**, click on **Adjust Exposure** in the Fix pane. The panel expands to show the following facets of exposure. You can adjust each of these options individually by sliding its control left (less) or right (more). The exposure of the photo in **Figure 11-3** has not been

adjusted. This photo is a little too dark. Details in the middle of the photo are not visible. In demonstrating changes, I will push effects a little too far so that you can see them easily in the book. Often, the best adjustments are very small.

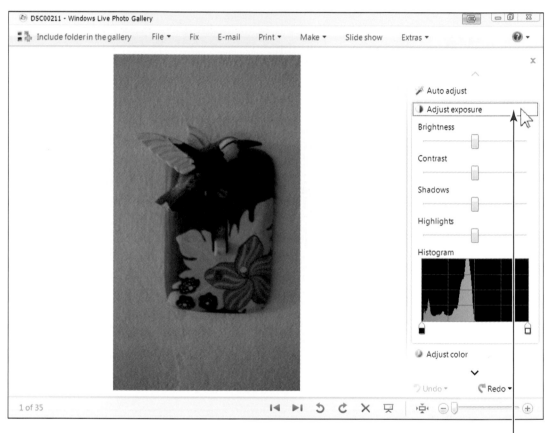

Click here to adjust the photo further.

Figure 11-3

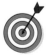 In addition to clicking and dragging the sliders to make adjustments, use the left and right arrows on the keyboard to adjust the selected slider. You can use the Tab key to move from one slider to the next (Shift+Tab moves to the previous slider).

⟹ **Brightness:** Use the Brightness slider to lighten (move the slider right) or darken (move the slider left) the entire picture. **Figure 11-4** shows the effect of

increasing the brightness in the sample photo. The black stripes in the center of the photo are more visible now, but the left edge is almost too bright.

➡ **Contrast:** Use this control to increase (right) or decrease (left) the difference between bright areas and dark areas. With increased contrast, light is pushed to one extreme or the other, making shadows darker and light areas brighter at the same time. Decreased contrast often makes details seem softer or fuzzier. **Figure 11-5** shows extremely decreased contrast in this photo. The black stripes are nicely visible, but the entire photo seems washed out.

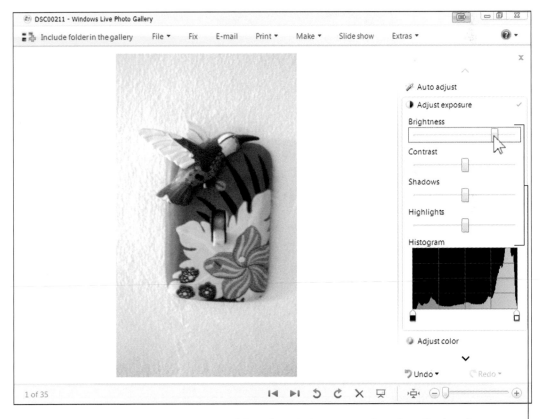

Use the sliders to make detailed adjustments.

Figure 11-4

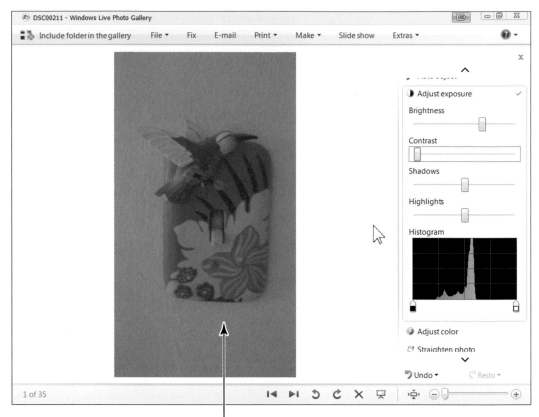

Decreasing the contrast too much results in a washed-out photo.
Figure 11-5

⟹ **Shadows:** Use this control to adjust darker areas separately from lighter areas. Move the slider to the right to make darker areas brighter, as in **Figure 11-6**. Unfortunately, pushing shadows too far to the right (too light) produces some mottling and speckling in this example. You may also see a halo-effect glowing to the right of the switch plate because this setting is pushed too far.

⟹ **Highlights:** Use this control to adjust lighter areas separately from darker areas. In **Figure 11-7**, I've reduced the highlights by moving the slider to the left. This changes the texture of the wall and brings out a bit of shadow to the right, along with some halo-effect, if taken too far.

Lightening the shadows too much causes the
photo to have a speckled appearance.

Figure 11-6

The controls for brightness, shadows, and highlights all brighten some part of the picture as you move the slider right and darken some part as you slide left. The contrast control increases the difference between light and dark as you slide right and decreases that difference as you slide left. I use the Shadows slider more than the others to adjust photos, but your photos or camera may be different from mine.

Figure 11-8 shows the effect of using all four of these controls together, instead of separately. The combination is more effective, in this case.

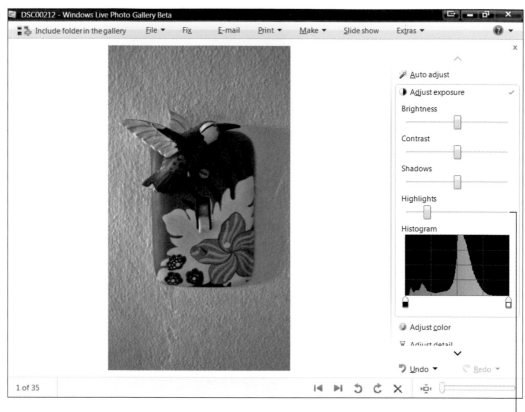

Use the Highlights slider to adjust light areas separately from darker areas.
Figure 11-7

Below these slider controls, you see a graph called a *histogram*. The histogram charts the distribution of light and dark within the entire frame. A chart with most of its peaks toward the left indicates a darker photo. Peaks to the right indicate more light in the photo. Compare the histograms in the preceding figures.

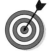 Your camera may have a histogram display as you compose a photo or after the photo is taken. This can help you recognize a photo may be overexposed

(peaks right) or underexposed (peaks left) when you can't really tell from the LCD preview. There is no perfect histogram. A beautiful photo of a full moon will peak to the left (dark) the more sky you include. A perfect beach scene may peak to the right (light).

Using all four sliders together can result in a well-balanced photo.

Histogram

Figure 11-8

Change a Photo's Colors

1. To adjust color, view the photo in Preview with the Fix pane showing. Click on **Adjust Color** in the Fix pane. The panel expands to show three color variations:

- **Color temperature:** This slider adjusts color in the photo from cool blue on the far left to hot red on the far right.

- **Tint:** This slider adjusts the tint of neutral gray and white. (In your camera, the white balance control does something similar.) Use very small adjustments to establish true gray or white within the photo, which, in turn, shifts all the other color in the photo from green on the far left to purple on the far right.

- **Saturation:** This slider adjusts the intensity of color in the photo. As you move the slider to the left, you drain color from the photo. As you move the slider to the right, you make colors more vivid. See **Figure 11-9**.

 As you open panels in the Fix pane by clicking on the text, such as **Adjust Color**, part of the Fix pane may scroll off screen. Use the small triangles that appear at the top or bottom of the Fix pane to scroll up or down, or click the panel text to collapse the panel the same way you expanded it.

2. Drag the sliders right and left to see the effect of each control. Small changes may work best. Use large changes for artsy effects. Use **Undo** (and **Undo All**, under the **Undo** button's triangle) and **Redo** (and **Redo All**, under the **Redo** button's triangle) for before and after comparisons. **Figure 11-9** shows a hot air balloon made even more colorful through these adjustments.

The Adjust Color controls

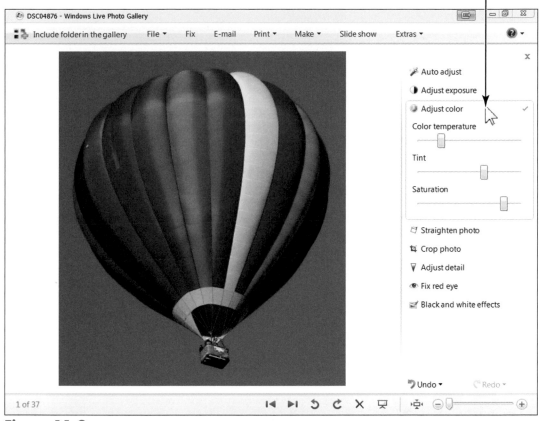

Figure 11-9

Turn a Color Photo into Black and White

1. Turning a color photo into black and white can make the photo look old, timeless, or dramatic. Black and white may disguise problems with exposure or color. In Photo Gallery, select a photo and click the **Fix** menu item at the top of the screen.

2. In Preview, with the Fix pane displayed, click **Black and White Effects**. The panel expands as in **Figure 11-10**.

3. Each of the six tools in the panel converts color to black
and white using different filters or color tones. Click each
tool to see its effect. Undo the most recent effect by click-
ing the **Undo** button (Ctrl+Z) or use the triangle next to
Undo to choose **Undo All** from a list of steps. **Figure 11-11**
shows the photo in black and white. (The photo has also
been cropped — see Chapter 10 — and straightened — see
the task "Straighten a Photo" later in this chapter.)

Click Black and White Effects to expand panel. Click one of the six options.

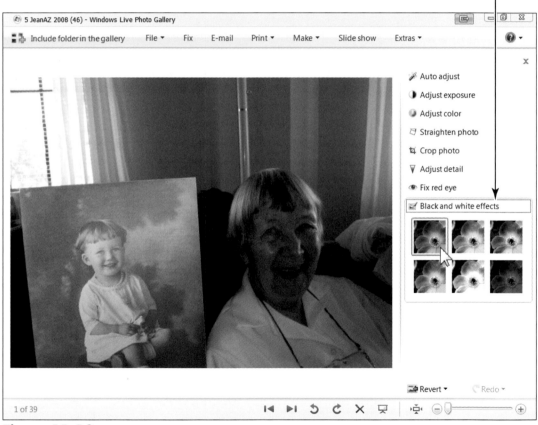

Figure 11-10
photo by Merri Rudd

The color photo with one of the black and white effects applied.

Figure 11-11

Sharpen a Photo

1. Click on a photo in Gallery view. Click the **Fix** menu item to switch to Preview with the Fix pane displayed on the right.

2. Click on **Adjust Detail**. The panel expands to show two independent tools: the **Sharpen** slider and the **Reduce Noise** slider. See **Figure 11-12**. Photo Gallery zooms in close automatically so that you can see details. You can zoom in or out using the slider in the bottom right of the screen at any time. You can also pan around the photo by clicking and dragging within the photo.

Sharpen lines and Reduce Noise (speckles).

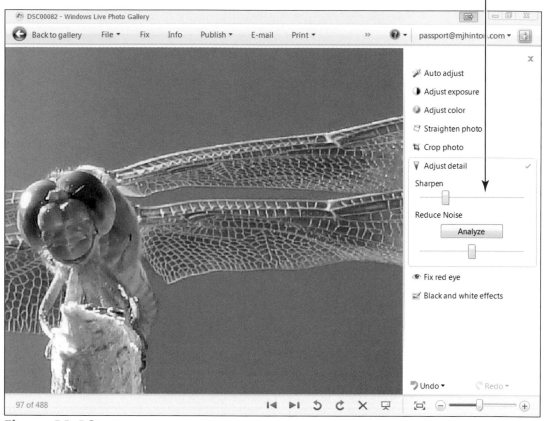

Figure 11-12

Sharpening emphasizes the edges between light and dark areas of a photo, producing sharper lines between these areas. Noise refers to specks, flecks, and spots of color, most obvious in the midst of areas that should be one color only. Noise is often worse in under-exposed (dark photos), particularly as you lighten them.

3. Click to the right of the Sharpen slider or click and drag the slider to the right. (You can also click on the slider and then use the right and left arrow keys on the keyboard.) As you move the Sharpen slider to the right, you increase the emphasis of borders between light and dark.

4. Click the **Analyze** button to let Photo Gallery attempt to compensate for noise automatically. After the analysis, you can manually adjust the **Reduce Noise** slider left (less reduction, or more noise) or right (more reduction, or less noise).

5. View the photo with **Fit to Window (Ctrl+0)** to make sure you're satisfied before you leave this photo. Remember you can still undo these changes.

Figure 11-12 shows the intricate details in a dragonfly's wings against a uniform background that easily showed noise before the adjustment.

Straighten a Photo

1. Objects in a photo may appear tilted because you held the camera at an angle or stood on uneven footing. If you want to straighten a photo, preview the photo and display the Fix pane. In **Figure 11-13**, the building appears to lean because the photographer leaned back to take in the full height of the Louisville Slugger.

2. Click **Straighten Photo**. Photo Gallery adjusts the picture automatically and displays a grid to help you adjust the photo further. (The Auto Adjust button also automatically straightens photos.) The photo is automatically cropped to fit the new alignment, so you may lose part of the edges of the photo.

3. To change the tilt, drag the **Straighten Photo** slider right or left to adjust the photo in either direction. Look for strong, straight lines in the photo to line up with the grid-lines. In **Figure 11-14**, I lined up the left edge of the building and the first column of windows along the grid. The left streetlamp in front of the building also lines up with the grid. However, the more distant building still seems to tilt. You can't always fix perspective.

Click the Straighten Photo button.

The building appears to lean because of the angle of the shot.

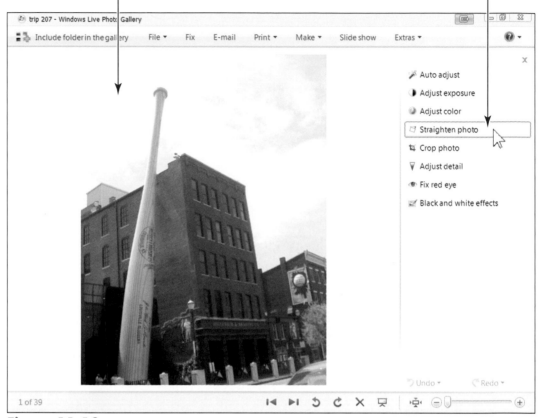

Figure 11-13
photo by Merri Rudd

4. You can repeatedly move the slider. Use the left and right arrow keys for small movements. Remember, you can undo, as well.

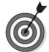 This photo has some other problems besides the apparently leaning building. See the task "Adjust Exposure Further" for information on improving the clouds and sky with highlights and shadows.

Drag the slider left or right.

Choose a strong vertical or horizontal line to line up with the grid.

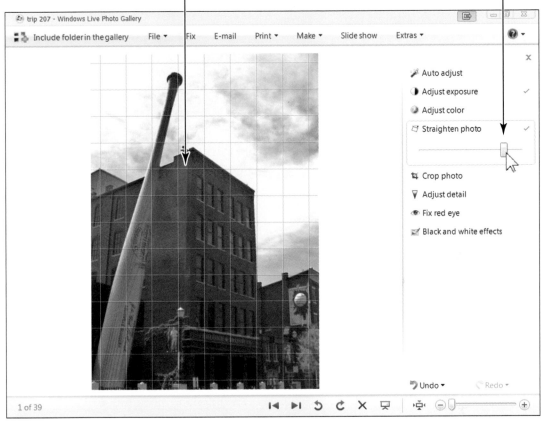

Figure 11-14

Stitch a Panorama Together

1. Create a panorama out of two or more overlapping photos. See Chapter 6 for information on shooting photos for a panorama.

2. In Gallery view, click on the first of the series of photos you plan to combine into a panorama.

3. For each additional photo, click in the upper left corner of the photo you are adding to the selection. In the lower left corner of the screen, you see a count of the number of photos selected, as in **Figure 11-15**.

4. Click the right mouse button over any one of the selected photos. Click **Create Panoramic Photo** on the context menu. (You can also use **Make⇨Create Panoramic Photo** from the top menu.)

5. The Stitching Panoramic Photo dialog box appears. It displays indications that the process is reading photos, and then compositing photos.

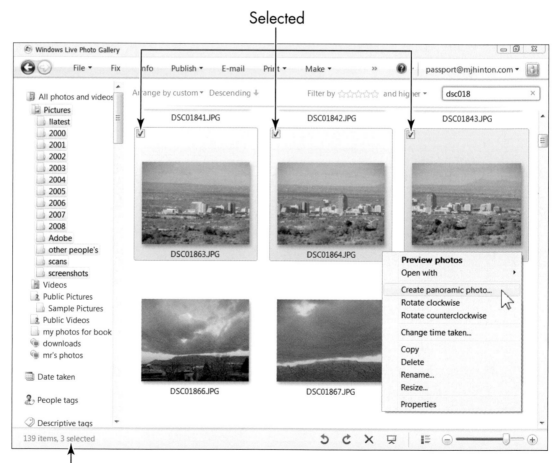

Selected

Three photos selected

Figure 11-15

6. The Save Panoramic Stitch dialog box appears. The location for saving is the same location as the original photos. The filename is the name of one of the photos plus the word **Stitch**. You can change the location or the filename. Click the **Save** button to finish.

7. The panorama appears in Preview, as in **Figure 11-16**. Black appears along the edges where Photo Gallery shifted photos to align them for stitching. See Chapter 10 for information on cropping photos to remove the unwanted areas.

Use Crop Photo (under Fix) to remove ragged edges.

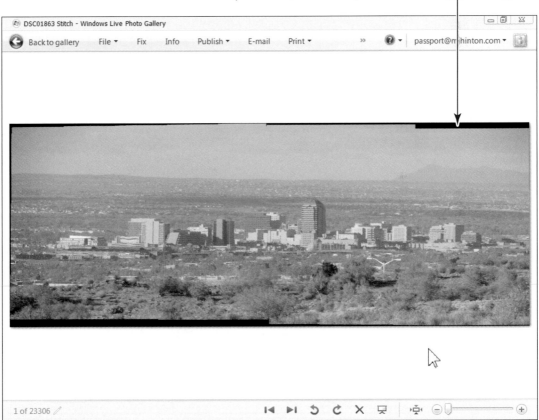

Figure 11-16

Part IV

Showing Off Your Photos

The 5th Wave By Rich Tennant

"Of course graphics are important to your project, Eddy, but I think it would've been better to scan a picture of your worm collection."

Printing Photos at Home

*P*rinting photos at home on your own printer is convenient. A printed photo is portable and handy to share with other people. You can print your photos to take with you or to send to friends and family.

Of course, printers cost money and so do the materials — ink and paper — that go into the prints. The best prints require special paper. Printing also takes some work. The trial and error that goes with learning new things can make costs add up quickly. If you want to consider other options for printing, see Chapter 13 for information on using a printing service.

E-mail, Web pages, digital frames, and portable computers make it unnecessary to print every one of your photos. Still, there's nothing like pulling out a few prints to pass around the table.

See Chapters 10 and 11 for information on editing your photos before you print.

Buy a Printer

Several different categories of printers may be suitable for home printing. As you shop, be sure to look for color-capable printers because some printers are black and white only. Think about the size of the printer and where you're

going to place it. Your printer should be within six feet of your computer, with easy access to add paper, and so on. Look at these categories of printers:

➡ **Inkjet:** Some printers use liquid ink in cartridges. These printers use tiny nozzles to spray the ink onto the paper. Printed pages require a few seconds to dry before handling. Typically, these printers have one black cartridge for text printing and one or more separate color ink cartridges. Some cartridges are refillable, but most are recyclable instead. Inkjet printers are fast, relatively quiet, and produce good results, although ink may not be suitable for large photos.

➡ **Laser:** Color laser printers are more expensive than inkjet printers. These printers use a dry toner that is melted into the paper. Toner cartridges cost more than ink cartridges, but print many more pages. Laser printers outperform ink printers in printing large numbers of pages in a short time.

➡ **All-in-One:** These multifunction devices include a printer (usually inkjet), a fax machine you connect to a phone line, and a scanner. A scanner makes the all-in-one a copier, as well. Using a scanner, you can convert old photos into digital files. Pictures in your old family albums can enter the 21st century as digital photos.

➡ **Specialty:** All printers print pages up to 8 1/2 x 11 inches. Most accept paper one quarter the size of a full sheet, which is comparable to a 4 x 6 inch print. If you need smaller or larger prints, look for a printer that specializes in odd sizes. Other specialty printers are very small, portable, and battery-operated.

 You need a cable to connect the printer to your computer. If a cable doesn't come with your printer, you'll have to buy one separately. This is likely to be a USB

cable, although some older printers use a parallel printer cable.

 Nothing lasts forever, but prints on regular paper printed at home probably won't last as long as top quality prints from a printing service. If you are printing at home for the ages, pay extra for *archival quality* photo paper.

Set Up and Connect a Printer to Your Computer

1. Take your printer out of the box. Keep all the packing material together until you know you won't need to return the printer. Arrange all the components for easy access. In addition to the printer, you'll probably find ink cartridges or a toner cartridge, a power cable, and a CD with printer software. Read the instructions for setup that come with your printer.

2. Remove all tape from the printer. Most printers ship with the print mechanism locked in place in some way. Look for brightly colored tape, paper, or plastic indicating what you need to move or remove to release the print mechanism.

3. Put the printer within cable length of your computer. Insert the ink or toner cartridge before you turn the printer on for the first time. Place some paper in the paper drawer or tray.

4. Unless your printer's instructions say otherwise, before you connect the printer to the computer, insert the CD into the computer disc drive. The setup program should start automatically. Follow the prompts.

5. After the software setup ends, plug the printer cable into the printer and into the computer. Turn the printer on. You may see some informational dialog boxes or pop-up messages as configuration completes.

6. To confirm that your printer is installed properly, use Start⇨Printers. You should see an icon for your new printer on screen. Click or double-click your printer icon to open the program that monitors your printer's activity. In the menu, use Printer⇨Properties (see **Figure 12-1**). At the bottom of the General tab, click the **Print Test Page** button. If a test page does not print, check both ends of the cable and make sure the printer is turned on. Double-check all the preceding steps and try to print a test page again. Contact the printer manufacturer, the location you bought the printer from, or the Web for more help.

Click to open the print monitor.

Click for a test page.

Figure 12-1

Print Directly from Your Camera or Card

You can print in several different ways without using a computer. Each of these requires that both your camera and your printer support the same method. Before you use any of the methods listed below, look for a print function on your camera's menus. If your camera has a built-in print function, you can select the photos you want to print before you connect to the printer. If your camera does not have a print function for selecting photos, your printer may have this feature. If neither the camera nor the printer lets you select photos, you may have to print all the photos on the memory card. (You may have hundreds of photos on your memory card.)

➡ **Memory card slot in printer:** If your printer has a card slot for the type of memory card your camera uses, remove the card from the camera and insert the card into the printer. Put your thumb on the card's label and insert metal contacts away from your hand. The printer detects the card. Use the printer's menus and screens to control how the photos print.

➡ **PictBridge:** The PictBridge standard uses a USB cable to connect cameras to compatible printers. Look for a Print option in your camera's menus and for the word PictBridge on the printer. Connect the USB cable from the camera to the printer. The USB connection on the printer for the camera is different from the one that connects the printer to the computer; it should be in front or on top of the printer. The printer detects the camera. Use the printer's menus and screens to control how the photos print.

➡ **Camera dock:** A few cameras have a dock, which is a small device the camera sits on or in. The dock may be used to charge the camera, or to connect it to a computer or printer. Connect the camera to its dock and the dock to the printer. The printer detects the connection. The dock may provide print controls. Otherwise, use the printer's menus and screens to control how the photos print.

Print from Your Computer

1. Use Start⇨All Programs⇨Windows Live Photo Gallery. In Photo Gallery, select the photo you want to print. If you want to print more than one of your photos at the same time, use the check box in the upper left corner of each photo to select those you want to print. (The next steps are the same in Gallery view or Preview.)

 You can also print any photo from Windows Explorer. Select the photo and click the right mouse button over the photo. Choose **Print** from the pop-up menu.

2. Use the top menu to select Print⇨Print (or use Ctrl+P on the keyboard). The photo opens in the Print Pictures dialog box. See **Figure 12-2**.

The first of your selected photos

> **How do you want to print your pictures?**
>
Printer:	Paper size:	Quality:	Paper type:
> | Brother HL-2040 ▾ | Letter ▾ | HQ 1200 ▾ | Plain Paper ▾ |
>
> Full page photo
>
> 4 x 6 in. (2)
>
> 5 x 7 in. (2)
>
> 1 of 1 page ◄ ►
>
> Copies of each picture: 1 ☑ Fit picture to frame Options...
>
> Print Cancel

Click to print.

Click arrows to see other selected photos (if any).

Figure 12-2

 If you selected more than one photo to print, use the right triangle below the photo (or the right arrow key on the keyboard) to preview each of the selected photos.

3. You can simply click the **Print** button for a print of your photo filling a full-sized page. However, use the options along the right-hand side of the dialog box to specify the size of each print. The number of prints that can fit on one page appears in parentheses next to each size. Select from these sizes:

- **Full page photo:** This option prints one photo per page. The photo fills most of the page.

- **4 x 6 in. (2):** Use this to print two photos per page (if you select more than one photo or more than one copy). This is a standard print-size for photos.

- **5 x 7 in. (2):** Prints two photos per page (if you select more than one photo or more than one copy). These prints are larger than those from the 4 x 6 in. option.

- **8 x 10 in. (1):** This option is the same as Full page, unless you have changed paper size in the printer options (see Step 6 for more on this).

- **3.5 x 5 in. (4):** This option prints four smaller photos per page (if you select more than one photo or more than one copy).

- **Wallet (9):** Use this option to print up to nine small photos per page (if you select more than one photo or more than one copy). Each print is 3 x 2 1/4 inches.

- **Contact sheet (35):** Use this option to print up to 35 very small photos per page (if you select more than one photo or more than one copy). Each print is 1 1/2 x 1

inches. The filename of each photo appears below the photo. This is a quick way to evaluate the print-worthiness of a large number of photos at once.

4. Choose the number of copies to print in the box below the photo, along the bottom of the dialog box. If you want more than one copy of your photo, increase the number of copies of each picture. (Type in a number or click on the small triangles to the right of the number to increase or decrease the number.) If you select more than one photo in Step 1, you print this number of copies of each photo. Two copies of three photos equal six prints, of course. That requires six sheets of paper for full-sized prints but only one for wallet-sized — with space for three more prints. See **Figure 12-3**.

5. Uncheck and re-check the **Fit Picture to Frame** option, watching how that changes the print preview. If checked, this option expands the shorter of width or height of the photo to fill the available space and eliminate any white space around the photo. As a result, the longer of width or height may extend beyond the edges of the print frame. Unchecked, the entire photo fits within the available space, but you may have blank space above and below or to both sides of the photo. (This space is shown as off-white around the photo in the dialog box.) Preview all the selected photos with this option checked and, again, unchecked. Use the setting that looks best for the selected photos. For many photos, this option won't make much of a noticeable difference. However, for images that don't fit standard print proportions, **Fit Picture to Frame** cuts off some portion of the print. **Figure 12-4** shows two photos with the **Fit Picture to Frame** option unchecked. Both photos are acceptable, although the one on the right has excess blank space on the left and right. For **Figure 12-5**, the **Fit Picture to Frame** option is checked. The photo on the left is fine either way, whereas the other

photo shows the potential problem of fitting (filling the frame). When the width of that narrow photo is expanded to fit the frame, the top and bottom of that photo are cut off. (The right-hand photo is also cropped badly for printing as a standard-size print. See Chapter 10 for information on cropping photos.)

Three photos Nine prints per page

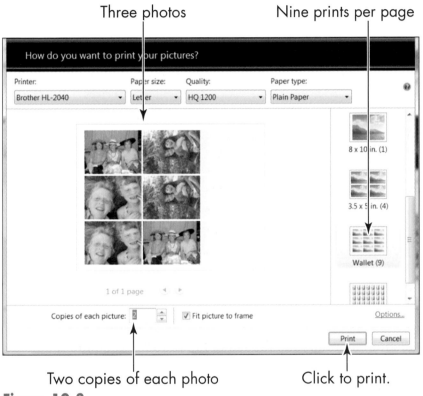

Two copies of each photo Click to print.

Figure 12-3

6. You may not need to change any of the printer options that appear across the top of the dialog box. These options are available:

- **Printer:** Your current default printer (possibly your only printer) is listed automatically. If you have another printer, you can choose it here.

- **Paper size:** Letter size is a standard 8 1/2 x 11 inch piece of paper. If you are printing on other sizes, you may need to choose a different paper size from this list.

- **Quality:** For the best prints, use the highest available quality (marked HQ in these figures). The numbers here refer to dots per inch — more dots make smoother images. You can switch to a lower quality for drafts and quick prints.

- **Paper type:** This choice may affect how your printer feeds paper or which paper tray the printer pulls the paper from. In most cases, you don't need to change this, even if you are actually using special paper.

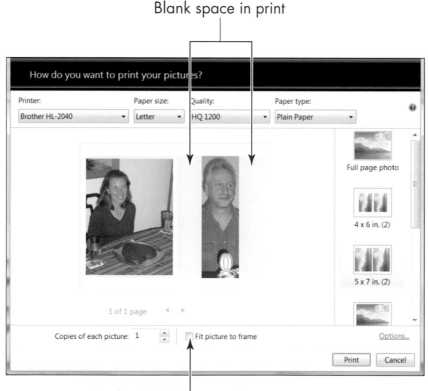

Blank space in print

Uncheck Fit Picture to Frame.

Figure 12-4

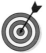 If you intend to print on specialty paper, such as preprinted stationery or photo paper, print a test on regular paper, first. That way, you don't waste special paper as you get the options set the way you want them.

7. When you're ready to print, click the **Print** button. The dialog box indicates a wait. Your prints should come out of the printer soon after. The more photos you select to print at once and the more copies you specify, the longer this step takes, as Photo Gallery formats each print. If nothing prints a few minutes after the dialog box disappears, check to make sure that the printer is on and its cable is connected. Use Start➪Printers. Double-click to open the icon for your printer and look for error messages.

Expanded width cuts off height in this photo

Check Fit Picture to Frame.

Figure 12-5

Using a Printing Service

You don't need your own printer to print photos. You can take the photos to a local printing service on your camera or CD or a flash drive. This is especially convenient when you're traveling and want prints on the spot.

Ordering prints online is even more convenient — you can do it in your bathrobe at 3 AM. You can upload your photos to an online service and pick up the prints locally or receive them in the mail. However, it takes time to upload photos from your computer to a print service. How much time it takes depends on the size and number of photos and the speed of your Internet connection. If you use a slow connection such as dial-up, you may be better off taking the disk to a local photo printer.

The process of ordering prints online isn't much more difficult than printing on your own printer. High quality, standard-size prints, such as 3 x 5 and 4 x 6, often cost less than 25 cents each.

Your photo may not fit perfectly on a photo print, especially if you have cropped the photo. (See Chapter 10 for information on cropping.) How do you fit a square photo on a rectangular print? Photo services vary in how they handle differences between the dimensions of a photo and a print. The print may have blank

space along the top and bottom or the sides to accommodate differences. In some cases, the service may cut off edges of the photo in order to fill the print area completely. These adjustments often matter little with snapshots, but may matter more for enlargements, such as 8 x 10. Order some standard prints before ordering larger prints to check how the service adjusts prints.

 Print test copies at home using your own printer, if you have one. Even black and white prints on plain paper give you an idea of what the photo will look like as a print. See Chapter 12 for information about printing at home.

Prepare Photos for Printing

Before you print your photos, you may want to edit them first. For example, you may want to crop the photo to emphasize the subject (see Chapter 10) or adjust exposure and color (see Chapter 11). Although printing services may allow some adjustment to your photos as you order prints, editing photos before you order prints is easiest.

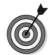 To make it easy to gather the photos you want to print, tag those photos with a unique tag, such as **print**, as you review them in Photo Gallery. At any time, you can use Photo Gallery to display only those photos with the tag you choose. This is much easier than trying to select a few photos among many as you get ready to print. See Chapter 9 for information about adding tags to photos in Photo Gallery.

 If you are going to print using an online service, see the task "Order Prints Online."

If you are going to carry or mail your photos to a service, copy the photos to a recordable CD or a USB flash drive:

⟹ To create a CD of photos in Photo Gallery, see the task "Copy Photos to a CD."

➡ To create a CD of photos using Windows Explorer, use Start⇨Pictures. Browse to the folder containing the photos you intend to print. Select your photos using check boxes or by holding down the Ctrl key as you select additional photos. Click the **Burn** button in the toolbar at the top of Windows Explorer. From this point, the process is identical in the Photo Gallery and Windows Explorer. See the task "Copy Photos to a CD."

➡ To copy photos to a USB flash drive, use Windows Explorer to select your photos. Click the right mouse button over one of the selected photos. Choose **Send To**, and then highlight your USB flash drive in the list, which is probably the highest letter, such as F:. After copying ends, remove your flash drive.

 You can use these same techniques to prepare a disc or flash drive to send to family or friends. See Chapter 16 for information on creating a DVD slideshow, which is suitable for sharing but not for printing.

Copy Photos to a CD

1. In order to copy photos to CD, buy recordable CDs at an office supply store or any store that sells electronics. CD-R (recordable) is inexpensive and readable by all types of machines. CD-RW (re-writable) makes it easy to add and remove files from the CD, but may not be readable in as many machines as CD-R. Recordable DVDs are also available. Don't buy DVDs unless you *know* your computer can record DVDs (that's not the same as playing them) and you know that you need the greater capacity. A standard CD holds at least 200 photos. A DVD holds almost 10 times as many. That's a lot of prints!

2. To create a CD of photos using Photo Gallery, use Start⇨ All Programs⇨Windows Live Photo Gallery. Use the check box in the upper left of each photo to select the photos you intend to print.

3. Click **Make** in the top menu. Choose **Burn a Data CD**. Don't use **Burn a DVD**, which creates a slideshow on disc using Windows DVD Maker. Insert a blank recordable CD into your computer's CD/DVD drive, which opens automatically. The dialog box in **Figure 13-1** appears.

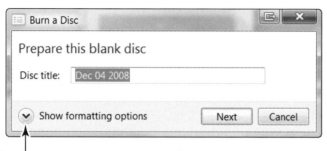

Click Show Formatting Options.
Figure 13-1

4. Enter a short disc title or leave the current date. Click the **Show Formatting Options** button. The dialog box in **Figure 13-2** appears.

5. Click the **Mastered** option. This makes the disc compatible with the widest variety of CD machines. Click the **Next** button.

6. You may see a dialog box as the disc is formatted and another as your photos are copied to the disc.

 When the copying of your photos to CD is complete, Windows may start the process of importing pictures into Photo Gallery. (Even though these photos are

probably already in Photo Gallery: Go figure.) Any time that Windows starts to import photos that you don't want to import, cancel the dialog box that appears.

7. Eject the CD from the drive by pressing the button beneath the drive door. Take the disc to the store or package it securely for mailing.

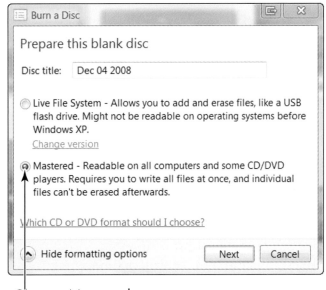

Choose Mastered.

Figure 13-2

Print from an In-Store Kiosk

1. Take a CD or flash drive with photos to a print service, such as a neighborhood drugstore or a retailer like Walmart or Target. If the service provides a photo kiosk — a kind of ATM for photos — insert your disc or flash drive. (If the kiosk can't read your disc, ask an employee what discs or formats the kiosk uses.)

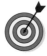 You don't have to have a computer to print your photos. Take your camera to any photo printing service. There, you can insert your camera's memory card into the store's printing kiosk or just hand the whole thing over to an employee to take care of.

2. The kiosk scans your disc and displays thumbnails of each photo found. You may have to select each photo you want to print using a touch screen. Look for check marks over the photos. Press your finger on a check mark or check box to change your selection.

3. After you select your photos, the kiosk may offer an option to edit those photos. Even if you have already edited your photos, you can use the preview in the kiosk's edit process to confirm that the way your photos will print is acceptable. If necessary, use the kiosk's menus to resize, crop, rotate, or move each photo within the print frame.

4. After selecting and editing, specify the size of each print and the number of prints you want. You may also have options for special printing, such as glossy, which has brighter colors, versus flat matte, which resists fingerprints.

5. Some kiosks offer a choice between using the kiosk's own internal printer or using the store's larger photo printing machine. The store's larger printer produces better quality prints.

Order Prints Online

1. It is very easy to order prints online from any one of a dozen services supported by Photo Gallery. In Photo Gallery, select the photos you want to print. From the top menu, click Print⇨Order Prints. A list of available services

appears, as in **Figure** 13-3. After you have used one of these services through Photo Gallery, that service appears directly on the Print menu, eliminating the need to pick it from the list the next time you order prints.

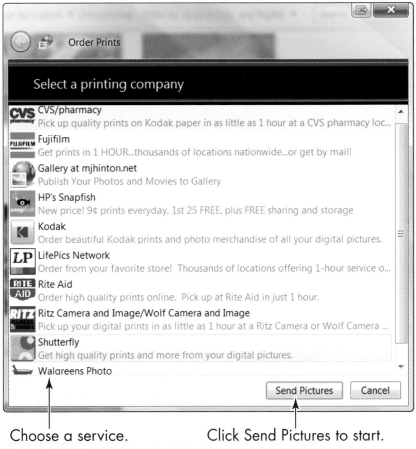

Choose a service. Click Send Pictures to start.

Figure 13-3

2. Choose a service from the list. Most of these services have local pick-up, many in just one hour. All of these services can mail photos to you, if you prefer. The process is similar for all services. You can use more than one service and change services anytime. If you are duplicating my steps, choose Walgreens and click the **Send Pictures** button.

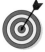 There are many more services than those listed in Photo Gallery. Using your Web browser, you can connect to any service (including those in Photo Gallery). If you use your browser, you have to select your photos during a step in the process, which can be cumbersome if you have to hunt for the photos. The advantage of using Photo Gallery is that you select your photos first, and then start the print process.

3. A dialog box like the one in **Figure 13-4** appears. This is a privacy notice that your photos may contain information you consider private. (Odds are, there is no financial data or anything that would contribute to identity theft in this data. See Chapter 9 for information on the data stored in photos.) Check the box next to **Don't Show This Again**, if you don't want to see this dialog box in the future. Click the **Send** button to continue.

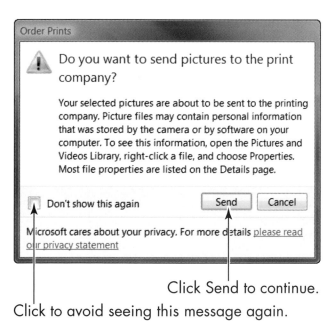

Click Send to continue.

Click to avoid seeing this message again.

Figure 13-4

4. The next dialog box is the order form. See **Figure 13-5**. Thumbnails of your selected photos appear, along with boxes to specify how many prints you want of the available sizes. You may see some sizes marked as not recommended, meaning that the service doesn't expect the quality of that size print to be acceptable. The price for the prints of each photo appears next to that photo. Although some services, such as Walgreens, display a total on this screen and a link to update that total as you make changes, not all services do so. In some cases, you won't see a total until the end of the process.

Specify number of prints.

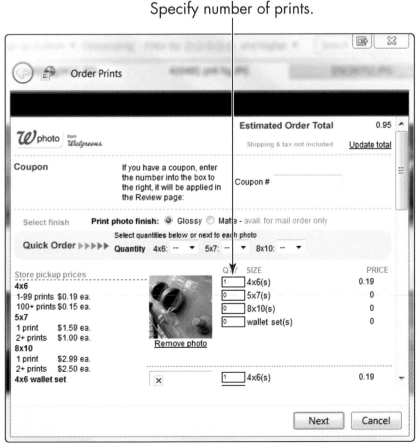

Figure 13-5

5. Change the quantities (in the Qty boxes) you are ordering as you wish. You can also use a link to remove a photo you don't want to print (or set the quantity to zero). Look for options to choose between photo finishes: **Glossy** is slick and shiny; **Matte** is textured and resists fingerprints. Other features may be available on this order form. Choose **Next** to continue with your order.

6. The next dialog box allows you to enter log-in information for a service you have used before or to create a new account for the first time you use the selected service. See **Figure 13-6**.

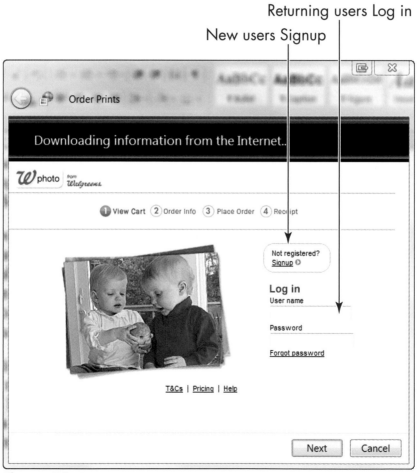

Figure 13-6

7. The first time you use a printing service, fill in the account setup information, as in **Figure 13-7**. All services require a name, e-mail address, and a password of your choice (keep a record of your password in a secure place). Fill in the information and click **Next** to continue.

8. In the next dialog box (see **Figure 13-8**), choose between local pickup (based on your ZIP code) or delivery by postal mail. (Some services may not offer a choice in delivery method.)

9. If you selected local pickup, a list of locations appears. Choose the most convenient location. If you chose mail delivery, enter your mailing address and choose shipping options. Click **Next** to continue.

10. If you chose to pick up your prints, a dialog box may appear to allow you to select what time to pick them up. Make a choice and click **Next** to continue.

11. You may receive a security alert regarding a certificate for this print service. This is a standard browser security measure and not a concern if you see this for a reliable merchant you are familiar with. Choose **Yes** to continue.

New users signup

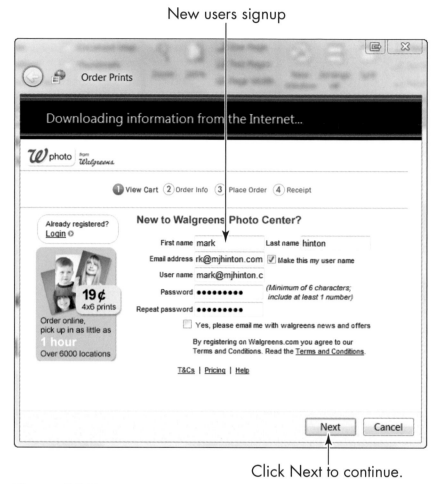

Click Next to continue.

Figure 13-7

12. Some services allow you to pay at pickup, but if the service requires credit card info, enter your info in the next dialog box. Use your name exactly as it appears on your credit card account. Click **Next** to continue.

13. A final confirmation of the order and price appears. Confirm the information. Click **Next** to continue.

Choose between local pickup and mail delivery.

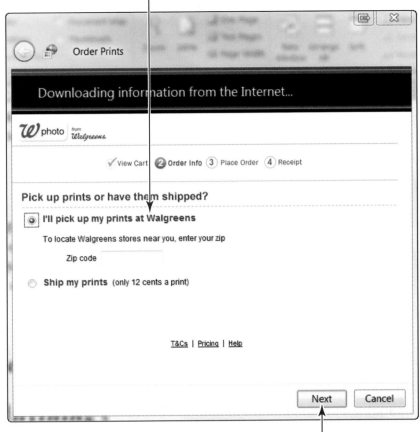

Click Next to continue.

Figure 13-8

14. Your photos upload from your computer to the printing service. How long this takes depends on the number of photos, the size of those files, and the speed of your Internet connection. A few minutes per photo is a reasonable estimate. See **Figure 13-9**.

The progress bar shows which photo is uploading.

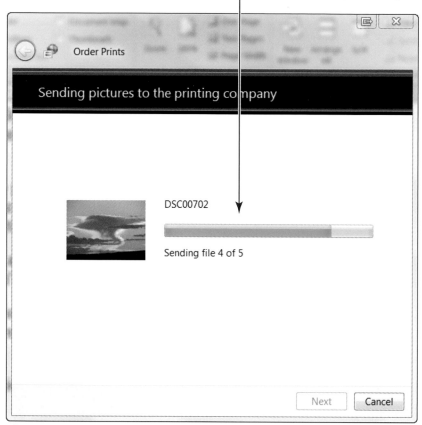

Figure 13-9

15. After the upload finishes, a receipt appears. If you want a copy of this receipt, click the right mouse button over the receipt and choose **Print** from the context menu. (You should also receive a receipt by e-mail.) Click **Next** to continue. Click the Finish button on the last dialog box.

16. The next time you use this service to print, the process is the same, except you log in using the information you used to create your account.

Sharing Photos on the Internet

*Y*ou don't need to print photos to share them with family and friends. E-mail and Web-based photo sharing services make it easy to share your photos one at a time or by the proverbial shoebox-full.

Attach a photo to an e-mail message and send it to someone special or to everyone in your address book. A photo in the inbox can brighten anyone's day.

To share more photos with more people, use a photo sharing service on the Web. You can mark photos as private to limit who can see them or make your photos public for the whole world to see.

Attach Photos to E-Mail with Photo Gallery

1. You can use Photo Gallery to attach photos to e-mail, if your e-mail program runs on your computer, such as AOL or Outlook. Use Start⇨All Programs⇨ Windows Live Photo Gallery. Find the photo you want to attach to e-mail. (Use tags, date taken, or the search box in the upper right corner to locate your photo.)

 Photo Gallery can't attach photos directly to Web-based e-mail accessed through a browser, such as Gmail or Yahoo! Mail. See the task "Resize Photos for E-Mail" if you use Web-based e-mail.

2. From the top menu, click **E-mail**. The Attach Files dialog box appears, as in **Figure 14-1**.

Select a photo, then click the E-mail button. Selected photo

Windows Live Photo Gallery
File ▾ Fix Info Publish ▾ E-mail Print ▾ Make ▾ » ?▾ passport@mjhinton.com ▾

All photos and videos Arrange by name ▾ Ascending ↑ Clear filter ☆☆☆☆☆ only ▾ Find a photo

 Pictures
 Videos ◂ All photos and videos (42 items, 1 selected)
 Public Pictures
 Public V
 my phot
 downloa
 mr's pho

Date take

People ta

Descripti

Attach files

Photo size: Medium: 1024 x 768 ▾

Total estimated size: 35.0 KB

Attach Cancel

020.JPG 051.JPG

✓

bosque 014.jpg DSC00532.JPG DSC00538.JPG

42 items, 1 selected ↺ ↻ ✕ ⬚ ≣ ⊝━━━━━●━ ⊕

Select a photo size.

Figure 14-1

 You can select more than one file before clicking **E-mail**. Click the check box in the upper left corner of each photo you want to attach to one e-mail message.

3. Click the **Photo Size** option. The sizes that appear show width and height in pixels. Pick one of the following sizes:

- **Smaller: 640 x 480:** This size fits almost any screen (except for handheld devices, such as cell phones).

- **Small: 800 x 600:** This size is also suitable for an e-mail attachment. Use this size in most cases for photos you don't expect the recipient to print.

- **Medium: 1024 x 768:** Although this size shows more detail in the photo than the smaller sizes, the entire photo may not fit within the area of the recipient's screen. Larger sizes may require the recipient to scroll the screen to see the entire photo.

- **Large: 1280 x 1024:** This size may be too large for most e-mail attachments. However, if the recipient might print the photo, use this larger size or original.

- **Original size:** This unaltered size is most appropriate if the recipient might print the photo. This size also results in the largest total estimated size, which takes longer to send and receive than the other sizes. File size is especially important if you or the recipient has a slow Internet connection, such as dial-up.

4. Click the **Attach** button. You may briefly see another dialog box as a copy of your photo is created and your e-mail program starts. (If your e-mail program doesn't start, see the task "Resize Photos for E-Mail" and attach the photo using your e-mail program.)

5. Complete the e-mail message and click the **Send** button.

Some e-mail programs display attached photos on-screen with the message. Other e-mail programs require the recipient to open the attachment separately. These are issues with the recipient's e-mail program and may be beyond your control.

Resize Photos for E-Mail

1. If you use Web-based e-mail, such as Gmail or Yahoo! Mail, Photo Gallery can't automatically attach a resized photo to an e-mail message. You can resize the photo in one step and then attach it to e-mail using any e-mail program. In Photo Gallery, you have to be in Gallery view to resize a photo, so, if you are in Preview, click **Back to Gallery**.

You may have other reasons than e-mail for resizing a photo. For example, you could resize photos before copying them to a digital picture frame, if you want to fit more photos on the frame.

2. In Gallery view, click the right mouse button over the photo you want to resize. The Resize dialog box appears. See **Figure 14-2**.

3. Click under **Select a Size** for a drop-down list. Consider these options that measure the longest side (width or height) of the photo in pixels:

- **Smaller: 640:** This size is adequate for photos you intend to attach to an e-mail message.

- **Small: 800:** This slightly larger photo is also suitable for e-mail.

Right-click over a photo.

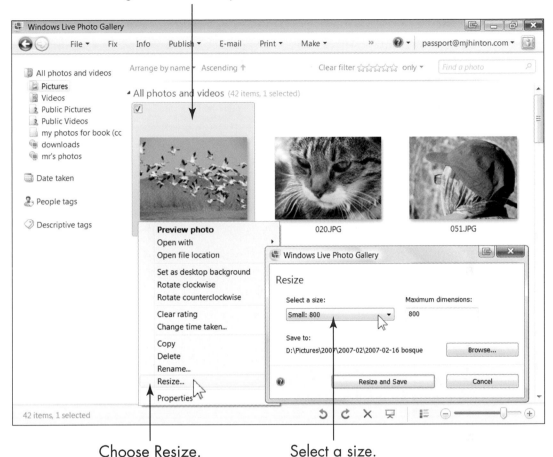

Choose Resize. Select a size.

Figure 14-2

- **Medium: 1024:** This size may be too large for an e-mail message. The recipient may have to scroll to see part of the photo.

- **Large: 1280:** The largest size available, as well as the original, unaltered size are best for printing and less fitting for e-mail.

- **Custom:** This option lets you specify the pixel dimensions for the longest size, whether width or height. If you select Custom, click in the box under **Maximum Dimensions** and type in a number smaller than the original width or height (whichever is larger) — current width and height appear in Details view, when you hover over a photo and in the Info pane for a selected photo.

4. You can save the resized copy in the same folder as the original. If you want to save the resized photo in a different folder, use the Browse button to choose a new location.

5. When you have made your selections, click the button to **Resize and Save**. You can click **Cancel** to reject changes. You can also click the question mark in the lower left corner of the dialog box to open a Web page in your browser with information on resizing pictures.

6. The resized file has the same filename as the original photo followed by the width and height in parentheses, such as **birds (640x480)**.

7. In Gallery view, if you do not see the resized photo, scroll down with the Page Down key or the mouse. If you still don't see the resized photo, press the F5 key at the top of your keyboard to refresh the screen. The resized photo should appear next to the original.

8. To attach the resized photo to e-mail, start your e-mail program. Create a new e-mail message and look for a paperclip icon for attaching files to e-mail. See **Figure 14-3**. The resized photo may also be useful for uploading to the Web.

 You can resize more than one photo at a time by selecting the photos before you right-click to select the **Resize** option. Click the check box in the upper left corner of each photo you want to resize. A check mark appears in each box as you select photos.

 The original photo is unchanged when you use the resize option. If you no longer want the original, you can delete it. If you don't want the smaller copy after you e-mail it, you can delete that one. See Chapter 9 for information about deleting photos.

Click here to attach your photo to an e-mail.

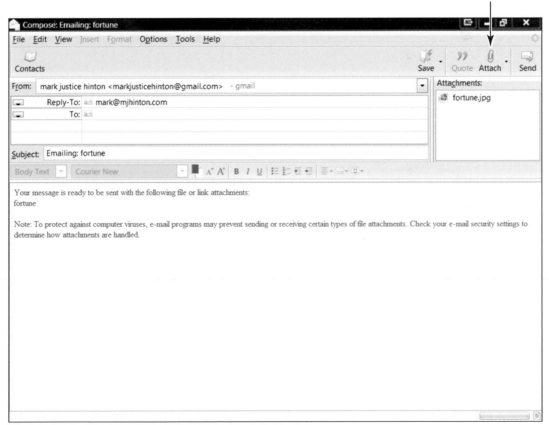

Figure 14-3

Choose a Photo Sharing Service

Use a Web-based photo sharing service to share your photos with friends, family, or the world. Photo sharing services enable you to easily upload photos, to categorize your photos with tags, and to organize your photos into online albums or galleries. Choose from one of these popular services, each of which has free accounts:

➡ **Flickr**: Flickr has a large and active community worldwide. Flickr sets the standard against which other services are judged. It is a good choice for most people. See www.flickr.com.

➡ **Microsoft Live Photos**: This is a part of Microsoft's online suite of services, including search, blogging, and e-mail. Although Photo Gallery connects to Microsoft Live Photos, it can also connect to Flickr. See http://photos.live.com/.

➡ **Google Photos**: This is part of Google's online suite of services, including search and e-mail. Although Google's photo organizer, Picasa, connects to Google Photos, it can also connect to Flickr. See http://picasaweb.google.com/.

➡ **Facebook, Myspace, and others**: Many people have accounts with so-called "social-networking" Web sites. Most of these sites have places for photos. Such sites can be great for staying current with the daily activities of family and friends around the world.

 Many photo printing services enable you to share your photos online, as well. This may be an especially attractive option if you want to allow others to order prints and pay for their own prints from your photos. See Chapter 13 for information about photo printing services.

 Each of the services listed previously enables photo uploading using your Web browser. You can also upload to each using the Windows Live Photo Gallery and other photo organizers.

Set Up a Flickr Account

1. Start your browser. Browse to www.flickr.com. If you have a Yahoo! account, you can log in with your Yahoo! ID. See **Figure 14-4**. To create a new Flickr account, click the **Create Your Account** button.

Click here to create a new Flickr account.

Figure 14-4

2. The next screen provides another opportunity to log in with a Yahoo! ID, if you have one. Otherwise, click the **Sign Up** link.

3. If you are signing up, fill in the account information screen, as in **Figure 14-5**. You do not have to provide any credit card information to set up a free account. Click the **Create My Account** button.

4. A screen summarizes your account details. Click the **Continue** button.

5. On the next screen, reenter your password and click the **Sign In** button.

6. The next screen prompts you to enter a new Flickr screen name. (If you logged in with an existing Yahoo! ID in a previous step, you automatically jump to this step, skipping steps 3 and 4.) The screen name can be different from your log-in ID and you can also change it later. Click the **Create a New Account** button.

7. Your Flickr home page appears. See **Figure** 14-6. You can personalize your profile, upload photos, or find friends. See the task "Upload Photos to Flickr."

Figure 14-5

Figure 14-6

Upload Photos to Flickr

1. You can upload photos to Flickr in several different ways. If you are logged into Flickr, use the menu at the top: You⇨Upload Photos and Videos. To use Photo Gallery to upload to Flickr (or another photo service), start Photo Gallery.

2. In Photo Gallery, choose the photos you intend to upload to Flickr. Use the check box in the upper left of each photo to select it.

3. Click **Publish** on the top menu. Choose More Services⇨Publish on Flickr. The first time you do this, you have to authorize Photo Gallery to connect to your Flickr account. Click **OK** to authorize the connection.

4. In the Publish On Flickr dialog box (see **Figure 14-7**), you can assign the photos you are uploading to a set (a photo album). You can also specify photo size. Choose a smaller size than the original to avoid exceeding the upload limit Flickr places on free accounts. The 800 pixels option is a good choice; the width or height — whichever is longer — will be scaled to the selected size.

Change the photo size here.

Control who can see your photos here.

Figure 14-7

 Flickr offers a *pro* account for $25 per year. There are no size limits on the pro account and no advertising appears on pro pages.

5. Select access permissions: public (anyone) or private. Private can be limited to just you, to contacts you identify as family, or contacts you identify as friends. Click the **Publish** button after making your choices.

6. A dialog box displays as your photos are uploaded. When uploading is complete, click the **View Photos** button. See **Figure 14-8**.

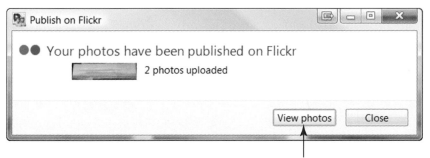

Click here after your photos finish uploading to see them.

Figure 14-8

7. You can change the title, description, and tags for your uploaded photos. See **Figure 14-9**. Click **OK** when you are done.

Figure 14-9

8. Your *photostream* page appears. Flickr calls your photo collection your photostream. Your most recently uploaded photo always appears first on your Flickr homepage. Photos uploaded earlier move down the page and onto other pages, eventually. See **Figure 14-10**.

Your most recently uploaded photo appears first.

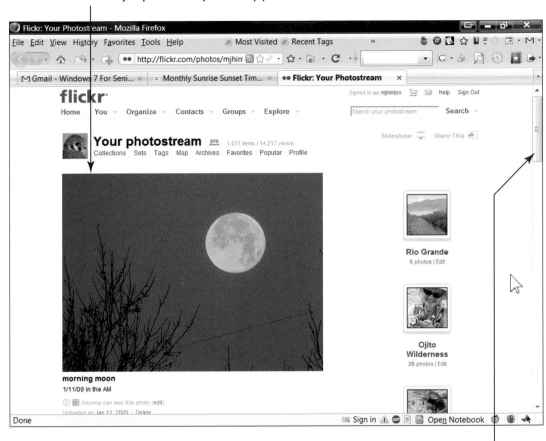

Scroll down the page for earlier photos.

Figure 14-10

Organize Your Photos on Flickr

Online, in Flickr, you can add or change information about your photos to categorize and organize them. All this info is optional. Using this info may make your photos more enjoyable or accessible. Any place you see this data displayed, you can update information simply by clicking on the text on screen. See **Figure 14-11**.

Type a title here, then click Save.

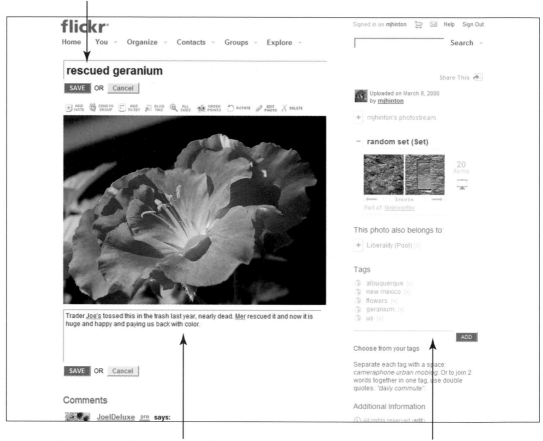

Type a description here, then click Save. Type tags here, then click Add.

Figure 14-11

⟶ **Title:** The title appears below the photo on some pages and above the photo on other pages. The title starts as the file name when you upload. You can change it to anything you feel is appropriate.

⟶ **Description:** This text appears under the photo on most screens. Feel free to describe the subject or context of the photo. The caption you enter for a photo in Photo Gallery becomes that photo's description in Flickr.

→ **Tags:** Tags categorize your photos. A photo can have any number of tags. Flickr displays the tags you assign in Photo Gallery. You have to view the individual photo to change tags. Click on a photo to view it on a separate page. Then, click on the **Add a Tag** link to the right of the photo. You can type tags in the box that opens or click the link below the box to **Choose from Your Tags**. To remove a tag from a photo, click the **(x)** next to the tag.

Use You⇨Your Tags to see a list of all the tags you have used. Click on a tag for an album of your photos that have the same tag.

→ **Sets:** Sets are another way to group photos into albums or galleries. You might create a set for all your vacation photos, for example. You can create sets during uploading. You can add individual photos to sets by using the **Add to Set** button.

Other Flickr members may find your photos as they search for specific tags you have used or text you use in your titles and descriptions. Think of the text you would use to search for these photos. That text should be in the title, description, or tags for your photos.

Share Photos with Family and Friends

1. Use your Web browser to browse www.flickr.com. If you are already logged in, your Flickr screen name appears near the top of the page. You also see Signed In As (your Flickr screen name) in the upper right corner of the screen. (If necessary, log in to your Flickr account using the **Sign In** link.)

2. Click the **You** menu item at the top of the screen. This is your Flickr home page and the top of your photostream (all your uploaded photos). The photos you most recently

uploaded always appear on this page. As you upload new photos, those currently on this page are pushed down to make room for the newest at the top. Older photos appear on pages linked to this page. Links appear at the bottom of this page as you add more and more photos. (The free Flickr account is limited to displaying your 200 most recent photos. The pro account has no limits.)

3. Send friends and family the link to your photostream home page (or any page on Flickr) by clicking the **Share This** link in the upper right corner of the screen. A dialog box appears as in **Figure 14-12**.

4. Enter e-mail addresses separated by commas in the first box of the dialog box. If you have marked any of your photos as private, you can send a guest pass to allow your family and friends who are not Flickr members to view those private photos (except those marked only for you). You don't see the guest pass option if you have marked all your photos as public.

5. You can click the **Send** button to send a generic invitation or click the **Add Your Own Message** link to enter a personal message.

6. If you just want the link for this page to paste into your own e-mail message, click **Grab the Link**. Click in the link box to select the link and copy by using Ctrl+C. In your e-mail program, start a new message and paste the link by using Ctrl+V. You can also copy the Web address of any Flickr page from your browser's Address bar and paste that in e-mail.

Click Share This, then type e-mail address here, then click Send.

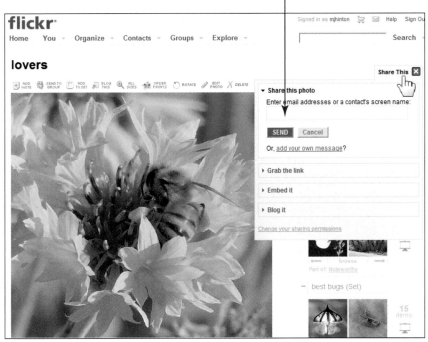

Figure 14-12

Share Photos with Flickr Groups

1. Contributing your photos to Flickr groups after you upload is a good way to put your photos in front of more people. Anyone can create a Flickr Group for any purpose. Most groups involve a subject as a theme, such as particular animals or locations. Search for groups that would interest you. Use the top menu: Groups⇨Search for a Group. (You can also use the **Create a New Group** menu item to create your own groups.) See **Figure 14-13**.

Type your search terms here, then click Search.

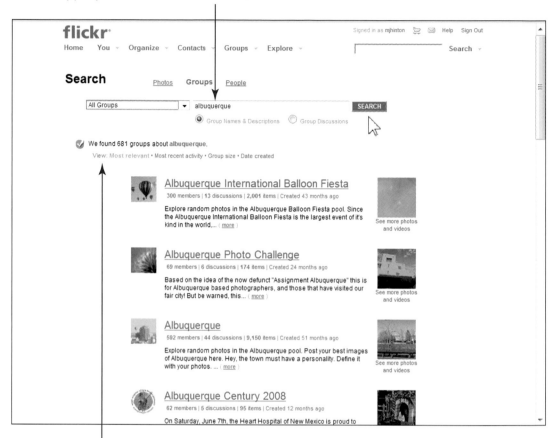

Sort found groups by relevance, group activity, group size, or date created.
Figure 14-13

2. Browse the photos of a group you are considering joining. Look for information about the group requirements or limitations. For example, some groups ask members to comment on other photos whenever they submit new photos. Some groups limit the number of photos you can submit each day. Some groups require an invitation or are completely private. If membership is open and you agree to that group's requirements, click the **Join This Group** link under the group's name.

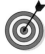
As people comment on your photos, explore their profiles and note the groups they have joined. This is an easy way to find new groups.

3. To submit one of your photos to a group after you have joined, browse your photostream and click on the photo you intend to submit. Between the title and the photo, click **Send to Group**. A list of groups you have joined appears. See **Figure 14-14**. Click the name of the group you are submitting to. You can submit a photo to more than one group by repeating this process.

4. Your submitted photo appears with other photos on the group's pages. Any changes you make to title, description, or tags are visible anywhere your photo appears.

Click Send to Group, then select a group you have joined.

Click the X next to the group name to withdraw the photo from that group.

Figure 14-14

5. On the page for individual photos you have submitted to groups, the group names appear to the right of the photo. You can click the group name to visit the group. You can click the (x) that appears next to the group name to withdraw the photo from that group.

6. See all the groups you have joined by clicking on **Groups** in the top menu.

Add Flickr Contacts

1. A Flickr contact is someone you add to your contacts list, a kind of address book for Flickr members. Add someone as a contact if you want to keep up easily with new photos they add.

2. To add someone as a contact, browse her photostream and click **Add (screen name) As a Contact**. See **Figure 14-15**. A dialog box gives you the option to mark the new contact as a friend or as family — that gives the contact access to photos for which you have set privacy limits. Leave the friend and family check boxes unchecked to grant your new contact access only to those photos you flag as public.

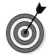 When someone leaves comments on your photos, consider viewing the commenter's photos by clicking on his screen name. If you like what you see, add that person as a contact.

3. Anyone can add you as a contact. You'll receive Flickr mail when someone adds you as a contact. (The Flickr Mail link appears as a small envelope in the upper right corner of every Flickr page. A number appears on the

envelope when you have one or more messages unread.)
When someone adds you as a contact, that does not auto-
matically make them your contact. You do not have to
add this person as your contact, but that is commonly
done. The more contacts you have, the more people are
likely to see and comment on your photos regularly.

4. To see new photos your contacts have added, use the
Contacts menu item at the top of each Flickr page.

Click to add as a contact.

Mark as friend or family for access to private photos.

Figure 14-15

Track Recent Activity on Flickr

1. Use your Web browser to visit `http://flickr.com/activity/`. If you do not see your Flickr screen name in the upper right of the screen, sign in using the **Sign In** link. See **Figure 14-16**.

Select a period of time.

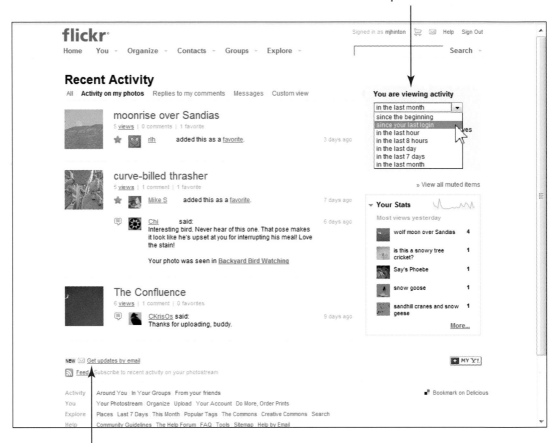

Get updates by e-mail.

Figure 14-16

2. You see recent activity on your photos, including comments and those people who have marked your photos as favorites (by clicking a star above one of your photos). On the right side of the screen, you can change the time period you are reviewing. Options range from the beginning of your account to within the last hour. Also on the right of the screen, you see your stats, which record those photos most viewed the previous day.

 See which of your photos are most popular by using the **Popular** link under your photostream heading (click on You to return to your home page, first). Photos are grouped according to most viewed, most marked as favorites by other members, and those with the most comments. All three of those properties factor into determining which of your photos are grouped as Interesting.

Enjoying Digital Picture Frames

Digital picture frames give you another option for enjoying and sharing your photos. A digital picture frame presents a continuous slideshow. You can display your photos in your home or office without needing a computer.

Digital frames may soon replace the photo albums of yesteryear. One frame, using a memory card from your camera or computer, may hold hundreds of photos. With a push of a button, thumbnails display to allow you to pick a photo to fill the screen. Other buttons enable you to flip through your photos as easily as flipping the pages of an album.

The number of frame manufacturers and models has increased tremendously in just a few years. At the same time, good frames cost less than ever. Unfortunately, choosing a frame is complicated by a wide variation in features, as you see in this chapter.

You may find good deals on frames online, but it is very hard to judge a frame without seeing it in use. Visit an office supply or discount electronics store to compare frames. **Figure 15-1** shows two frames.

Slight padding on edges for cropped photo

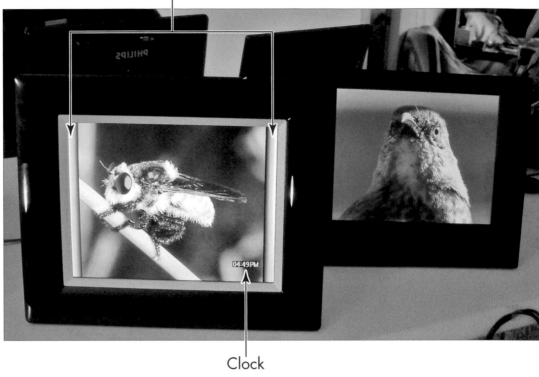

Clock

Figure 15-1

After you have your frame, you can insert a memory card directly from your camera. If you have a computer, you can copy photos from it to a flash drive or memory card to use in your frame.

Select a Digital Picture Frame

As with cameras, there are many features to consider when shopping for a digital picture frame. A few of these features are essential considerations, whereas other features may be less important to you.

 If you have access to a computer, search the Web for digital picture frame reviews. One good site is www.digitalpictureframereview.com. You'll also find many consumer comments at www.amazon.com.

Among the most important considerations are the following:

➡ **Screen dimensions:** The display area of a frame is usually smaller than the overall dimensions of the frame, which includes a border or mat that may be anywhere from less than an inch around up to a few inches. A large frame may have a small display area. The display area is measured diagonally in inches. A 7" display area is comparable to a standard 4 x 6 print. A display area 7" or smaller might be ideal on a desk or by the phone. For a frame that will sit on a table or shelf, 8" or greater may be better. Frames with a display area greater than 10" are more expensive and tend to have more features than many people need.

➡ **Screen resolution:** Resolution is measured in pixels (dots) for width and height. High resolution is indicated by bigger numbers. Good resolution ranges from 800 x 600 to 1024 x 768. Resolutions below that range may not be sharp enough.

 As you compare two frames, consider both the diagonal measure and the resolution. If two frames have the same diagonal measurement, the one with the higher resolution should be sharper and clearer.

➡ **Aspect ratio:** Your eyes may glaze over at this term, but it is no less important than the preceding features. *Aspect ratio* refers to width versus height. Most digital cameras take photos with a 4:3 aspect ratio. (That's the same ratio as TV before digital.) Both 800 x 600 and 1024 x 768 are 4:3, which makes those resolutions ideal for most digital photos. Some frames display photos at a higher ratio of 16:9, which is wider than the other ratio. (That's the same ratio as high-definition digital TV.) When a photo with one ratio displays on a frame with another ratio, something's gotta give. Most frames put black borders around part of a photo to make the adjustment,

padding the difference in width or height. Some frames may adjust the photo to fit the frame if the photo and frame have different aspect ratios. If the frame adjusts the photo, there is a chance for distortion or for the edges of the photo to be cut off. Look for frames with the 4:3 aspect ratio or, if your camera and frame both have 16:9, set your camera to that option in the setup menus. See Chapter 3 for information on setting your camera's resolution.

 Regardless of aspect ratio, portrait photos fit oddly in landscape frames, and vice versa, although most people don't set the frame up in portrait orientation. In most cases, black bars appear left and right of the portrait to fill the width. Live with this or avoid putting portraits on your frame.

➡ **Memory card slots:** Frames accept camera memory cards so that you can display photos from the same card you use to take photos. Make sure the frame you buy reads the same card you use in your camera. Most frames read more than one type of card. If your frame and camera use different cards, you can use a computer to prepare photos for the frame. For more on that, see the task "Copy Photos from Your Computer."

Along with the preceding features, consider a few more as you compare frames:

➡ **Brightness:** A bright screen shows off your photos in their best light. Although specifications may help in comparing frames, it is difficult to judge brightness without seeing a frame in use.

➡ **Contrast ratio:** Contrast is the difference between light and dark areas on the screen. The greater the ratio (for example, 300:1), the better.

➡ **Viewing angle:** This feature refers to how far off-center you can stand or sit and still clearly see the photo. An extremely narrow viewing angle requires you to be directly in front of the frame to see your photos. A wide horizontal viewing angle lets more people gather around a frame and see photos equally well. When you are beyond the viewing angle of any screen, the photo is unrecognizable. The vertical viewing angle becomes more significant if you intend to place the frame on a low table or a high shelf. Theoretically, a 180 degree vertical viewing angle and a 180 degree horizontal viewing angle would be perfect — you could see it standing off to the side. Many frames have a viewing angle of less than 90 degrees in either direction.

➡ **Internal memory:** Not all frames have internal or built-in memory for storing photos. Those that do have memory vary in how much they have. The more internal memory a frame has, the more pictures it can store without using a memory card. However, you may choose to store your photos on removable memory cards. In that case, you may not need much or any internal memory.

➡ **Controls:** All frames have buttons and switches for power, menus, and moving from one picture to the next. These controls are often on the back of the frame or the sides. Some frames have touch screens, either on the display area or in the frame outside the display area. The size and location of these controls, and the effort required to press them, affects ease of use. Some controls are very slow to respond and require a firm press and patience. This is another feature you can only judge by using it.

 One downside of touch screens is that most show fingerprints and smudges. See **Figure 15-2**. A remote control frees you from touching the frame to change photos or settings. If a frame comes with a remote, make sure it's not too small to use easily.

Here are some other features you may consider important:

➡ **Audio speakers:** Do you want to play music on your frame? Will you play videos with sound? If not, speakers don't matter.

➡ **Battery power:** All frames plug in for power. If you want to use a frame as a portable photo album to pass around, look for one that uses rechargeable batteries, as well.

➡ **Clock or calendar:** Many frames have built-in clocks. Some let you set alarms. Some frames have calendars. You may be able to display the time or a calendar next to your photos.

 Some frames let you schedule times to turn the frame on and off to save power.

➡ **Frame style:** Some frames are sleekly modern with glossy plastic or metal. Others imitate traditional photo frames with wood. Some come with extra faceplates or mats to change the color of the area outside the display area.

➡ **In-frame editing:** Basic editing includes rotating a portrait into vertical position and cropping to emphasize the subject by removing the surrounding area in the photo. If you have a computer, you may find it more convenient to edit on the computer than by using the frame's functions for editing. Your camera may also have some basic editing features.

Smudges

Fingerprints

Figure 15-2

➡ **USB connections:** Some frames accept USB flash drives as an easy way to transfer photos from a computer. (Ads may refer to the frame as a *USB host*, in this case.) Separately, most frames accept a USB cable to connect directly to a computer to transfer photos. This requires taking the frame to the computer and also plugging in the frame's own power cord, unless the frame runs on batteries.

➡ **Video format:** Do you want to play movies on your frame? Compare the format your camera records with the formats the frame can play.

➡ **Wireless connectivity:** A wireless function allows a computer to send photos directly to a frame without wires. Photos can even come from friends and family over the Internet. Unfortunately, this can be tricky to configure, so don't get this feature unless you have experience with wirelessly networking computers or know someone who does.

 Small laptop computers may be a suitable alternative to a digital picture frame. An 8″ *netbook* may cost two or three times as much as a frame, but you'll get more, including photo organizing and editing functions, as well as Internet connectivity. When you want your laptop to act like a frame, start a slideshow. See Chapter 16 for information on computer slideshows.

Set Up Your Picture Frame

1. Unpack the parts from the box. Keep all packing material until you are certain you won't need to return the frame. Identify the frame, stand, and the power supply.

2. Attach the stand to the frame. Some stands insert, clip, or screw onto an area on the back of the frame. Some frames have different connections depending on whether you want the frame horizontal (landscape) or vertical (portrait). Set the frame up for horizontal display, unless most of the photos you intend to display are portraits. See **Figure 15-3**.

3. Put the frame in a spot safe from pets and traffic, within a cord's length of a wall plug. Connect the power supply to the frame on the back or side. Plug the frame into the wall.

4. Turn the frame on. The power switch is a button or slider on the side or back of the frame. The frame's logo and a screen with information on switches appear on some models. A demo slideshow starts automatically. See the task "Display Photos from Your Camera's Memory Card."

Power switch

USB for computer

USB Host for flash drive

Figure 15-3

Display Photos from Your Camera's Memory Card

1. If you have photos on your camera's memory card, you can display them on your frame. (If you don't have any photos on the memory card, take some.)

2. Turn the camera off. Eject the memory card, noting how the card was inserted originally. If you have a spare memory card, insert it into the camera.

 If you have two or more memory cards, one can be in the camera and another in the frame at all times.

3. If the frame is on, turn it off. Locate the slot appropriate for your memory card. Most frames use combination slots that take more than one type of card. Wide slots make it trickier to insert the card correctly than in a camera. Metal contacts go in first. Insert the card gently. Warning: Don't push the card in beyond the edge of the slot or you may have trouble removing the card. (Try using tweezers if your card gets stuck.) If the card does not slide easily into place, pull it out and turn it over and try again or look for another slot. Be gentle: Do not force the card or pull it out too strongly.

4. Turn the frame on. A menu may appear at first, but after a moment, most frames begin to show photos from the memory card.

Change Frame Settings

1. If the frame is off, turn it on. If you normally use a memory card, leave that card inserted in the frame.

2. Locate the Menu or Setup button. This may be on the back, side, or front. You also need to identify the **OK** button (it may be the same as the Menu button) and other buttons that move the selection highlight up, down, left, and right. Press the **Menu** button.

3. Look for a **Settings** or **Setup** option on the menu, which is sometimes represented by a gear or wrench. The menu may also include options to select a source for pictures. The picture source is usually selected automatically based on which card is inserted. Use the appropriate button to move the selection highlight over **Settings** or **Setup**. Press the **OK** button to begin setup.

4. Your frame may have some but not all of these options. Some options may appear only after you select another option:

- **Frequency or interval:** How often do you want a new photo to appear? Choices may range from a few seconds to 24 hours. Choose 30 seconds or a minute to start. At an interval of 5 seconds or less, photos fly by. If you set the interval too long, you may feel impatient waiting for the photo to change. Some frames have Next and Previous buttons on the frame or remote to enable you to switch photos without waiting for the automatic interval to pass.

- **Order:** Random order offers the most surprise. However, if your photos tell a story that progresses with each photo, choose something other than random. Other ordering options include by filename and by date taken.

- **Effects or transitions:** Transition effects create a show as one photo replaces another. Without transitions, one photo disappears and the next replaces it instantly. With a transition, you may see parts of each photo until one replaces the other. Transitions can be entertaining or irritating.

- **Clock:** If the frame has a clock, you do not have to set the clock to use the frame. However, if the frame also has an option to turn on and off automatically at a specified time or to display a clock on screen, set the clock, including date, if that is an option.

- **Brightness and contrast:** You may be able to adjust the brightness and the contrast between light and dark. Wait until you've seen how your pictures look with the default settings.

Edit Photos for Frames

If a photo isn't exactly right, you may be able to fix it by editing. You may be able to perform basic editing using your camera or your frame. Your most complete editing option is to use software on a computer, such as the Windows Live Photo Gallery. (See Chapters 10 and 11.) These are the most common editing tasks:

➡ **Rotate:** Photos taken while holding the camera vertically, instead of horizontally, may appear horizontally in the frame. Some cameras and frames automatically rotate these photos. Otherwise, you need to rotate the photos using editing options. Many frames rotate a photo temporarily. In such a case, the next time you turn the frame on, the photo may be back to its original unrotated orientation.

➡ **Crop:** By cropping a photo, you discard some of the area around the subject to make the subject a larger part of the photo, which is especially good on small frames. However, if you crop a photo, you increase the odds the frame has to add black bars to the sides or top and bottom to fit the photo in the frame. (You can crop using the frame's aspect ratio to avoid this problem.)

 Some frames enable you to zoom into a photo. This doesn't change the original photo, while letting you see part of the photo more closely. The next time you see this particular photo, it will be back to unzoomed.

➡ **Resize:** Most digital cameras produce photos that are much larger than necessary for viewing on most frames. A large photo takes more room on the memory card than a smaller photo. Large photos also take longer to copy and might display more slowly. However, you only need to resize photos if you are

trying to fit more photos on the memory card for the frame. (It may be easier to buy a larger memory card.) See Chapter 14 for information on resizing photos.

➡ **Adjust exposure:** A photo may be too dark or too bright. Some frames automatically adjust exposure, color, and contrast. You may be able to fix a photo's exposure.

➡ **Delete:** If a photo really is beyond saving, you can delete it using the camera's delete function (see Chapter 2) or a function on the frame, if it has one. You'd be surprised what you can do to fix a photo on a computer. Consider copying all your photos from the camera to the computer, fixing them there, and putting on the frame just those photos you want to see there. See the task "Copy Photos from Your Computer."

Copy Photos from Your Computer

1. Choose a method supported by both your frame and your computer, whether a USB flash drive or a memory card. If you are using a memory card, insert it into your computer's card reader. If you are using a USB flash drive, insert that into a USB port on the front or back of the computer. (If an Autoplay dialog box appears, close it.)

2. Use Start➪All Programs➪Windows Live Photo Gallery. Select the photos you intend to copy to your frame by clicking the check box in the upper left corner of each photo. Your card or flash drive may hold hundreds of photos.

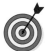 Take advantage of tags and ratings for selecting the photos you want to display. See Chapter 9 for information on tagging and rating your photos.

3. With the mouse pointer over any one of the selected pho-
tos, click the right mouse button. Choose **Copy** from the
context menu that appears. See **Figure 15-4**.

4. Use Start⇨Computer. The flash drive or memory card
appears as a removable disk with a letter and a colon,
such as E: (or whatever the last letter visible is). Right-
click over the icon for your flash drive or memory card.
Choose **Paste** from the menu. Your photos are copied to
the flash drive or memory card. See **Figure 15-5**.

Check to select.

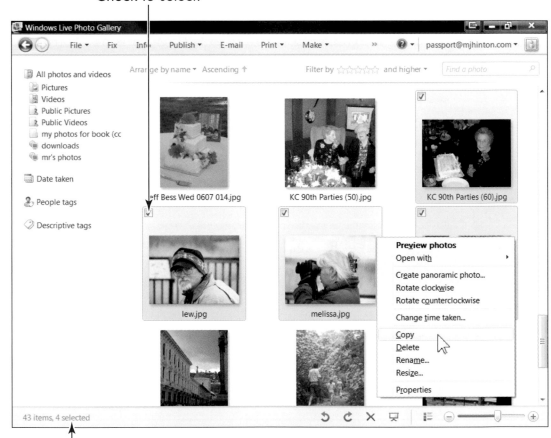

Number of selected photos

Figure 15-4

Select Paste Flash drive

Figure 15-5

5. Remove the flash drive or memory card. With the frame off, insert the flash drive or memory card into the appropriate slot on your frame. Turn the frame on. A few seconds later, a slideshow should automatically begin to display the photos you copied.

 If your frame came with a USB cable, you can also use that to connect your frame directly to your computer. The steps are the same, except that you choose the frame in the Step 4. The frame appears as a removable disk with a letter such as E: (the last letter visible).

Having Fun with Your Photos

*T*aking and sharing photos is fun. You'll want to see your favorite photos again and again in ways that weren't possible with film, negatives, and prints. You can reuse your digital photos in so many new ways.

For example, make a favorite photo the background of your computer desktop, so that you see it every time you start and shut down your computer.

Turn your computer into a digital picture frame by using a photo screen saver to run an endless slideshow. Or make a slideshow on DVD to send to family and friends.

Insert your photos into letters and other documents. Your annual holiday letter will be that much more interesting.

Create a book of your photos for less money than you might imagine. Go online to a service that lets you combine photos and layouts into books to print as keepsakes or gifts.

 The same companies that print books also print photos on other things, including greeting cards, mugs, and even postage stamps. After you have a library of uploaded photos, you can create all kinds of fun things.

Get ready to . . .

Make a Photo Your Computer Desktop Background

1. Use Start⟹All Programs⟹Windows Live Photo Gallery. Select the photo you want to see as your desktop background (also called wallpaper).

2. In Gallery view or Preview, click the right mouse button over the photo. On the context menu that appears, choose **Set As Desktop Background** (see **Figure 16-1**).

3. To see your desktop background, minimize or close any open windows.

Click the right mouse button over any photo to make it your desktop background.

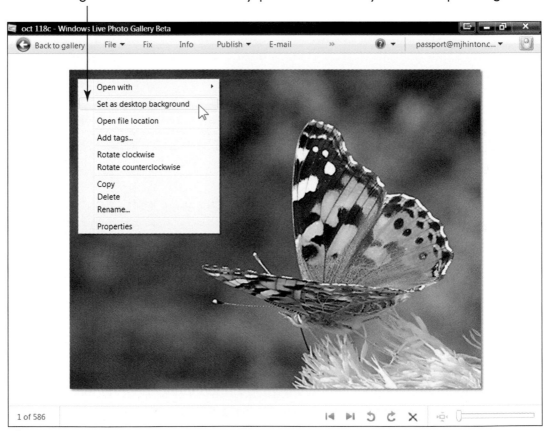

Figure 16-1

 If open windows keep you from seeing your desktop, press the Windows logo key located between Ctrl and Alt plus the letter D to display the desktop (Win+D). Press Win+D a second time to redisplay your program windows as they just were.

 Free software can automatically change this background on a regular schedule (by the minute or by the day). Use a search engine such as www.google. com to search for "**wallpaper changer.**" Vista users can include the word "**gadget**" for Sidebar. You can also visit the book's Web site for links: www.mj hinton.com/dpfs/.

Use a Photo Screen Saver

1. Use Start⇨All Programs⇨Windows Live Photo Gallery.

2. In Gallery view, choose File⇨Screen Saver Settings. See **Figure 16-2**.

3. In the Screen Saver Settings dialog box, click the drop-down menu under Screen Saver and choose **Windows Live Photo Gallery**. See **Figure 16-3**.

4. Click the **Settings** button. Choose one of the following options to determine which photos appear in your screen saver:

• **Use All Photos and Videos from Windows Live Photo Gallery**: This uses all your photos and videos. You can limit the photos and videos displayed by specifying a tag or a star rating. You can also omit photos and videos based on a tag. See **Figure 16-3**.

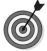 In Photo Gallery, you can add a unique tag to only those photos you want to see in a screen saver as a way to fine-tune your screen saver selections.

- **Use Photos and Videos from**: Specify a folder containing photos and videos you want to see. Use the **Browse** button to locate the folder. For example, you might choose your most recent travel photos by folder.

Under the File menu, choose Screen Saver Settings.

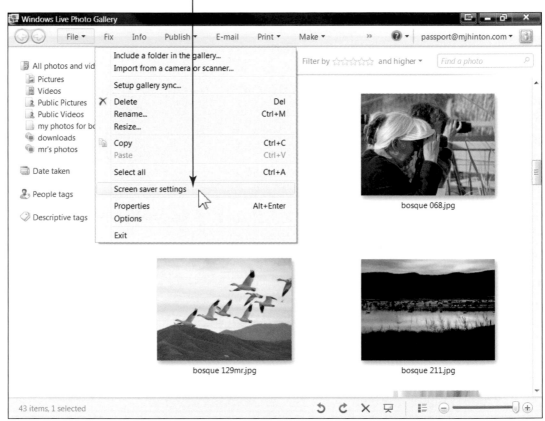

Figure 16-2

5. You may want to modify the following settings, as well:

- **Use This Theme:** Changing from one photo to the next can also display transitions in which part of the previous photo and part of the next photo appear. The Random theme uses a different theme each time the screen saver runs.

- **Slide Show Speed:** This option determines roughly how long each photo remains on-screen. Choices are slow, medium, or fast.

- **Shuffle Contents:** Check this option to shuffle your photos into a random order in the screen saver. Uncheck this to display photos in the order in which they appear in Photo Gallery or in a folder.

6. Click the **Save** button.

7. Back in the previous Screen Saver Settings dialog box, click the **Preview** button to test the screen saver. Don't touch the keyboard or mouse during the preview. After you have seen enough of the preview, touch the keyboard or wiggle the mouse to end the preview.

Select Windows Live Photo Gallery, then click the Settings button.

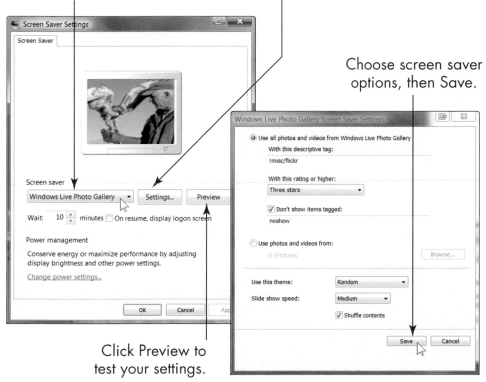

Choose screen saver options, then Save.

Click Preview to test your settings.

Figure 16-3

8. Use the **Wait** option to determine how many minutes of inactivity pass before the screen saver begins. Do not check the **On Resume, Display Logon Screen** option.

 In Windows Vista, to run the screen saver without waiting the preset time of inactivity, click the **Start** button in the taskbar and type **wlxpgss.scr** in the Start search box. Press the **Enter** key on the keyboard to start the slideshow. Wiggle the mouse or touch a key on the keyboard to end the slideshow.

Create a DVD Slideshow

1. Use Start⇨All Programs⇨Windows Live Photo Gallery.

2. In Gallery view, select the photos you intend to include in a slideshow on a DVD for family or friends. Use the check box in the upper left corner of each photo to select it. To sift through your photos, use the navigation pane on the left to display photos by location, date, or tag. Use the option above the photos to filter by star rating if you want to limit photos displayed to those with a particular rating or higher.

3. From the top menu, choose Make⇨Burn a DVD. (You may have to click on >>, if you don't see the Make menu item.) See **Figure 16-4**.

4. Windows DVD Maker starts and displays your selected photos. See **Figure 16-5**. You can add photos using **Add Items** at the top of the screen. Select photos you want to remove from the DVD and click **Remove Items**. Use the blue up and down arrows to rearrange the order of the selected photos.

Select photos with check marks before clicking Make, and then Burn a DVD.

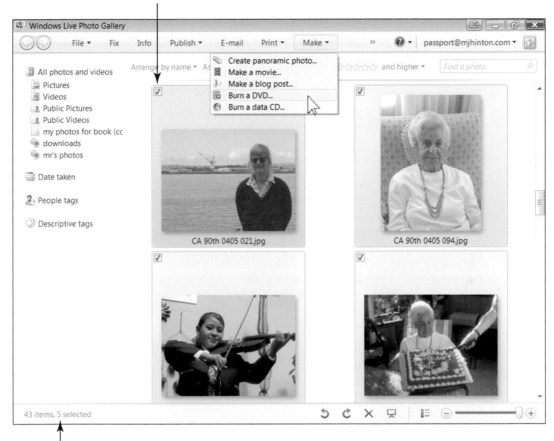

Number of photos selected for the DVD slideshow
Figure 16-4

5. In the lower left corner of the DVD dialog, see the minutes remaining on the DVD. (A DVD is capable of holding more than 1,000 photos.) You can specify the disc title at the bottom of the screen. The title is the current date by default.

6. After you have added all the photos you want, removed those you don't want, and rearranged the remaining photos, click the **Next** button.

Add or Remove photos.

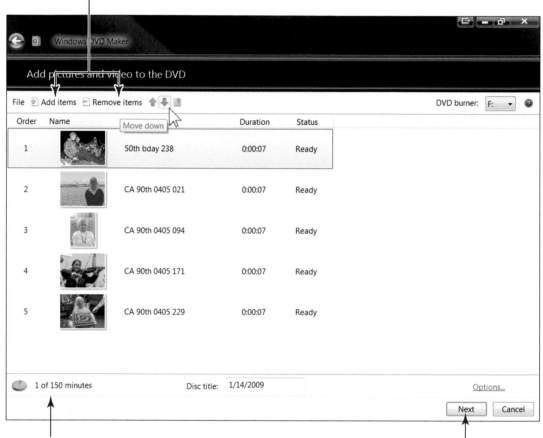

Number of minutes used and remaining on DVD Click Next to continue.

Figure 16-5

7. The Ready to Burn Disc screen appears (see **Figure 16-6**).
You can preview your slideshow using the **Preview** button
at the top of the screen.

8. On the Ready to Burn Disc screen, there are many features
of the slideshow you can modify, but all are optional. If
you want to create the DVD without changes, click the
Burn button. You may want to examine these options:

 • **Menu Text:** Change the text and font for the disc title,
 Play button (starts the show), Scenes button (displays
 individual photos), Notes button, or notes.

- **Customize Menu:** Change the font for the menu and buttons, add videos or audio to the menu, or modify the style of the individual photos presented when the Scenes button is pressed.

- **Slide Show:** Whereas Preview shows you the DVD as it should appear on any machine, this option lets you view the photos you have selected without any additional formatting.

- **Menu Styles:** These styles determine where the DVD play menu appears on screen, as well as background color and image placement on the menu.

Click here to preview your show.

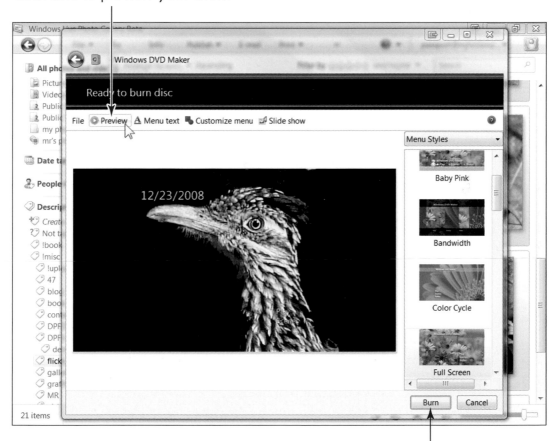

Click Burn to create the DVD.

Figure 16-6

9. Click the **Burn** button to create the DVD. A dialog box appears to prompt for a blank DVD in the DVD drive. (The drive door does not open automatically. Press the button below the drive door on the computer to open it.) Several small dialog boxes report the progress of the DVD creation over a period of a few minutes. The last dialog box indicates that your disc is ready. You can click a button to make another copy of this disc or you can click the **Close** button if you are done.

Add Photos to Microsoft Word Documents

1. In Gallery view, select a photo you want to include in a letter or other Microsoft Word document. Use File⇨Copy to copy the photo.

2. Use Start⇨All Programs⇨Microsoft Office⇨Microsoft Office Word to start a new document. If you want to include the photo in an existing document, open that document next.

3. Click to place the cursor at the beginning of a paragraph in the Word document where you want your photo to appear. Use Edit⇨Paste to insert the photo into the document.

This method may work with other programs. Try it. If you can't paste a photo directly from Photo Gallery into another program, paste the photo into a Word document, and then select the photo in Word and use Edit⇨Cut or Copy. In the other program, use Edit⇨Paste to insert the photo.

You can select more than one photo in Photo Gallery before you copy. Then, you can paste all the selected photos into Word in one step.

4. If the photo is too large, click once on the photo to select it. Click and drag any of the eight small circular or square handles that appear in the corners and the middle of each

side to reduce the photo in size. See **Figure 16-7**. If you can't drag the handles, click the right mouse button over the photo and use Format Picture⇨Size. Use the Scale section to shrink the photo (try 25%). See Chapter 15 for an alternate way to resize the photo before you copy it into your document.

5. To wrap text to flow around your photo, click the right mouse button over the photo and choose Text Wrapping⇨ Square, as in **Figure 16-8**. To keep text from wrapping around the photo, forcing text and photo to separate lines, use Text Wrapping⇨Top and Bottom.

Click on the photo to select it, then click and drag any of the handles to resize the photo.

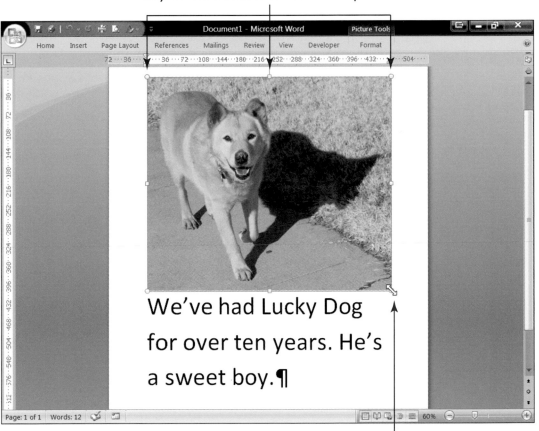

The Resize arrow

Figure 16-7

Click on the photo to select it, then click and drag
any of the handles to resize the photo.

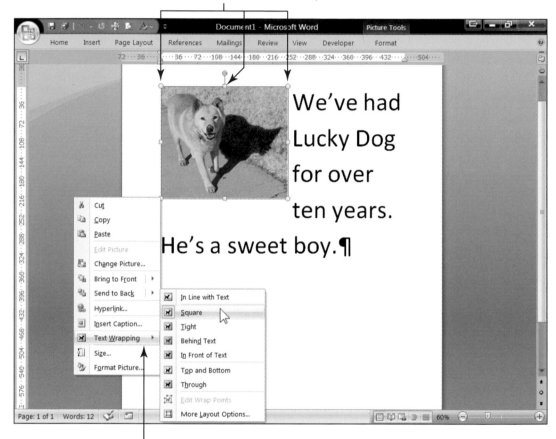

To flow text around the photo, click the right mouse button
over the photo, then choose Text Wrapping.

Figure 16-8

6. To reposition the photo in the text, click and drag the
photo to a new position on the page. You can also use
Edit⇨Cut to remove it and Edit⇨Paste to put the photo in
a new cursor location.

Microsoft Word has WordArt for fancy text and also
has some drawing tools under Insert⇨Shapes.

7. Use File⇨Save to save your Word document. Use File⇨
Print to print the document.

Create a Photo Book Online

1. Use your Web browser to visit www.shutterfly.com. Under Shop For Products, click the **Photo Books** link. (You may see other links to the same page.) **See Figure 16-9.**

 Tasks you perform on the Web work the same for Windows and Mac users.

Browse www.shutterfly.com.

Choose Photo Books.

Figure 16-9

2. On the Photo Books page, select one of the book styles. Each style has a link to learn more about its features. The following steps are based on the 5 x 7 style, an affordable option for experimentation. To match the figures, scroll down to 5x7 Casual Book and click the **Go** button under that section. See **Figure 16-10**. Other styles will have some of the same options and screens.

Click Go under 5x7 Casual Book.

Figure 16-10

3. Observe the features of the 5x7 Size book. See **Figure 16-11**. You may want to click the link to **Watch Photo Book Demo**. You can also select a book style under **Shop By Occasion**. However, for these steps, click the **Get Started** button on the right.

Watch a demo. ┐ ┌ Click Get Started.

Figure 16-11

4. On the next screen (see **Figure 16-12**), choose the paper pattern from the Styles on the left. The preview book in the center of the screen shows you what the paper looks like with photos and text. Feel free to try any or all styles before you continue.

5. On the same screen, below the preview, choose the font, size, and color for text in the book. The preview does not show changes to this section. Choose a **Photo Edge** style, which appears around each photo. You can choose and change all these settings later as well, even on individual pages. When you are ready to continue, click the **Next** button at the top-right of the screen.

Try different paper styles. Click Next.

Figure 16-12

6. The Join Shutterfly screen appears, as in **Figure 16-13**. (This screen may appear at some other point in the process.) Enter your first name, last name, e-mail address, and the password you want to use (twice — write it down, too). Click the **Yes, I Accept The Shutterfly Terms and Conditions** check box. (My lawyer says I should advise you to read those terms and conditions, first.) Click the **Join Now** button. (If you already have an account with Shutterfly, click the **Member Sign In** link.)

Fill in your information for a new account (or sign in, if you have an account).

Click Join Now.

Figure 16-13

7. After you join or sign in, you see the Collect Pictures screen, which is largely blank the first time you see it. On this screen, click the **Upload** button in the upper left corner of the screen. The Upload Pictures screen appears, as in **Figure 16-14**.

8. On the Upload Pictures screen, click the **Choose Files** button. Use the next dialog box to locate your photos folder and to select photos. You can repeat this process as many times as necessary.

Click Choose Files to browse your computer for photos to print.

Click Start after you've chosen all the photos you want to upload.
Figure 16-14

 You may not use all the photos you select here, but it's better to have too many than too few so that you have choices as you go on. Because it is easiest to pick photos from a single folder, consider copying all the photos you intend to print into a new folder before you go online.

9. After you have selected all the photos you may include in the photo book, click the **Start** button at the bottom of the screen. Uploading begins and you see a progress indicator on screen, as well as an estimate of remaining time

in the upload. Do not close this window. After the upload completes, the next screen offers a button to **Upload More**, if you want to select more photos. When you have uploaded all your photos, click the **View Pictures** button. If this window doesn't close automatically, click the link to **Close This Window**.

10. Your uploaded photos appear in the Collect Pictures screen. Select any of these pictures by clicking once on the photo. Use the **Select All** link to select all photos. You can unselect any photo by clicking on the little check mark in the upper left of the photo. When you are ready, click the **Add to Photobook** button in the upper right corner. A dialog box asks if you want to add additional pictures to the photobook (see **Figure 16-15**). Click **Yes** to return to the Collect Pictures screen, where you can upload more photos or select from others you have already uploaded. Click **No** if you are done selecting photos and wish to continue.

11. The photos you have selected for the photo book appear on the Organize Pictures screen, as in **Figure 16-16**. To rearrange photos, use the **Sort** option on the far right (that option is hidden behind the thumbnail in **Figure 16-16**). To manually rearrange, click on a photo, and then click on the tiny triangle that appears in the lower right corner of the photo. Use **Move To** to specify the number of the position you want this photo to occupy, or choose **End** to move to the last position. You can also remove a photo from the book using this menu.

 Drag and drop doesn't work here to rearrange photos. Take care in choosing photos in the order you want them to appear in the book. You can also rename the photos before you upload them so that if you sort by name, that is the order the photos should appear in the book (photo01, photo02, and so on).

Click Yes if you want to add more photos
to your book or No if have all you want.

Figure 16-15

12. After you have selected and arranged your photos, click
the **Next** button. The Edit Pages screen appears. All your
photos appear in a tray below the pages area. Click and
drag one of your photos and drop it on the cover page.
Across the top of the screen, a series of gray boxes indi-
cates which facing pages you are working on. Click on a
page or use the small triangles at the end of the page bar
to move through the book. Click on a page to select it,
and then choose a page layout from those that appear on
the left of the screen. You can use the same or different
layouts for every page. Some page layouts are for one
photo, while some are for up to five or more photos per
page. (A single photo filling a page is lovely.) Some pages

have captions, some do not. Some allow for more text. Drag photos from the tray below the page area onto the page into the empty boxes that appear as you choose a layout (see **Figure 16-17**). You can also drag photos off the page back to the tray of photos along the bottom. As you add photos to pages, they disappear from the tray (if **Hide Used** is checked). Click in text areas such as captions and headings to add text. In the Edit Text box, you can type, as well as select a font, size, color, and alignment of text. Click **Done** to add the text.

After you have arranged your photos, click Next.

Click on a photo, then click the tiny triangle in the lower corner of the photo for a menu.

Figure 16-16

For the selected page, choose a layout.

When you are done
with all pages, click Next.

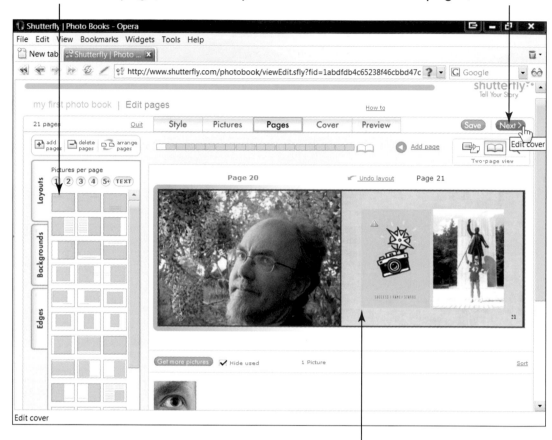

Click and drag photos between the tray and the page.

Figure 16-17

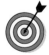 A triangle with an exclamation point appears on pictures that do not have sufficient resolution to print at that size. Such pictures may be usable if you pick a layout that puts more, smaller photos on the page.

13. Review each page. Click the **Save** button to save the current project. When you are ready to continue, click the **Next** button. The Edit Cover screen appears. Choose a color and style for the book cover. Click **Next**.

14. Preview your book again, page by page (see **Figure 16-18**). Any problems are highlighted with a triangle in an exclamation point. Click on any page to return to the layout for that page. When you are satisfied, click the **Order** button. If you haven't saved your project, you'll be prompted to do so next.

15. Review your order on the Quantity and Recipients screen (see **Figure 16-19**). Click the check box next to your address under Recipients. You can add addresses for other recipients there. Click the **Next** button.

Review
every page.

When you are done with
all pages, click Order.

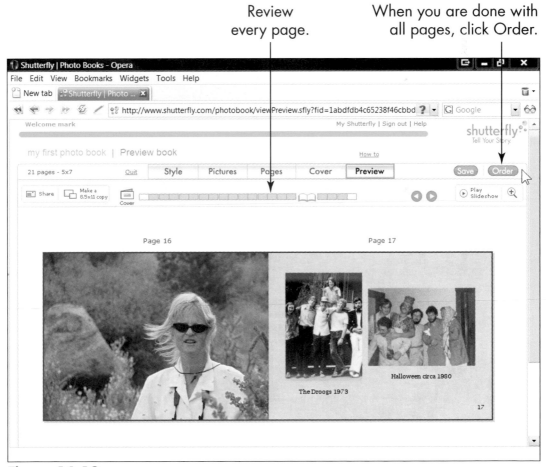

Figure 16-18

Specify how many books you want.

When you are ready to pay, click Next.

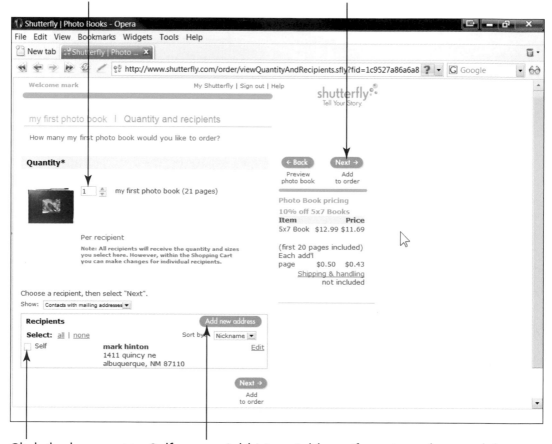

Click the box next to Self or use Add New Address if you intend to send this book to someone else.

Figure 16-19

16. The Shopping Cart screen appears. You can review or change your order or select a shipping speed. When you are ready, click the **Go to Checkout** button.

17. On the Choose Payment screen, if this is your first order, enter credit card info. (You can also pay with check, money order, or gift certificate.) Click the Place My Order Now button. The Order Confirmation screen appears. You can note the order number if you want, but you should also receive an e-mail with the same information. You're done. Sit back and wait for your book!

Glossary

aperture: The adjustable opening of the lens that lets light into the camera.

Aperture Priority mode: The camera setting you use to set the aperture, letting the camera control other settings.

aspect ratio: The ratio of width to height for a photo or screen. Most digital cameras have an aspect ratio of 4:3. High-definition is 16:9 (wider than 4:3).

auto-focus: The standard setting that enables the camera to automatically focus when you hold down the Shutter Release button halfway.

Automatic mode: With this mode, the camera automatically controls all settings, while you point and shoot.

bracket: To shoot several photos with small adjustments to settings. Some cameras have an automatic bracketing option.

bridge camera: A style of camera between compact cameras and DSLRs. Bridge cameras have more features and options than compacts, but fewer than DSLRs.

Burst mode: This mode shoots several photos using the same settings to capture objects in motion.

compact camera: A small camera designed with ease of use and a low price point in mind.

composition: The plan for a photo with the careful placement of the subject and background in mind. Composition is also sometimes called *framing*.

contrast: The difference between light and dark areas of a photo. High-contrast photos are sharper than the soft effect of low-contrast photos.

crop: To remove part of a photo with the intention of improving the composition or emphasizing the subject.

depth of field: The area in focus in front of and behind the subject. With shallow depth of field, areas closer to the camera or farther will be out of focus or intentionally softer or blurred. With deep depth of field, a larger area in front of and behind the subject will be sharply focused and clear.

digital picture frame: An electronic screen for displaying photos. Digital picture frames store multiple photos and display them in a configurable slideshow.

Digital Single Lens Reflex (DSLR) camera: cameras use exchangeable lenses, such as a close-up lens versus a zoom lens. Specialty lenses are a costly way for photographers to expand their options.

electronic viewfinder (EVF): An electronic viewfinder lets you hold the camera up to your eye to compose the photo. The EVF displays camera settings superimposed over the scene.

Exchangeable Image File Format (EXIF): A standard for storing information about camera settings at the time a photo was taken.

exposure: The amount of light and dark in a photo.

exposure compensation (EC): Involves small adjustments to the settings a camera chooses for exposure.

focus: The degree of sharpness or clarity in part or all of a photo.

frame: To compose or arrange a photo with the entire scene in mind. Also, a reference to a digital picture frame.

f-stop: Aperture is measured in f-stops, or fractions of the length of the lens. F2 or f/2 is a wide aperture. F16 or f/16 is a narrow aperture. Each f-stop admits twice as much light as the next narrower f-stop and half as much light as the next wider f-stop.

histogram: A graph of the distribution of light and dark within a photo. A histogram on a camera or in editing may help you determine whether a photo is or will be underexposed, overexposed, or unevenly exposed.

image sensor: The computer chip in a camera that captures and records the photo onto a memory card.

image stabilization: Image stabilization minimizes the effects of unintentionally moving the camera. Without image stabilization, even small movements or vibrations can ruin the focus of a photo, especially in a zoom or macro shot.

ISO: From the International Standards Organization, which sets standards for many devices and technologies. In the context of cameras, ISO refers to the adjustable light-sensitivity of the image sensor. A high ISO setting makes the sensor more sensitive, producing better exposure in lower light.

JPEG: The standard for storing photos as files, as decided by the Joint Photographic Experts Group.

landscape: Landscape orientation is the normal position of a camera, where the photo will be wider than it is tall. Landscape mode is a scene mode used to take photos of scenery.

liquid crystal display (LCD): The display on the back of a camera. You can compose and review photos on the LCD, as well as view menus.

macro: A macro shot is an extreme close-up, such as a shot of a flower or bug that fills the entire photo. Use Macro mode to set the camera for extreme close-ups.

megapixel (MP): Millions of pixels (dots). Image and screen resolution are measured in megapixels.

memory card: Photos are stored in the camera on a removable memory card.

metering: Metering is the process the camera uses to calculate the light available in the scene.

monopod: A single-leg stand, 4 to 6 feet high with a connector at the top for a camera, used to support the camera and provide some stability.

noise: Specks, color flecks, and other artifacts on a photo. Noise is more noticeable at higher ISO settings.

overexposed: More light than necessary was used to expose the photo, washing out detail in lighter areas.

panorama: A wide shot composed of two or more photos stitched together by the camera or using photo-editing software.

pixel: A single dot of light and color. Photos and screens are measured in pixel width and height.

point-and-shoot camera: A compact, easy to use camera.

portrait: Portrait orientation is a vertical shot taken by turning the camera 90 degrees. Portrait mode is a scene mode for close-ups of people.

prosumer camera: A camera with features intended to please camera enthusiasts. (The word is a cross between *pro*fessional and con*sumer*.) A prosumer camera is a bridge camera with more features than a compact camera but fewer features than a DSLR.

RAW: RAW is a file format for storing photos. RAW stores more exposure information (useful for editing) in larger files than the more common JPEG format.

red-eye: Light reflected from the back of a person's eye appears as red dots in the pupils. Cameras have settings for minimizing red-eye, which can also be fixed with photo-editing software.

resolution: Refers to the number of pixels in a photo. A high resolution photo has more pixels than a low resolution one. As a result, high resolution images can be printed as larger prints than low resolution images.

Rule of Thirds: A photographic guideline that suggests placing strong horizontal lines, such as the horizon itself, along imaginary lines dividing the frame into thirds. Strong vertical lines, such as a flagpole, should be placed along imaginary vertical thirds. Furthermore, the subject of a photo can be placed where a vertical third intersects a horizontal third — instead of dead center — to create interest or tension within the frame.

scene modes: Camera settings optimized for specific conditions, such as Sports mode or Portrait mode. Choose a scene mode using a dial or menu.

shutter: Keeps light out of the camera until you are ready to take a picture. Then the shutter opens to let light into the camera for the exposure.

Shutter Release button: Opens the shutter to expose the photo.

shutter speed: A measure of the length of time the shutter is open, which affects the brightness of the exposure. A slow shutter speed leaves the shutter open longer, admitting more light. A fast shutter speed closes the shutter sooner, admitting less light.

Shutter Speed Priority mode: This mode allows you to set a shutter speed, while the camera controls other settings.

telephoto lens: A telephoto lens varies from wide angle to zoom. In non-DSLR cameras, this is more commonly called a zoom lens.

TIFF: The tagged image file format is another format sometimes used to store photos. TIFFs are larger files with more exposure information than JPEGs, but they have less information and are smaller than RAW files.

tripod: A three-legged stand with a connector on top that attaches to the bottom of your camera. A tripod lets you position your camera precisely and hold that position indefinitely as you compose and take photographs. The stability of a tripod is essential in low light.

underexposed: Insufficient light for a photo, blacking out details in dark areas.

viewfinder: The small window at the top of a camera that you put your eye near to compose a photo.

white balance: Certain lights have a color cast. For example, regular light bulbs cast a yellow light. White balance refers to the adjustment necessary to correct for that color cast to keep white objects from looking yellow.

wide angle lens: A wide angle lens allows more width in a photo, such as for photographing a building or large group. Most digital cameras range from wide angle to zoom using a lever.

zoom lens: A zoom lens brings distant subjects closer to the camera.

Index

• C •

• *N* •